# TYPOGRAPHY

WATSON·GUPTILL PUBLICATIONS/NEW YORK

Edited by Susan Davis
Art direction by Jonson Pedersen Hinrichs & Shakery Inc.
Page layout by Jay Anning
Graphic production by Ellen Greene
Photography by Bill Sonntag
Composition by Trufont Typographers

# CONTENTS

# CHAIRMAN'S STATEMENT

**VICTOR E. SPINDLER**
Chairman, TDC-30
President, Spindler Productions
New York

With over 3,600 entries from ten countries all over the world, the 30th annual competition of typographic excellence conducted by the Type Directors Club of New York broke many records and produced an outstanding exhibition of over 200 pieces.

Even the truly "blue ribbon panel" of jurors reflected the international flavor that this competition is taking on. From Frankfurt, Germany, came Olaf Leu, who owns his own design firm and is a frequent recipient of awards of typographic excellence. John Gibson of MacLaren Advertising came from Toronto, Canada, where he is presently Director of the ICA Certificate course in print production.

Renowned names in the industry like Ed Benguiat of Photo-Lettering, Inc., the designer of many popular typefaces, and advertising art director Bob Czernysz of Young & Rubicam, winner of many gold and silver medals for the Time, Inc. campaign, were included. Andy Kner, then the Executive Promotion Art Director of *The New York Times* and Art Director of *Print* Magazine and now Creative Director of Backer & Spielvogel, lent his time and talent. B. Martin Pedersen of Jonson Pedersen Hinrichs & Shakery, one of New York's "hottest" designers, Jessica Weber, Executive Art Director for the Book-of-the-Month Club, and I rounded out the panel, with Minoru Morita of the Creative Center here in New York acting as alternate juror.

These participants comprised one of the most conscientious juries possible. The show was judged over a two-day period in New York City. To win, a submission had to receive a vote from a majority of the panel.

The jury was given the charge to select only those pieces that truly displayed excellence in typography and calligraphy and to try to avoid taking other graphic or photographic standards into greater consideration. Each piece received extremely careful scrutiny, and the winners this year are truly the creme-de-la-creme, creating a very exciting and important collection of work.

The jurors' reaction to this year's entries was almost unanimous: "High quality, a wide range of styles and techniques with no strong trends or fads in particular." While there were no direct comments by the judges, the general feeling was that there was a definite lack of entries in the advertising typography area. Only 14 out of the 202 winners were advertisements.

I heartily urge anyone interested in calligraphy and typography to see the exhibition and add *Typography 5* to his or her collection.

**Vic Spindler** is currently owner of Spindler Productions, a full-service audiovisual house specializing in typographically oriented slides as well as multiprojector slide presentations. Spindler previously opened and operated The Slide House and the National Typesetting Service. Prior to that he was Art Director for CBS Television Network, where he specialized in on-the-air graphics, promotion, and film animation.

Vic Spindler has many interests including typography, computers, computer graphics, railroading, and Tiffany glassmaking. He earned his B.F.A. in advertising design from Pratt Institute.

# JUDGES

**EPHRAM EDWARD BENGUIAT**
Vice-President/Creative Director,
Photo-Lettering, Inc.
New York

It was a great honor to have been chosen as a judge for the TDC show. It really helped boost my ego. I needed that! For many years the Type Directors Club of New York City has produced annuals of award-winning pieces. They're aimed specifically at typography and these are the only permanent records available. I should like to thank all those who helped to organize and put it all together.

The selection of award-winning entries seemed more difficult than I had ever anticipated. The work, the talent, the capabilities, and ingenuity behind the many pieces were all of the highest caliber. If I had my way and could bypass the committee, I would have personally given an award to many, many more than what were selected.

Unsurpassed technology has given typography the world's most advanced, state-of-the-art, computerized systems. It is a new frontier for the communication industry. What's in store for the future is anyone's guess. Creativity factors will and must go to even higher levels in design.

**Ed Benguiat** is well known for his many typeface designs. To date he has designed over 500 typefaces, many of which are proving to be mainstays of typographic usage.

Benguiat was born in New York City, to a family of well-known art connoisseurs and collectors. From a young age he was strongly influenced in the direction of graphics.

After flying with the Air Force during World War II, he returned to earn a B.A. degree in music at Brooklyn College and then pursued a career as a successful progressive jazz drummer. Not much later his family influenced him toward a career in the graphic arts.

Ed studied at Columbia University and also attended the Workshop School of Advertising Art in New York City. He gained an impressive background by working as a designer and art director with many of the major advertising agencies and publishing companies in New York City.

Benguiat is presently Vice-President/ Creative Director at Photo-Lettering. Inc., and he teaches at the School of Visual Arts and lectures at Columbia University. He is also the Vice-President of the International Typeface Corporation and still is creating and designing letterforms. In addition, he finds time to fly his own private airplane.

**BOLESLAW (BOB) CZERNYSZ**
Vice-President, Senior Art Director,
Young & Rubicam
New York

**JOHN GIBSON**
Manager, Graphic Services,
MacLaren Advertising
Toronto, Canada

**ANDREW KNER**
Vice-President, Creative Director,
Backer & Spielvogel
New York

Judging the TDC Show 30/Typography 5 was a remarkably rewarding experience for me. The work was exciting and creatively stimulating. Particularly striking were the examples of the so-called new wave or post-modern approaches in graphic design, of which typography is an integral part. Typography appears to be freeing itself from self-imposed limits, to the extent that an art supply catalog becomes a thing of beauty.

The judging procedures were well-planned and thoughtfully organized. Each entry, no matter how small, received the undivided attention of the judges, with sufficient time allotted for consideration. All in all, it was the kind of show I like to be associated with, whether as judge or entrant.

**Bob Czernysz**, Vice President, Senior Art Director, has been with Young & Rubicam for over 20 years, and for the past ten years, much of his work has been on the Time, Inc. account. He's been associated with some striking successes. For *Sports Illustrated*, he developed "The Third Newsweekly" campaign, often cited as a classic. For *People* he created a campaign that ran for six years, broke all records for readership, and is regarded as a major factor in the immense success of the magazine. Bob has received many awards for excellence in advertising. Last year his *Fortune* campaign won two gold medals at The One Show and a silver medal at The Art Director's Show.

The system of judging by which each member of the jury makes an individual decision on every piece, without consultation with the others, is time consuming and draining but is without doubt the fairest and most satisfying system that I have experienced.

Each night, I left the sessions drained of energy. To *not* vote for a piece that is beautifully conceived and produced, but in some way flawed, is much more difficult than to vote *for* something.

I personally found it impossible to judge the oriental work and decided, perhaps wrongly, that I could not vote for any of them.

**John Gibson**, born in London, England, apprenticed as a printer. He studied at the London School of Printing and was teaching design and typography there at the age of 21. Since coming to Canada in 1952, John has worked with major typeshops and advertising agencies in Toronto, Montreal, and New York.

John was a founding member of the GDC (Graphic Designers of Canada) in 1956 and became National President in 1978. He is past President of the Advertising Agency Print Production Association (Ontario). In line with his continuing interest in education, John is presently Director of the ICA Certificate course in print production. He also has an interest in calligraphy, both teaching and practicing, for the past twenty years.

Judging the TDC Typography 5 Show was a thoroughly satisfying experience—for two reasons.

First of all, the quality of work was high, and it was a pleasure just to be able to look at all that good work. And then, it was all so varied—there was no style that seemed to dominate.

The second reason was that the judging itself was handled in such a fair and thoughtful way. There was no talking among the judges, and no one saw how anyone else voted. A certain number of yes votes got a piece into the show. A simple and fair system that ought to become the industry standard.

**Andrew Kner** was born in Hungary, where his family has been involved in design since the 18th century. He came to the United States in 1940 at the age of 5 and received his B.A. from Yale in 1957 and his M.F.A. in 1959.

He worked in promotion design for *Esquire* and *Look* magazines before joining *The New York Times* as Art Director for the Sunday Book Review. In 1970, he became Art Director for the Times Promotion Department, a position he held until 1984 when he left to join Backer & Spielvogel as Vice-President, Creative Director for Sales Promotion. Kner has also been, since 1962, Art Director of *Print* magazine.

Kner teaches design at Parsons School of Design and is currently President of the New York Art Directors Club.

**OLAF LEU**
President, Olaf Leu Design & Partner
Frankfurt, Germany

The quality of entries ranged above the average in symbiosis with the excellent reputation of the TDC and its competitions. I was disappointed, however, in the submitted advertisements which have stagnated within formal criteria since the late sixties and early seventies. In Germany the opinion is evolving that the shows of the TDC are surpassing those of the ADC since they contain formally more interesting exhibits.

The judging system is tough on entrants and jury. To find "the best of the best" remains subjective and puts high requirements of visual knowledge on each juror. In that sense the show mirrors the jury. The TDC judging system is exemplary—and will gladly be exported.

**Olaf Leu,** President of Olaf Leu Design & Partner in Frankfurt, Germany, is an internationally acclaimed designer/art director whose work is most often typographically oriented. He is also a Professor of Visual Communications part-time at St. Martin's School of Art in London. Leu is a long-time European member of the Type Directors Club and is a many-time recipient of TDC certificates of "typographic excellence."

**B. MARTIN PEDERSEN**
Partner, Jonson Pedersen Hinrichs
& Shakery, Inc.
New York

This year's show seems to have developed into the year of the bars. There were bars underlining names in stationery, bars accentuating posters, bars underlining figures in annual reports, and bars making points in promotion brochures. Most were handled nicely and some even brilliantly. The show is wonderful, bars and all, and my special lauds to those pieces in the show that remained barless. Perhaps with all the new shows that have evolved recently, some entrepreneural soul will develop a "bars only" graphic design competition. I know that I could submit a few myself.

**B. Martin Pedersen's** early career began in advertising, where he worked at a number of agencies and design studios such as Benton & Bowles, D'Arcy Advertising, and Geigy Pharmaceuticals. In 1966 he became corporate Design Director for American Airlines. With the opening of his own studio in 1968, he did award-winning work in all creative areas including corporate identity, advertising, product design, annual reports, publications, and marketing communications.

In 1976, Pedersen merged with Vance Jonson and Kit and Linda Hinrichs; Neil Shakery joined them in 1978 to form the present association. With offices in New York and San Francisco, Jonson Pedersen Hinrichs & Shakery, Inc., has, in its short history, gained an international reputation for its compelling design solutions and graphic style.

Pedersen has taught at schools and universities throughout the country, and is a frequent lecturer at design conferences and seminars. He has served as juror and chairman for numerous major shows and design competitions, and is presently a member of the Board of Directors of the American Institute of Graphic Arts, the Art Directors Club of New York, and the Society of Illustrators. In November of 1983 Pedersen was named a member of the U.S. Government Printing Office Information Industry Council.

**JESSICA WEBER**
Executive, Art Director,
Book-of-the-Month Club, Inc.
New York

I can't tell you how impressed I was with the TDC's smoothly orchestrated judging. I have *never* judged a show that was so organized. It made the two days fly. My congratulations on TDC's efficient and very peppy staff. The quality of the work was on a generally very high level and the diversity of the entries made for a very interesting judging.

**Jessica Weber,** a graduate of Parsons School of Design and New York University, is currently Executive Art Director of Book-of-the-Month Club, directing the design of the company's five monthly magazines and newsletters, record covers and collateral material for its record division, and catalog for its merchandise division. She was previously founding art director of the *International Review of Food and Wine* magazine. She redesigned the magazine when it was acquired by the American Express Publishing Company and renamed *Food & Wine*.

Awards for her work have come from the New York Art Directors Club, the Society of Illustrators, and the Society of Publication Designers. An article on her work appears in the August 1984 issue of *Idea* magazine. Weber has been a member of the faculty of the Parsons School of Design since 1980. She lectures frequently and has served on juries for visual art competitions. In 1984 she was guest lecturer and critic at the Illustrators Workshop and judged the Japanese Graphic Idea Exhibition.

**MINORU MORITA**
President, Creative Center, Inc.
New York

I started out as a worker for the preparation of the judging of TDC 30, but my role would soon change as I later found out. Due to a shortage of judges, I was asked to be an alternate judge.

I enjoyed viewing many different logos and letterheads. Since there was only type and no illustrations or photographs, I was able to focus my concentration on the creativity of typography. I didn't see a strong trend or fad of any sort in particular, even in the computer area.

Typography is a rather modest field, but perhaps it is the most significant ingredient for visual communication. Anyone can set type, but to utilize it creatively is quite a different thing.

At the judging, there were 200 winners out of 3,600 entries, giving odds of 1 in 18. This might possibly be considered the most difficult design contest of all in the graphic design industry. All the selected pieces spoke for themselves. I really enjoyed being an alternate judge (my second time) and hope to do it again.

**Minoru Morita,** President of the Creative Center, Inc., in New York City and Chairman of the "Japan Typography Exhibition" Committee, has been a professor of typography at Pratt Institute for six years.

Having served as chairman of TDC 24, he brought the exhibition to Japan in 1978. Ever since, Japan has held a TDC exhibition every year. In addition to being a member of the Japan Typography Association, Morita is a fifth degree black belt and Vice-President of the Shorinjiru Kenyakai karate federation. He is considered by many to be a *bridge* between the United States and Japan in the field of typography.

# TYPOGRAPHY

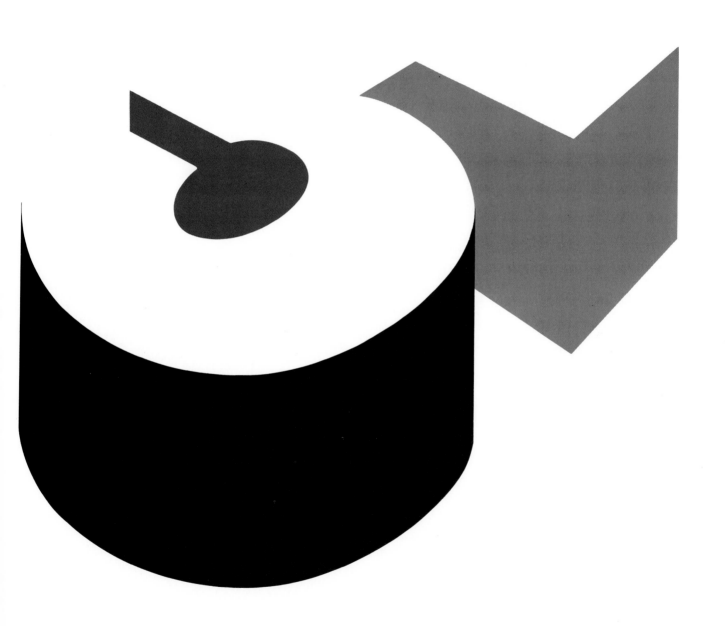

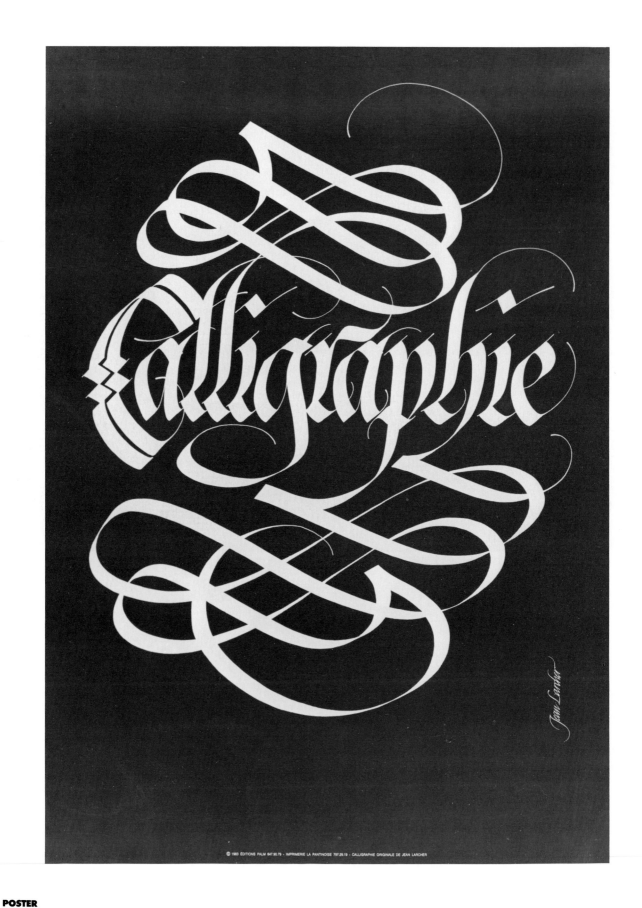

**POSTER**
**DESIGN** *Jean Larcher* **CALLIGRAPHER** *Jean Larcher* **TYPOGRAPHIC SUPPLIER** *La Pantinoise* **AGENCY** *Imprimerie La Pantinoise*
**STUDIO** *Jean Larcher Workshop* **CLIENT** *Palm/Lotus Engel* **PRINCIPAL TYPE** *Helvetica Book* **DIMENSIONS** *19.6 × 27.5 in. (50 × 70 cm)*

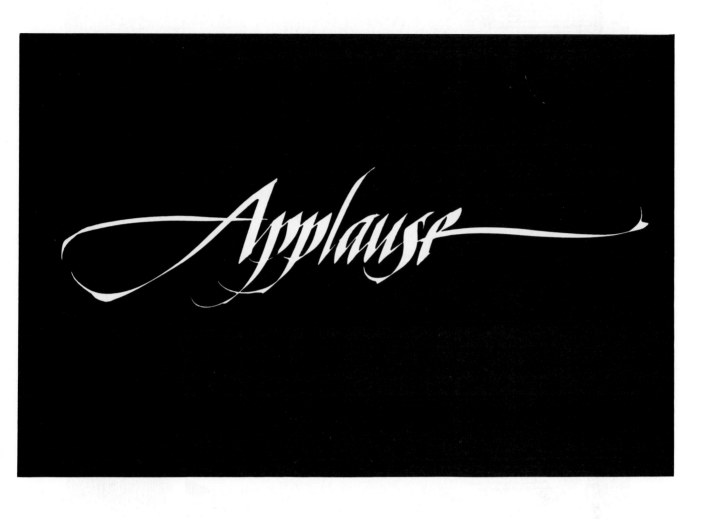

**LOGOTYPE**
**DESIGN** *Holly Dickens* **CALLIGRAPHER** *Holly Dickens* **STUDIO** *Holly Dickens Design* **CLIENT** *Holly Dickens Design*
**DIMENSIONS** *13.3 × 3.1 in. (33.7 × 8 cm)*

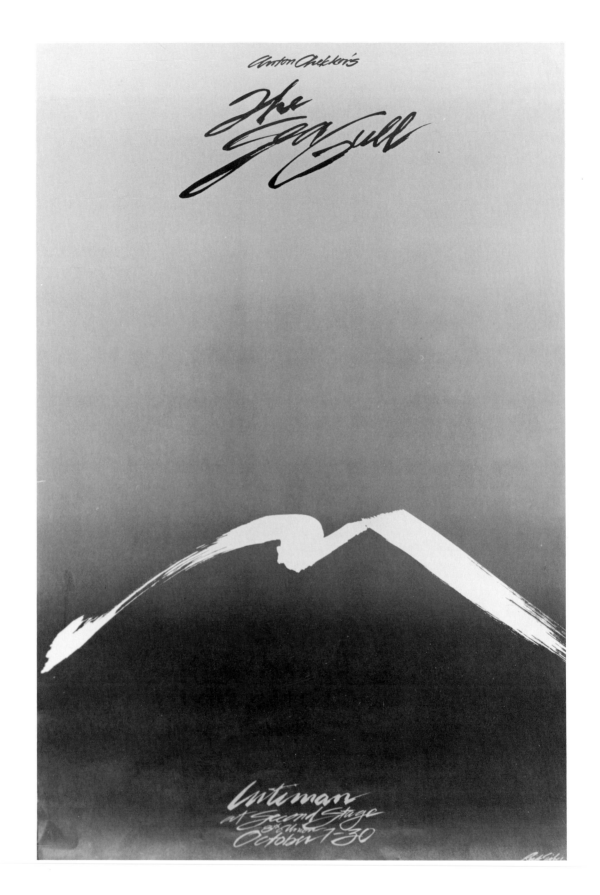

**POSTER**
**DESIGN** *Rick Eiber* **CALLIGRAPHER** *Rick Eiber* **STUDIO** *Rick Eiber Design (RED)* **CLIENT** *Intiman Theatre* **DIMENSIONS** *24 × 36 in. (61 × 91 cm)*

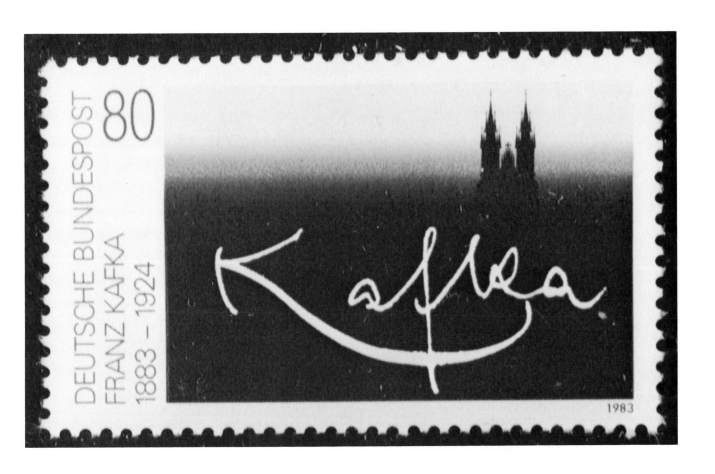

**STAMP**
**DESIGN** *Hans Günter Schmitz* **CALLIGRAPHER** *Franz Kakfa* **STUDIO** *Hans Günter Schmitz Design*
**CLIENT** *Bundesministerium für das Post- und Fernmeldewesen* **DIMENSIONS** *1 × 1.7 in. (2.5 × 4.3 cm)*

**LOGOTYPE**
**DESIGN** Holly Dickens/Jim Moheiser **CALLIGRAPHER** Holly Dickens **AGENCY** Marsteller **STUDIO** Holly Dickens Design
**CLIENT** Allnet Communications **DIMENSIONS** 6.5 × 9 in. (16.5 × 22.9 cm)

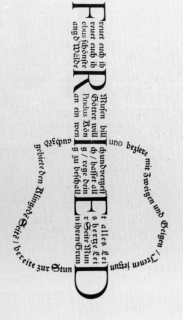

Zwei grundsätzliche Richtungen lassen sich in der Kunst der Figurendichtung unterscheiden. Steht das gereimte Gedicht im Vordergrund, dann entstehen zumeist recht geometrische Bilder, die lediglich durch unterschiedlich lange Zeilen charakterisiert sind (beispielsweise Kreuz, Säule oder Pokal). Geht es dem Dichter dagegen vor allem um die Figur, dann werden die Formen freier und die dichterische Leistung konkurriert mit der des ausführenden Setzers. Hängt doch die Wirkung jedes Figurengedichts stets auch von seinen Fähigkeiten ab! Bei der hier abgebildeten Geige,

von Johannes Praetorius 1672 in seinem »Der Friedseligen Irenen Lustgarten« veröffentlicht, war seine Kunstfertigkeit ganz besonders gefordert. Doch sollte bei aller Bewunderung für den Setzer (bzw. den Neu-Setzer) nicht die textliche Qualität übersehen werden. Die großen Antiqua-Buchstaben müssen für jede Zeile gelesen werden, I und D jeweils auch noch für die Bögen, eine nicht ungebräuchliche Technik der Barockpoeten. Die Manier, lateinische Namen und Zitate bei Fraktur und Schwabacher in Antiqualettern zu setzen, galt übrigens bis in unser Jahrhundert.

**BOOK**
**DESIGN** *Walter Staehle/Basse & Lechner* **CLIENT** *Basse & Lechner Verlag* **PRINCIPAL TYPE** *Alt-Schwabacher (Lead)*
**DIMENSIONS** *9 × 9.8 in. (23 × 25 cm)*

**CATALOG**
**DESIGN** Mark Lichtenstein  **CALLIGRAPHER** Mark Lichtenstein  **TYPOGRAPHIC SUPPLIER** Foxglove Graphics
**AGENCY** Lichtenstein Marketing Communications  **CLIENT** RSCA  **PRINCIPAL TYPE** Berling/Avant Garde  **DIMENSIONS** 8.5 × 11 in. (22 × 28 cm)

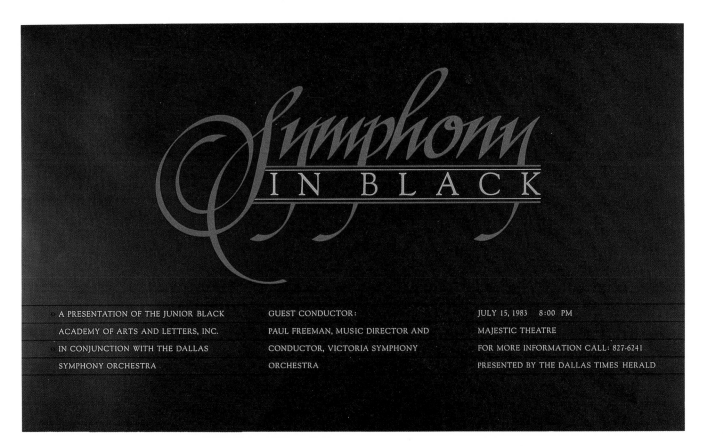

**POSTER**
**DESIGN** *Mark Steele* **CALLIGRAPHER** *Mark Steele* **TYPOGRAPHIC SUPPLIER** *Dallas Times Herald*
**AGENCY** *Dallas Times Herald Promotion Department* **STUDIO** *Dallas Times Herald Promotion Department*
**CLIENT** *Junior Black Academy of Arts & Letters* **PRINCIPAL TYPE** *Goudy Old Style* **DIMENSIONS** *18 × 30 in. (45.7 × 76.2 cm)*

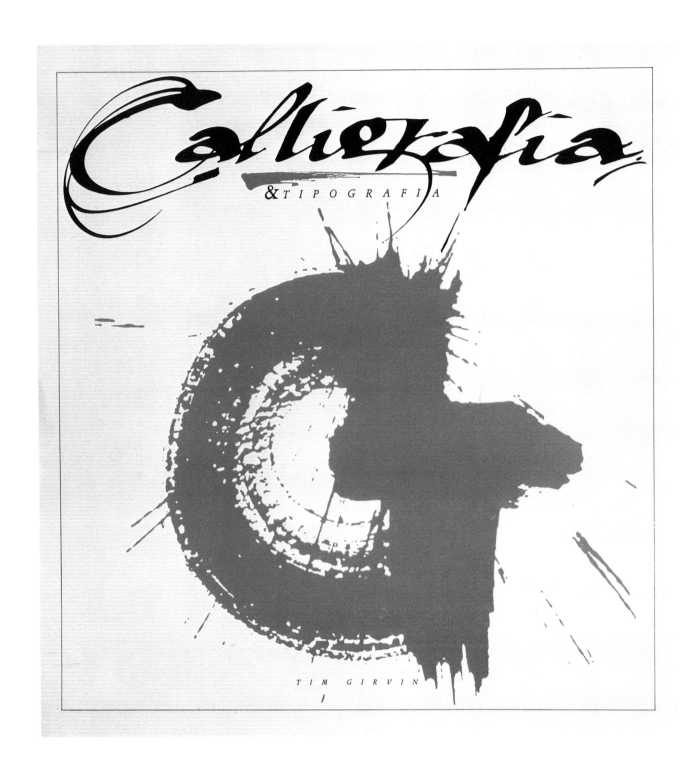

**EDITORIAL**
**DESIGN** Oswaldo Miranda **CALLIGRAPHER** Tim Girvin **TYPOGRAPHIC SUPPLIER** Tipograph **STUDIO** Miran Estudio **CLIENT** Gráfica Magazine
**PRINCIPAL TYPE** Garamond Italic **DIMENSIONS** 10.2 × 10.5 (26 × 27 cm)

# Six Good Reasons to Visit Seneca Park Zoo.

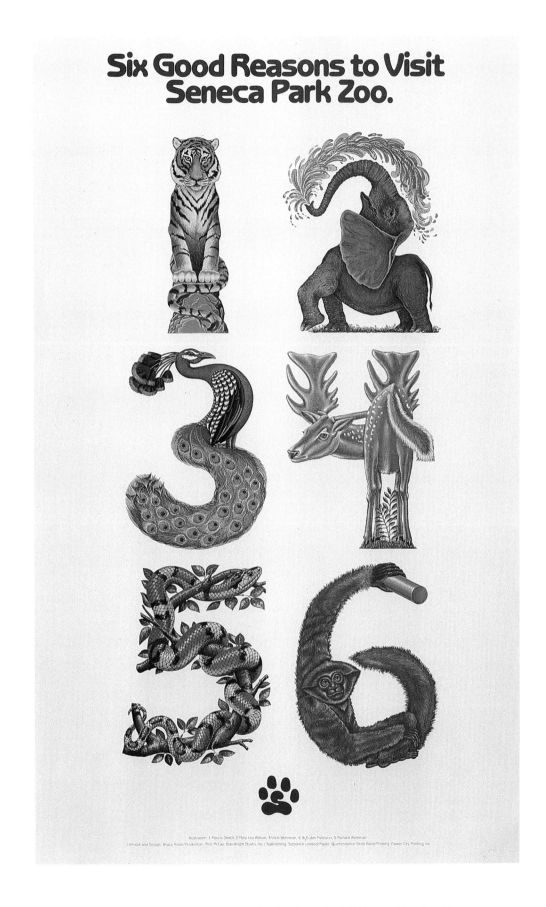

**POSTER**
**DESIGN** *Bruce Kielar* **CALLIGRAPHER** *Jim Mattiucci/Marcia Smith/Richard Wehrman/Vicki Wehrman/Mary Lou Wilson*
**TYPOGRAPHIC SUPPLIER** *Setronics Limited* **AGENCY** *The Bob Wright Creative Group Inc.* **STUDIO** *The Bob Wright Creative Group Inc.*
**CLIENT** *The Seneca Park Zoo* **PRINCIPAL TYPE** *Benguiat Gothic* **DIMENSIONS** *17.8 × 29 in. (45 × 73.6 cm)*

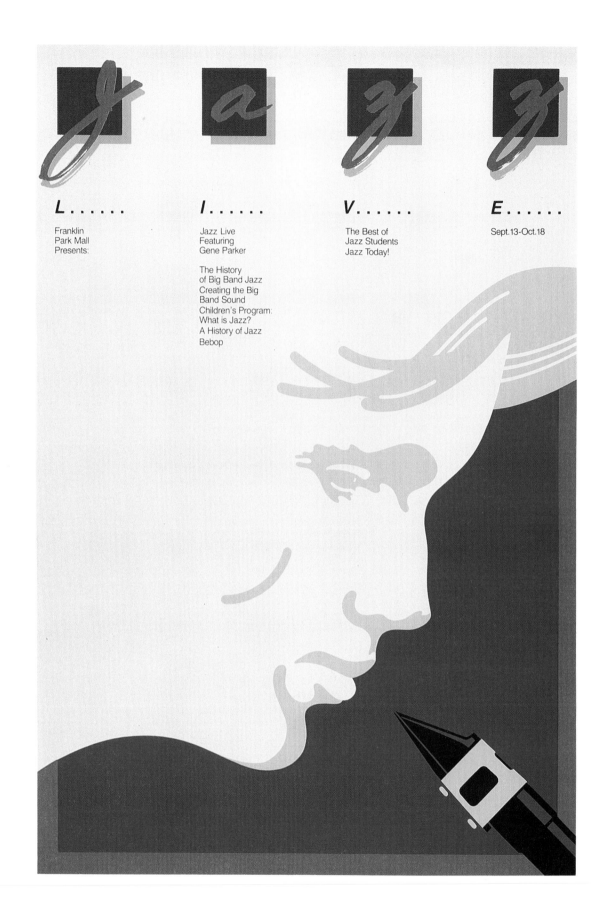

**L......**

Franklin
Park Mall
Presents:

**I......**

Jazz Live
Featuring
Gene Parker

The History
of Big Band Jazz
Creating the Big
Band Sound
Children's Program:
What is Jazz?
A History of Jazz
Bebop

**V......**

The Best of
Jazz Students
Jazz Today!

**E......**

Sept.13-Oct.18

**POSTER**
**DESIGN** Bob Cairl  **CALLIGRAPHER** Bob Cairl  **TYPOGRAPHIC SUPPLIER** Type House  **AGENCY** Marketing Communications Group
**STUDIO** Bob Cairl  **CLIENT** Franklin Park Mall  **PRINCIPAL TYPE** Helvetica  **DIMENSIONS** 25 × 37 in. (63.5 × 94 cm)

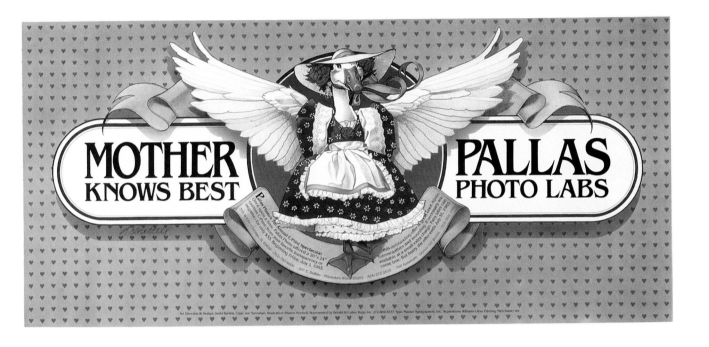

**POSTER**
**DESIGN** David Bartels **CALLIGRAPHER** Bill Kumke **TYPOGRAPHIC SUPPLIER** Master Typographers Inc. **AGENCY** Bartels & Company
**STUDIO** Sharon Knettell **CLIENT** Dallas Photo Labs, Inc. **PRINCIPAL TYPE** Benguiat **DIMENSIONS** 28.5 × 13 in. (72.4 × 33 cm)

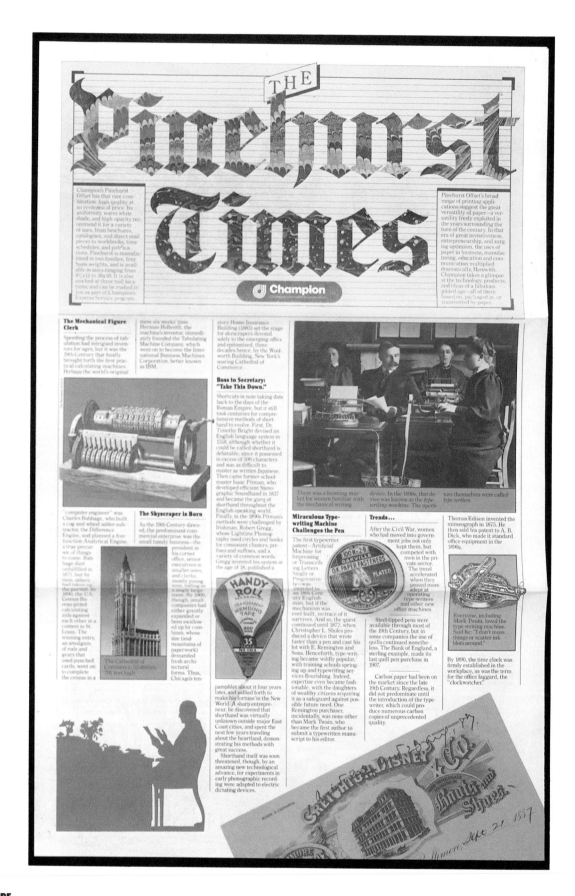

**BROCHURE**
**DESIGN** Hoi L. Chu/Benjamin Perez/Steve Jenkins   **CALLIGRAPHER** Hoi L. Chu   **TYPOGRAPHIC SUPPLIER** Haber Typographers
**AGENCY** H. L. Chu & Company, Ltd.   **STUDIO** H. L. Chu & Company, Ltd.   **CLIENT** Champion International Corp.
**PRINCIPAL TYPE** Cheltenham Ultra Condensed/Century Old Style   **DIMENSIONS** 28 × 22 in. (71 × 56 cm)

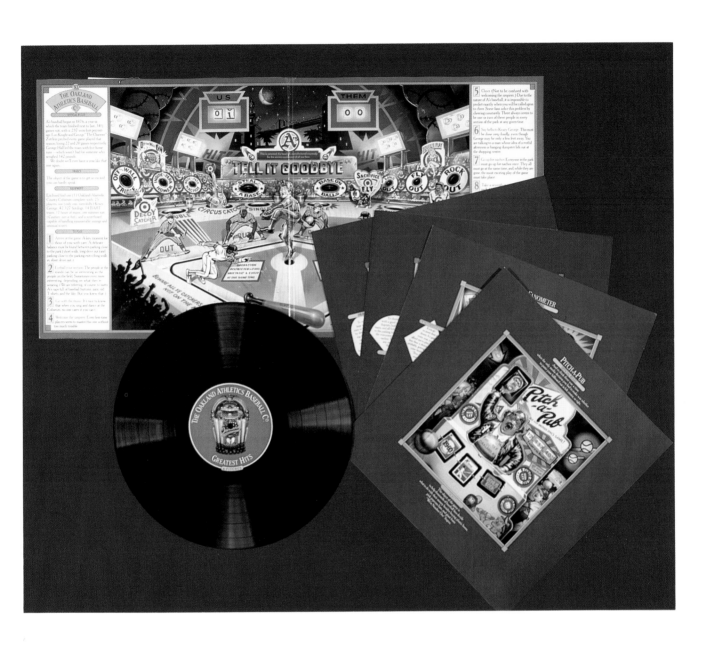

**PROMOTION**
**DESIGN** *Kit Hinrichs* **TYPOGRAPHIC SUPPLIER** *Omnicomp* **AGENCY** *Ogilvy & Mather* **STUDIO** *Jonson Pedersen Hinrichs & Shakery Inc.*
**CLIENT** *Oakland A's* **PRINCIPAL TYPE** *Cheltenham Old Style & Old Style Condensed* **DIMENSIONS** *12.5 × 12.5 in. (31.8 × 31.8 cm)*

**THE YELLOW ROSE**

Set under the open Texas sky, the Yellow Rose ranch covers some 200 thousand acres of modern-day Texas Panhandle. Old Wade Champion left his spread to his family, and they carry on in his time-honored tradition.

Roy Champion (David Soul), tough, rugged and born to lead, handles the day-to-day running of the ranch. Wade's half-breed son Quisto Champion (Edward Albert, Jr.) is a skilled attorney who handles the Yellow Rose's finances—which have grown rather precarious of late. Handling the breeding and sale of the horses is Colleen Champion (Cybil Shepherd), the old man's 29-year-old widow. Her two young sons hope to own the Yellow Rose themselves one day. But others have their eye on portions of the Champion land, for there may be oil under the property.

The long-time ranch hands like Luther Dillard (Noah Beery, Jr.) are loyal to the Champions. New to the ranch is an independent, solemn loner of a cowboy, known as Chance (Sam Elliott). His background is shrouded in mystery, but he's good to have around when the chips are down. The one who just might know something about him is attractive Grace McKenzie (Susan Anspach), who runs the kitchen.

This sprawling drama series of modern Texas is from Nightwatch and American Flyer Productions in association with Warner Brothers Television; Michael Zinberg and John Wilder, executive producers.

**PACKAGING**
**DESIGN** *Charles Blake/Vásken Kalayjian* **CALLIGRAPHER** *Gerard Huerta Design* **TYPOGRAPHIC SUPPLIER** *Photo-Lettering, Inc.*
**STUDIO** *Glazer & Kalayjian Inc.* **CLIENT** *NBC Marketing Department* **PRINCIPAL TYPE** *Cheltenham* **DIMENSIONS** *8.8 × 7.5 in. (22.3 × 19 cm)*

**BOOKLET**
**DESIGN** *Tetsuya Matsuura* **CALLIGRAPHER** *Gerard Huerta* **TYPOGRAPHIC SUPPLIER** *Pro-Type* **CLIENT** *NBC Marketing Department*
**PRINCIPAL TYPE** *Helvetica Condensed* **DIMENSIONS** *9 × 9 in. (22.9 × 22.9 cm)*

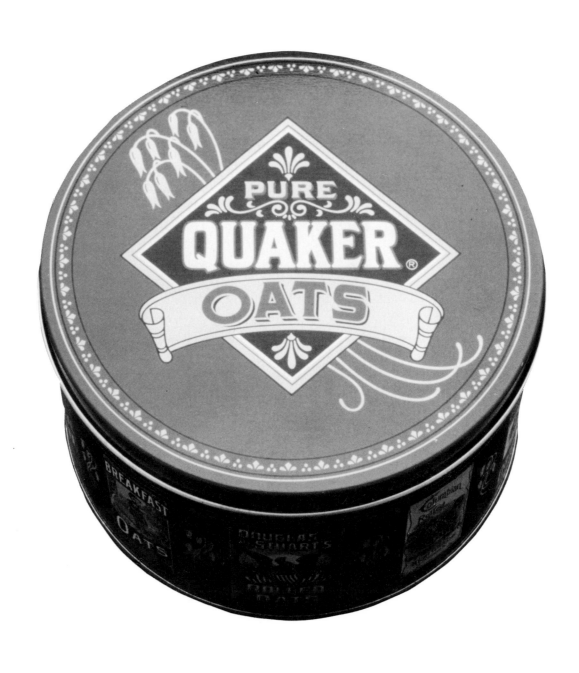

**PACKAGE DESIGN**
**DESIGN** *Linda Voll* **CALLIGRAPHER** *Ted Havlicek* **STUDIO** *Murrie, White, Drummond, Lienhart & Associates* **CLIENT** *The Quaker Oats Company*
**DIMENSIONS** *7.1 × 4.1 in. (18 × 10.5 cm)*

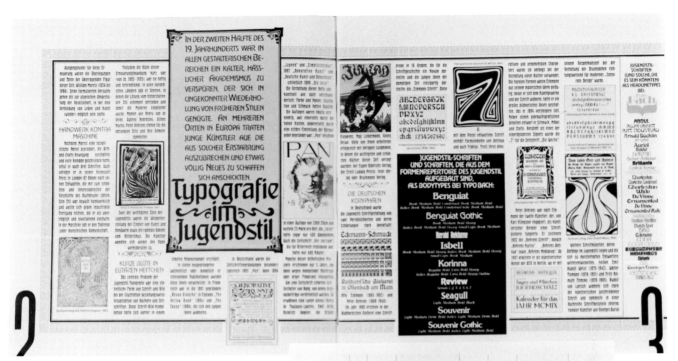

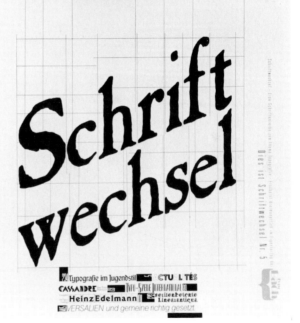

**PERIODICAL**
**DESIGN** *Karl-Heinz Oberfranz* **TYPOGRAPHIC SUPPLIER** *TypoBach* **AGENCY** *Oehler, Fuchs & Brand* **CLIENT** *TypoBach*
**PRINCIPAL TYPE** *Various* **DIMENSIONS** *11.4 × 11.4 in. (29 × 29 cm)*

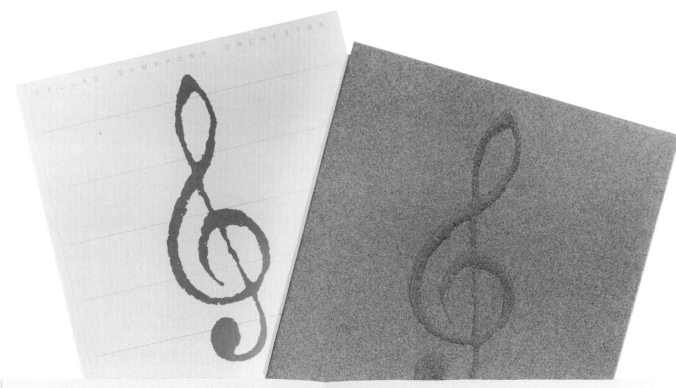

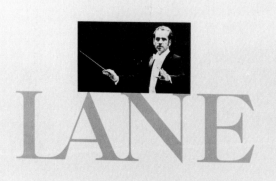

Born in Eagle Pass, Texas, Louis Lane has been associated with Cleveland since 1947, when he won a nationwide competition to become apprentice to Cleveland Orchestra conductor George Szell. In 1970, he became resident conductor for the Cleveland Orchestra. He appeared as guest conductor with leading orchestras across the United States, conducted widely in Europe, and served as music director of both the Canton Symphony Orchestra and the Akron Symphony in Ohio. In 1973, he was invited to join the DSO as principal guest conductor; he became the orchestra's artistic advisor in 1974. A brilliant man and gifted musician, Lane conducted the DSO with dignity and with a flair for performance. His tenure as artistic advisor was marked by both highs and lows in the life of the Symphony. In 1974, he led the orchestra through one of its most difficult times, when a lack of funds forced a temporary suspension of activities. He was also on the podium the following year for the DSO's triumphant 75th anniversary season.

(1974–1977)

**BOOK**
**DESIGN** *D.C. Stipp/Brent Croxton/Ron Sullivan* **CALLIGRAPHER** *Various* **TYPOGRAPHIC SUPPLIER** *Chiles & Chiles*
**STUDIO** *Richards, Brock, Miller, Mitchell & Associates* **CLIENT** *Dallas Symphony* **PRINCIPAL TYPE** *ITC Garamond Light/Helvetica Light*
**DIMENSIONS** *9 × 9 in. (22.9 × 22.9 cm)*

**CALENDAR**
**DESIGN** *Clement Mok* **CALLIGRAPHER** *Georgia Deaver* **TYPOGRAPHIC SUPPLIER** *Vicki Takla* **AGENCY** *Apple Computer/Creative Services*
**STUDIO** *Apple Computer/Creative Services* **CLIENT** *Apple Computer/MacIntosh* **PRINCIPAL TYPE** *ITC Garamond Light*
**DIMENSIONS** *8 × 8 in. (20.3 × 20.3 cm)*

**POSTER**
**DESIGN** *Richard Stumpf/Teri Kahan-Stumpf* **CALLIGRAPHER** *Richard Stumpf/Teri Kahan-Stumpf* **TYPOGRAPHIC SUPPLIER** *Letraset*
**AGENCY** *Graphique Design Studio* **STUDIO** *Graphique Design Studio* **CLIENT** *Joslyn Center of the Arts* **PRINCIPAL TYPE** *Futura*
**DIMENSIONS** *16.5 × 22 in. (42 × 55.9 cm)*

**ADVERTISEMENT**
**DESIGN** *David Wojdyla* **CALLIGRAPHER** *Tim Girvin* **TYPOGRAPHIC SUPPLIER** *Professional Typographic Services, Inc.*
**AGENCY** *HBO Creative Services* **CLIENT** *Home Box Office* **PRINCIPAL TYPE** *Optima* **DIMENSIONS** *16 × 20 in. (40.6 × 50.8 cm)*

**CHRISTMAS CARD**
**DESIGN** *Rod Chism/David Pelham* **TYPOGRAPHIC SUPPLIER** *Futura-Foto Ltd.* **CLIENT** *Pentagram* **PRINCIPAL TYPE** *Poppl-Pontifiex*
**DIMENSIONS** *5.8 × 4.2 in. (10.5 × 14.8 cm)*

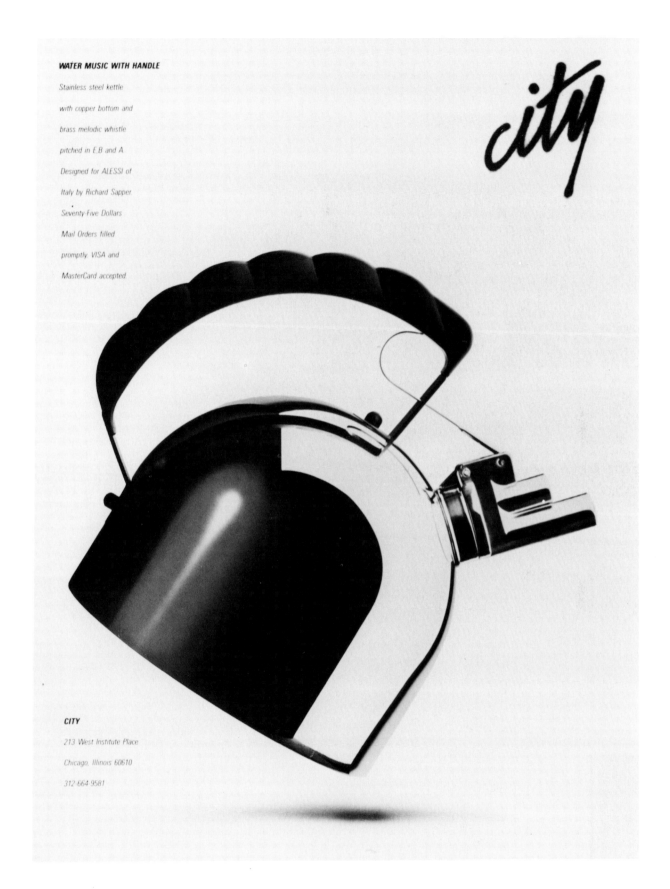

**WATER MUSIC WITH HANDLE**

*Stainless steel kettle*

*with copper bottom and*

*brass melodic whistle*

*pitched in E, B and A.*

*Designed for ALESSI of*

*Italy by Richard Sapper.*

*Seventy-Five Dollars.*

*Mail Orders filled*

*promptly. VISA and*

*MasterCard accepted.*

*city*

**CITY**

*213 West Institute Place*

*Chicago, Illinois 60610*

*312-664-9581*

**ADVERTISEMENT**
**DESIGN** *Jeff A. Barnes* **CALLIGRAPHER** *Jeff A. Barnes* **TYPOGRAPHIC SUPPLIER** *The Typesetters* **AGENCY** *Barnes Design Office*
**STUDIO** *Barnes Design Office* **CLIENT** *City of Chicago* **PRINCIPAL TYPE** *Univers 47 & 67* **DIMENSIONS** *8.3 × 11 in. (21 × 28 cm)*

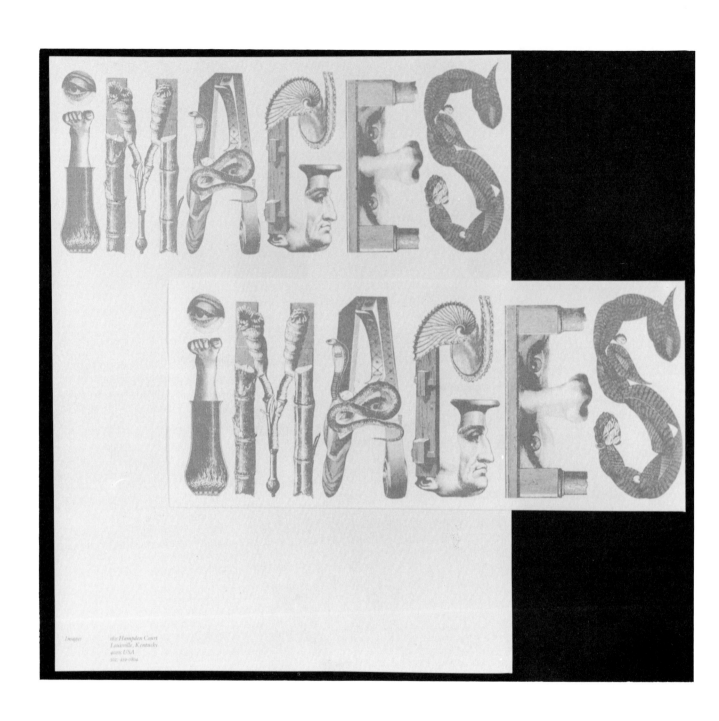

**STATIONERY**
**DESIGN** *Julius Friedman/Walter McCord* **TYPOGRAPHIC SUPPLIER** *Photo-Lettering, Inc.* **STUDIO** *Images* **CLIENT** *Images*
**PRINCIPAL TYPE** *Galliard Light Italic* **DIMENSIONS** *8.5 × 11 in. (22 × 28 cm)*

**34**

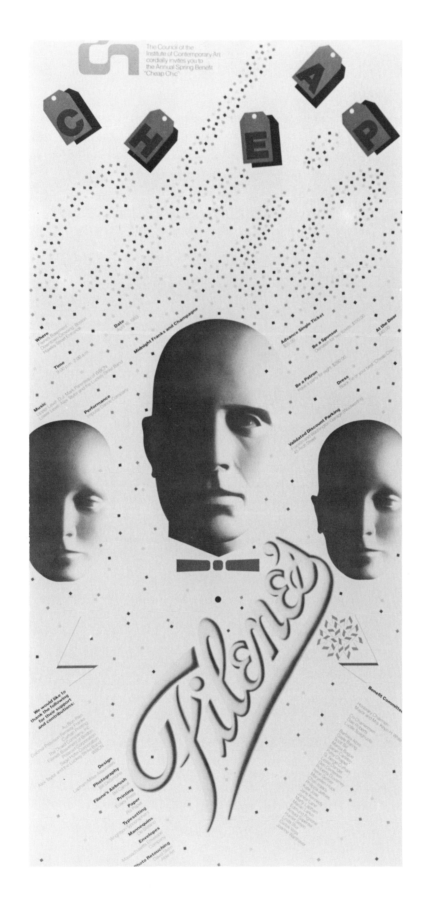

**POSTER**
**DESIGN** *Marty Lapham* **CALLIGRAPHER** *Marty Lapham* **TYPOGRAPHIC SUPPLIER** *Wrightson Typographers* **AGENCY** *Lapham/Miller Associates*
**STUDIO** *Lapham/Miller Associates* **CLIENT** *Institute of Contemporary Art* **PRINCIPAL TYPE** *Helvetica Light*
**DIMENSIONS** *11.3 × 23.8 in. (29 × 60 cm)*

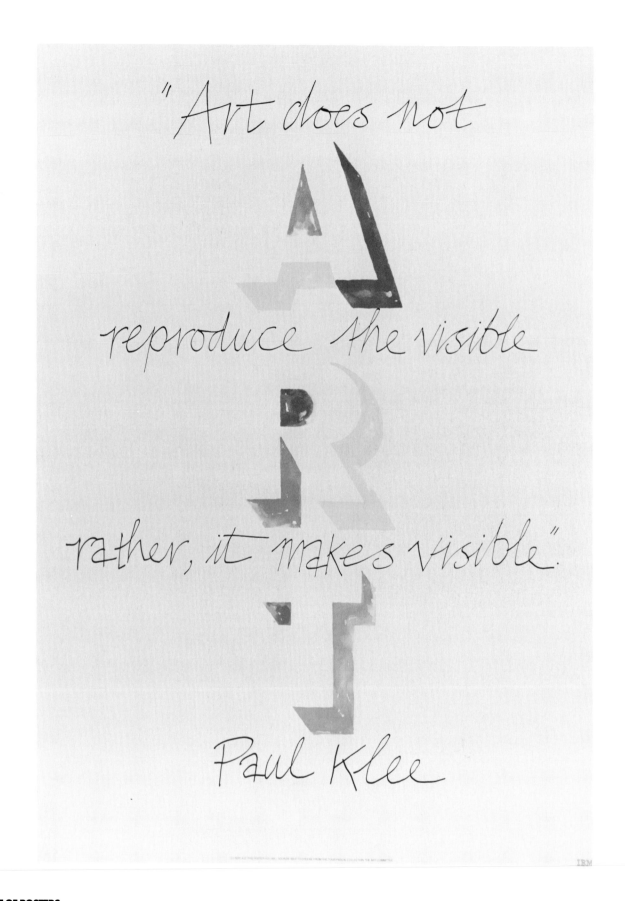

**SET OF POSTERS**
**DESIGN** *Alan Fletcher* **CALLIGRAPHER** *Alan Fletcher* **STUDIO** *Pentagram* **CLIENT** *IBM Europe* **DIMENSIONS** *33.1 × 23.4 in. (84.2 × 59.4 cm)*

Work Illustrated:

"Prayer"
Oil on Formed Canvas
1981
55' x 70'

Other Works in Exhibition:

Study for Prayer
Oil on Formed Canvas
1981
24' x 28'

"Painting"
Bronze Casting on Cherrywood
1981
31' x 28' x 8½'

Untitled Watercolor
1973
32' x 24'

"Smith"
Cast Paper
1980
28' x 23'

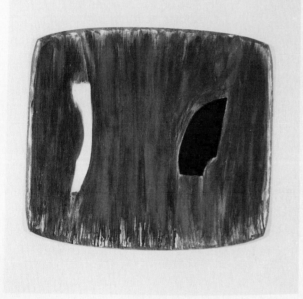

*I would call Robert Vogele a creative patron. In the Fall of 1979, three weeks before my show in Chicago which opened the new Loft location of the Young-Hoffman Gallery, Robert called and suggested that I should have at least one very large painting in the show because of the scale of the space. He suggested stretcher sizes and even helped with the financing of the largest painting. He had gone over to see the new space and anticipated this show for me. As a result the show was better with Robert's help. We have since collaborated on several other projects, some of which have yet to be fully realized. In my experience, Robert does more than simply buy a work of art, he also involves himself with the artists and their projects. His collaborative style has been an inspirational force for me.* **RON GORCHOV**

Ron Gorchov is an artist who might be regarded at this time as a "painter's painter," one who is acknowledged and admired most by those who are similarly fascinated by paint as a medium for producing visual images. One unique aspect of Gorchov's work is that since the late '60s he has developed a way of stretching canvas, creating a rounded surface, concave in one direction and convex in the other. At the same time as he observes certain formality, Gorchov paints a deep and moody space created by translucent layers of paint, by a textured surface typically revealing some unprimed canvas, and by a slightly disturbing placement of irregular geometric forms, all of which encourage a viewer's inquiry into some obscure mystery. The response to this work essentially has to be intuitive, drawing upon the poetic reserves of the viewer; the paintings quietly and consistently challenge and intrigue.

**EXHIBITION CATALOG**
**DESIGN** *William Cagney/Robert Vogele* **TYPOGRAPHIC SUPPLIER** *Design Typographers, Inc.* **AGENCY** *Communication Design Group, Inc.*
**STUDIO** *Communication Design Group, Inc.* **CLIENT** *Northern Illinois University's Swen Parson Gallery* **PRINCIPAL TYPE** *Century Old Style*
**DIMENSIONS** *7 × 11 in. (17.8 × 27.9 cm)*

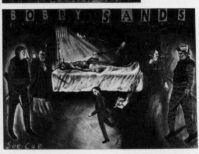

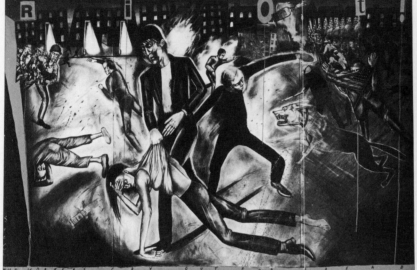

**EDITORIAL**
**DESIGN** *Dian-Aziza Ooka* **CALLIGRAPHER** *Dian-Aziza Ooka* **TYPOGRAPHIC SUPPLIER** *MacKensie & Harris* **CLIENT** *Mother Jones Magazine*
**PRINCIPAL TYPE** *Trade Gothic & Condensed* **DIMENSIONS** *16.3 × 10.8 in. (41.3 × 27.4 cm)*

 MARTIN FULLER IST EIN MALER, DER SICH SCHON ENDE DER 60ER JAHRE AUF SEINE GEGENWÄRTIGE THEMATIK FESTLEGTE, ZU EINER ZEIT ALSO, IN DER DIE UNGEGENSTÄNDLICHE KUNST IHRE BLÜTEZEIT HATTE, UND IN DER FIGÜRLICHE DARSTELLUNG ZWAR NOCH NICHT TOTGESAGT WAR, ABER AUCH NICHT GERADE DEM DAMA LIGEN ZEITGEIST ENTSPRACH. SEINE ANGEBORENE, VITALE AUSDRUCKSKRAFT WAR ZUDEM WEDER IM UNMITTELBAREN NOCH IM ÜBERTRAGENEN SINNE DAS, WAS DEM DAMALIGEN KÜHLEN, SACHLICHEN UND KONZEPTIONELLEN TREND ENT SPRACH. ABER ZEITEN ÄNDERN SICH. MARTIN FULLER IST SICH UND SEINER AUSDRUCKSWEISE IN SEINEN ARBEITEN TREU GEBLIEBEN UND HEUTE SCHEINT ES, ALS SEI SEINE ARBEIT NIE RELEVANTER UND ZEITGEMÄSSER GEWESEN. ABER AUCH HEUTE ERKENNEN WIR, DASS ER SEINEN EIGENEN, BESONDEREN WEG GEHT. SEINE BILDER HABEN SICH ÜBER DIE JAHRE NOTWENDIGERWEISE ENTWICKELT UND SIND HEUTE VON EINER DICHTE UND INTENSITÄT, DIE MIT DEN KLEINEN FORMATEN IN WOHLTUENDEM KONTRAST STEHEN ZU DER INFLATION U DER GESCHÄFTSMÄSSIGKEIT, DIE DEN GEGENWÄRTIGEN NEUEN EXPRESSIO UND SEINE BILDSPRACHE KENNZEICHNET. MARTIN FULLER'S EIGEN SPRACHE IST SEHR EIGENSTÄNDIG. SIE IST EIN UNMITTELBARER UND WITZ KOMMENTAR UNSERES URBANEN LEBENS, ZUGLEICH ELEGANT UND BE MANCHMAL GRIMMIG UND AMÜSIERT, TROSTLOS UND KULTIVIERT, ZÜ UND GEFÄHRLICH, UND IMMER HÖCHST UNTERHALTSAM. WIR DENKEN AN GEORGE GROSZ UND DIE MALER DER WEIMARER ZEIT IN BERLIN, MARTIN FULLER'S EIGENE ZEITGENOSSEN, WENN WIR SEINE BETRACHTEN, UND DOCH IST SEIN WERK ZWEIFELSFREI EIN PRODUKT SEINE UNSERER EPOCHE, GANZ IM EINKLANG MIT DEN ACHTZIGER JAHREN IN STIMMUNG, SEINEM STIL, SEINEN ERKENNTNISSEN UND SEINER GENOMMENHEIT. WILLIAM PACKER, KUNSTKRITIKER, LONDON, OKTOBE IN DIE DEUTSCHE SPRACHE ÜBERTRAGEN VON KLAUS FABRICIUS, L

MARTIN FULLER BIOGRAFIE 1943 GEBOREN IN LEAMINGTON SPA, GROSSBRITAN NIEN · 1964 GUGGENHEIM-STIPENDIUM, POSITANO, ITALIEN · EINZEL-AUSSTEL LUNG, POSITANO, ITALIEN · 1966 GRUPPEN-AUSSTELLUNG, LEAMINGTON ART GALERIE · 1968 11 ENGLISCHE KÜNSTLER, WANDERAUSSTELLUNG, ARNOLFINI GALERIE, BRISTOL · EINZEL-AUSSTELLUNG IN DER ARNOLFINI GALERIE, BRISTOL GRUPPEN-AUSSTELLUNG, POSITANO, ITALIEN · EINZEL-AUSSTELLUNG, MIDLAND ART GALERIE, BIRMINGHAM · 1969 EINZEL-AUSSTELLUNG, CENTAUR GALERIE, BATH · 1970 WANDERAUSSTELLUNG DER ARNOLFINI GALERIE-KÜNSTLER · EINZEL AUSSTELLUNG, CITY ART GALERIE, BRISTOL · 1971 EINZEL-AUSSTELLUNG, ARNOL FINI GALERIE, BRISTOL · EINZEL-AUSSTELLUNG, BEAR LANE GALERIE, OXFORD · EIN ZEL-AUSSTELLUNG, CAMDEN ARTS CENTRE, LONDON · 1972 GRUPPEN-AUSSTEL LUNG, ARNOLFINI GALERIE, BRISTOL · 1973 EINZEL-AUSSTELLUNG, BEAR LANE GALERIE, OXFORD · EINZEL-AUSSTELLUNG, FESTIVAL GALERIE, BATH · EINZEL-AUS STELLUNG, GRABOWSKI GALERIE, LONDON · 1974 GRUPPEN-AUSSTELLUNG, FESTI

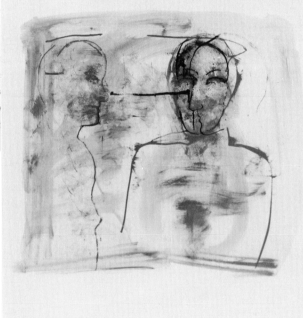

DIE RZA GALERIE PRÄSENTIERT MARTIN FULLER · AQUARELLE · GOUACHEN · ZEICHNUNGEN · ÖLBILDER VOM 10. NOV BIS 23. DEZ. 1983 IN DER RZA GALERIE · ELISHER STRASSE 202 A · 4000 DÜSSELDORF · TEL. 0211/359810

**BOOKLET**
**DESIGN** Friedrich Meyer  **TYPOGRAPHIC SUPPLIER** RZA Werberealisierung GmbH  **AGENCY** RZA Werberealisierung GmbH
**STUDIO** RZA Werberealisierung GmbH  **CLIENT** Martin Fuller  **PRINCIPAL TYPE** Garamond Italic Normal
**DIMENSIONS** 13.5 × 9.6 in. (34.2 × 24.5 cm)

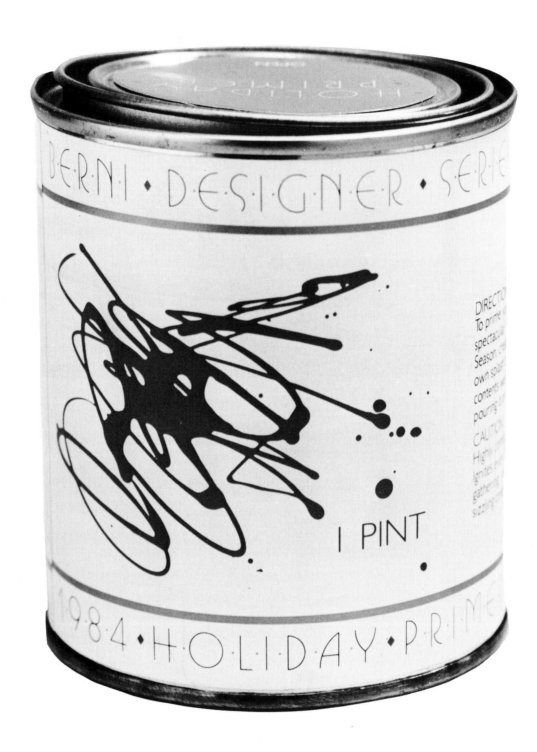

**PROMOTION**
**DESIGN** Larry Edlavitch, PDC **TYPOGRAPHIC SUPPLIER** Set-To-Fit, Inc. **AGENCY** The Berni Corporation **STUDIO** The Berni Corporation
**CLIENT** The Berni Corporation **PRINCIPAL TYPE** Busorama/Gill Sans Light **DIMENSIONS** 3.6 × 11.3 in. (9 × 28.6 cm)

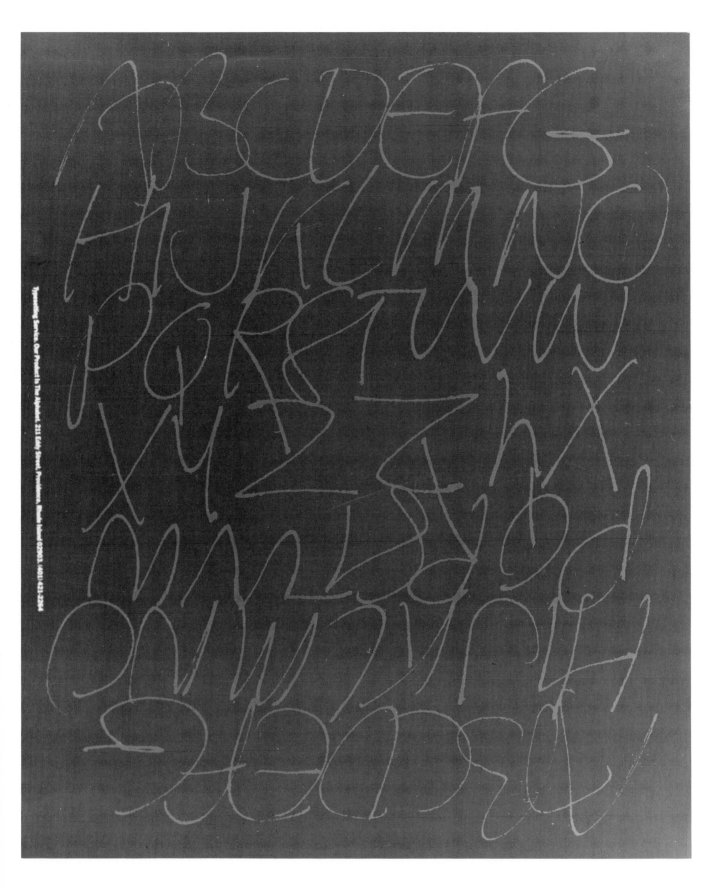

**POSTER**
**DESIGN** *Tyler Smith* **CALLIGRAPHER** *Tyler Smith* **TYPOGRAPHIC SUPPLIER** *Typesetting Service Corp.* **STUDIO** *Tyler Smith*
**CLIENT** *Typesetting Service Corp.* **PRINCIPAL TYPE** *Franklin Gothic Condensed* **DIMENSIONS** *26 × 31 in. (66 × 78.7 cm)*

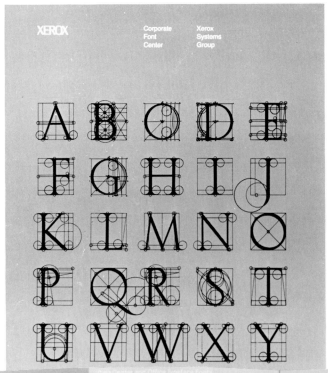

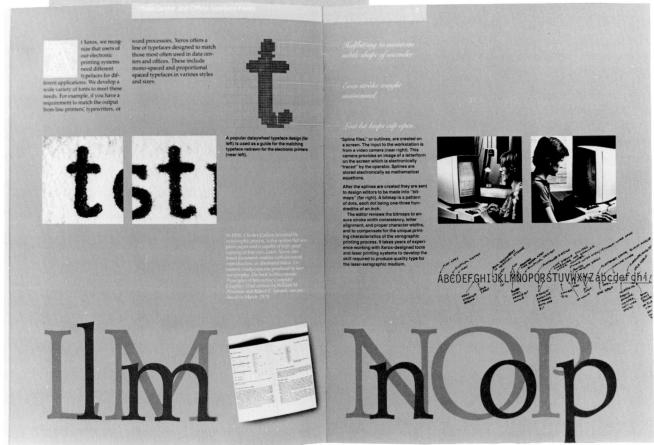

**BROCHURE**
**DESIGN** Tom Bloch/Richard Ikkanda  **TYPOGRAPHIC SUPPLIER** R S Typographers  **AGENCY** Richard Ikkanda Design Associates
**CLIENT** Xerox Corporation  **PRINCIPAL TYPE** Palatino  **DIMENSIONS** 8.5 × 11 in. (22 × 28 cm)

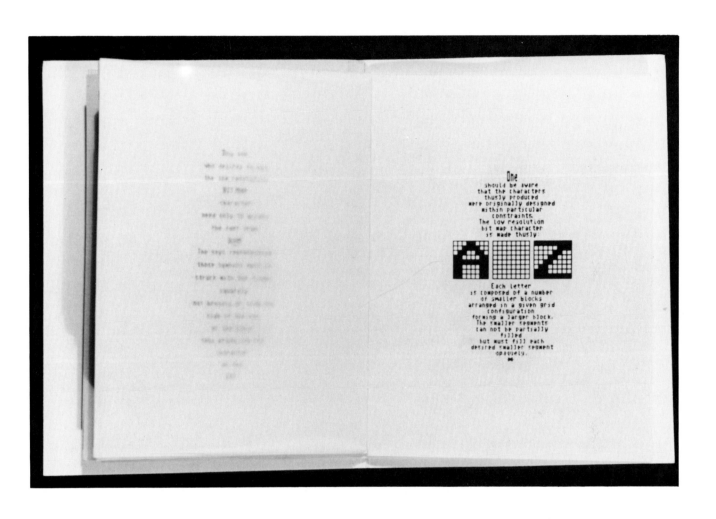

**BOOK**
**DESIGN** Tom Norton **CALLIGRAPHER** Tom Norton **TYPOGRAPHIC SUPPLIER** Tom Norton **AGENCY** Tom Norton Designs
**STUDIO** Tom Norton Designs **CLIENT** Tom Norton **PRINCIPAL TYPE** Computera **DIMENSIONS** 4.6 × 6 × .25 in. (1.2 × 1.5 × .07 cm)

ANNOUNCEMENT
**DESIGN** *Cecelia Rogers* **TYPOGRAPHIC SUPPLIER** *Davidson Typographers* **STUDIO** *Holabird & Root/Graphic Design*
**CLIENT** *Holabird & Root/Architect* **PRINCIPAL TYPE** *Avant Garde Bold & Light* **DIMENSIONS** *5.3 × 5.3 in. (13.5 × 13.5 cm)*

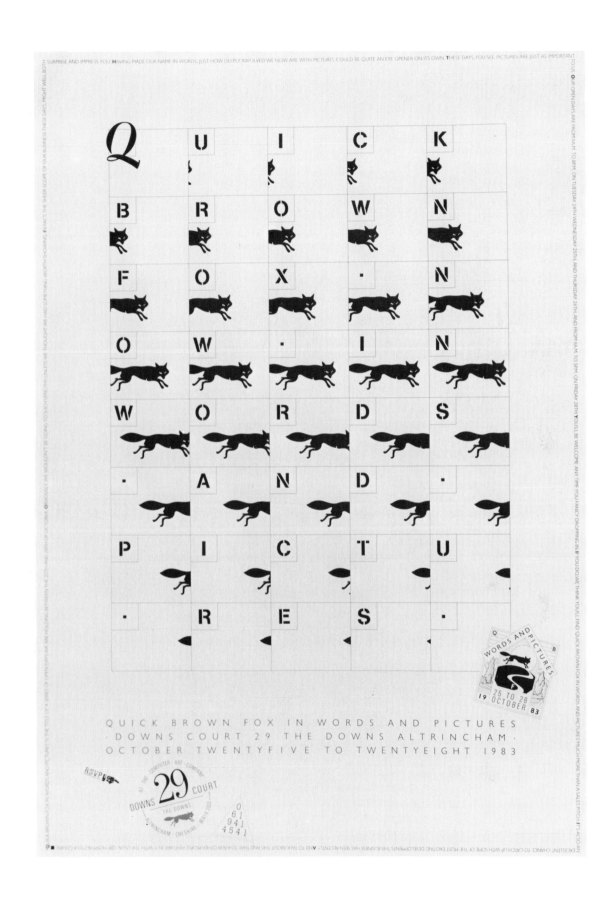

POSTER
**DESIGN** *Lionel Hatch/Malcolm Wood* **TYPOGRAPHIC SUPPLIER** *The Quick Brown Fox Co.* **STUDIO** *Typographics, England*
**CLIENT** *The Quick Brown Fox Co.* **PRINCIPAL TYPE** *Glaser Stencil* **DIMENSIONS** *23.5 × 16.5 in. (59.7 × 41.9 cm)*

**CALENDAR**
**DESIGN** *Olaf Leu/Fritz Hofrichter* **TYPOGRAPHIC SUPPLIER** *Christian Grützmacher GmbH* **STUDIO** *Olaf Leu Design & Partner*
**CLIENT** *Gebr. Schmidt Druckfarben* **PRINCIPAL TYPE** *Univers Italic* **DIMENSIONS** *16.5 × 23.4 in. (42 × 59.4 cm)*

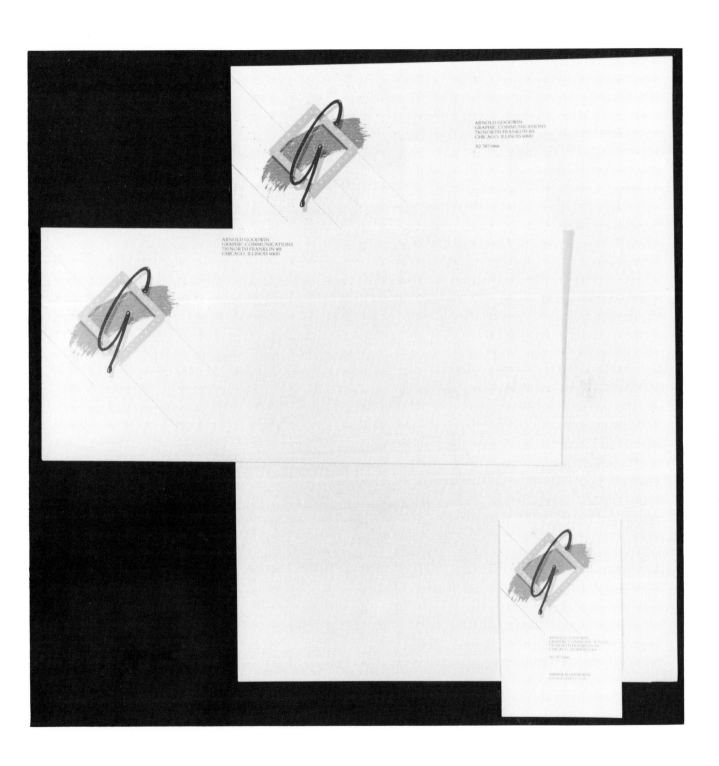

**CORPORATE IDENTITY**
**DESIGN** *Arnold Goodwin* **CALLIGRAPHER** *Arnold Goodwin* **TYPOGRAPHIC SUPPLIER** *Tele/Typography*
**AGENCY** *Arnold Goodwin Graphic Communications* **STUDIO** *Arnold Goodwin Graphic Communications* **CLIENT** *Arnold Goodwin*
**PRINCIPAL TYPE** *Bembo* **DIMENSIONS** *8 × 11.3 in. (20.3 × 28.6 cm)*

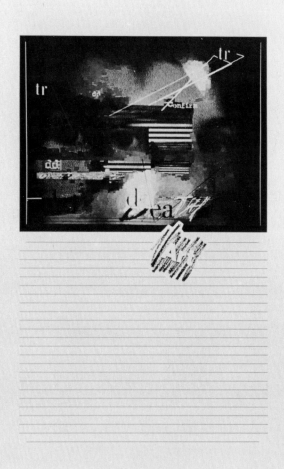

**POSTER**
**DESIGN** *Tom Knights* **TYPOGRAPHIC SUPPLIER** *Tiger Typographics* **AGENCY** *Design Services* **STUDIO** *Design Services*
**CLIENT** *Northern Arizona University* **PRINCIPAL TYPE** *Helvetica* **DIMENSIONS** *24 × 17.8 in. (61 × 45 cm)*

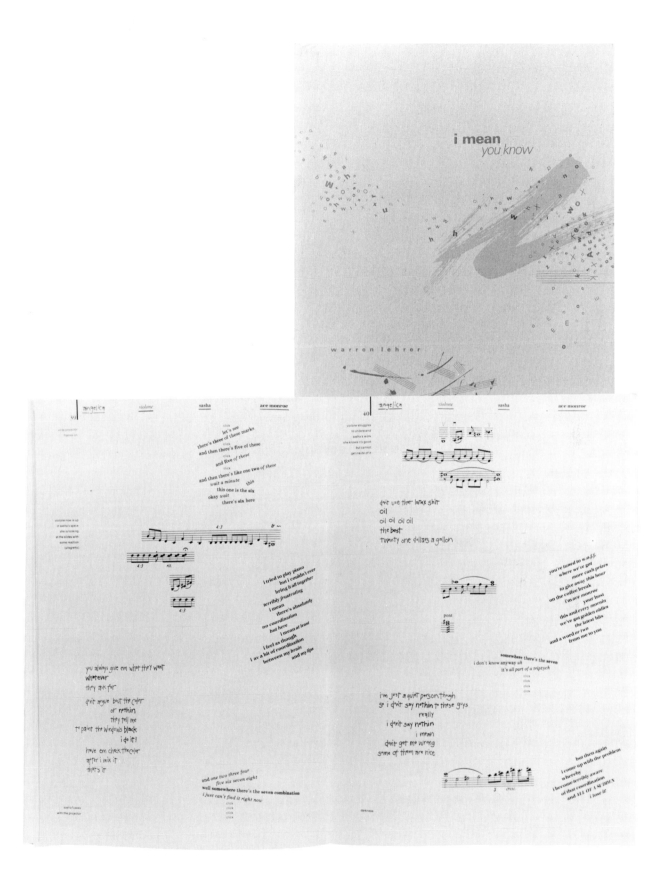

**BOOK**
**DESIGN** *Warren Lehrer* **CALLIGRAPHER** *Jan Baker* **TYPOGRAPHIC SUPPLIER** *Warren Lehrer* **STUDIO** *Warren Lehrer* **CLIENT** *Ear-Say*
**PRINCIPAL TYPE** *Various* **DIMENSIONS** *9 × 12.5 in. (23 × 32 cm)*

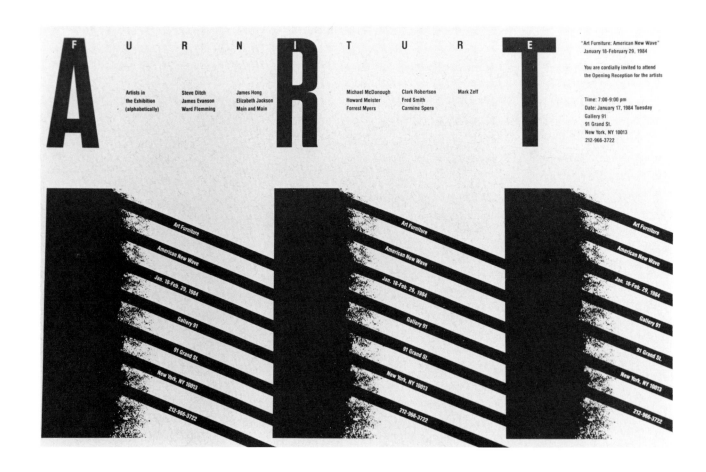

INVITATION
**DESIGN** *Takaaki Matsumoto* **TYPOGRAPHIC SUPPLIER** *Susan Schecter* **STUDIO** *Takaaki Matsumoto* **CLIENT** *Gallery 91*
**PRINCIPAL TYPE** *Helvetica Condensed* **DIMENSIONS** *16.6 × 11.6 in. (50 × 29.5 cm)*

### The Program

This year Art Directors and Artists Club of Sacramento presents its fifth annual designers' workshop, "Business by Design." The two day conference is open to designers, photographers, architects, illustrators, printers, interior designers, copywriters and others.

Through slide presentations, exhibits, demonstrations and small informal workshops, speakers will cover market analysis and strategies, sales calls, developing estimates and proposal writing. Other topics include running an office profitably and efficiently, setting business goals, vendor management, banking, copyrighting and other legal matters.

This year's program is important to you whether you are a free-lancer, employee or employer.

### The Format

Each morning of both days the program will consist of an introductory presentation by the guest speakers. Each afternoon of both days the participants will break into smaller groups for a series of informal workshops by the guest speakers. Attendees will have an opportunity to select particular workshop sessions throughout the afternoon.

**October 22 and 23, 1983**
Saturday and Sunday
9 a.m. to 4 p.m.

**Sierra 2 Community Center**
2791 24th Street
Sacramento, California

### The Site

The Sierra 2 Community Center for the Arts is a charming school rehabilitated for contemporary use by various arts organizations. The facilities include a theater for major visual presentations and individual classrooms for workshops, informal discussion and speaker exhibits.

### Registration

The registration fee for Business by Design is $90 for students, $130 for members of the Art Directors and Artists Club (as of October 1, 1983) and $150 for nonmembers. This fee covers all activities for both days from 9 a.m. to 4 p.m. Saturday and Sunday, including lunch and coffee breaks.

### Registration is limited to 300.

Mail registration form and fee to ADAC, 2791 24th Street, Sacramento, CA 95818 No later than October 14, 1983. For further information, phone ADAC, Sacramento at 916/731-8802.

Upon receipt of the registration form and fee (VISA or Master-Card accepted), a confirmation card will be sent to you. Please present this at the registration table on the first day of the conference.

Produced by the Art Directors and Artists Club of Sacramento, a nonprofit educational organization for professionals and students.

**Guy Day**, President
Chiat/Day Advertising, Inc.
"Prospecting: Identifying yourself in your market"

**Ken White**, President
Ken White Design Office, Inc.
"Sales Calls: How to talk with clients"

**Eric Johansen**, President
Marketing by Design, Inc.
"Estimating Costs: Bidding, breaking even and covering your overhead"

**Richard Burns**, President
The GNU Group
"Proposal Writing: Format, specifications and personality"
"Corporate Growth: Goals into reality"

**Richard Danne**, Partner
Danne & Blackburn
"Office management: Investing your staff time wisely"

**Betty Hahn, CPA**, Owner
Betty M. Hahn, Certified Public Accountants
"Money: Now you've made it, how are you going to keep it?"

**Dan Gilbert**, Partner
Miller Gilbert Publishing
"Production Management: Thorough communication through brainstorming, agreements and nagging"

**Ron Bakal**, Senior Partner
Bakal and Kaplan
"Ownership and Copyright: Protecting your self"

**Laura Mason**, Director of Marketing
**Thomas Dille**, Assistant Credit Administrator
Point West Bank
"The Bank: Using it as your business partner"

**James Wood**, President
James B. Wood Photography, Inc.
"Success: Self image and long term goals"

**Jann Church**, President
Jann Church Advertising and Graphic Design
"Realistic Expectations: Remember nothing in life is always perfect"

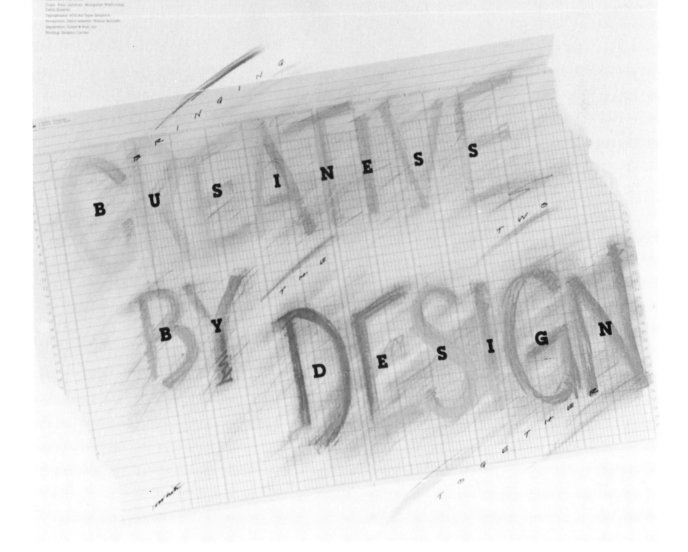

**POSTER**
**DESIGN** Ken White **CALLIGRAPHER** Ken White **TYPOGRAPHIC SUPPLIER** ATG/Ad Type Graphics **AGENCY** Ken White Design Office, Inc.
**STUDIO** Ken White Design Office, Inc. **CLIENT** Art Directors & Artists Club of Sacramento **PRINCIPAL TYPE** Lubalin Demi Book
**DIMENSIONS** 17 × 22 in. (43.2 × 55.9 cm)

SDSCOTT

Process
Color
Guide

**BOOK**
**DESIGN** Marshall Harmon/Lucille Tenazas **TYPOGRAPHIC SUPPLIER** Typogram **AGENCY** Harmon Kemp Inc. **STUDIO** Harmon Kemp Inc.
**CLIENT** S.D. Scott Printing Co. **PRINCIPAL TYPE** Franklin Gothic/Century Expanded **DIMENSIONS** 12 × 12 in. (31 × 31 cm)

PROMOTION
**DESIGN** *Marshall Harmon/Lucille Tenazas* **TYPOGRAPHIC SUPPLIER** *Typogram* **AGENCY** *Harmon Kemp Inc.* **CLIENT** *International Paper Co.*
**PRINCIPAL TYPE** *Franklin Gothic/Century Expanded* **DIMENSIONS** *9 × 12 in. (23 × 30.5 cm)*

University of Washington
School of Art

**MFA Thesis exhibition
1983**

Mfa **22**

Henry Art Gallery

University of Washington

**CATALOG**
**DESIGN** Christopher Ozubko/Randall Sexton **TYPOGRAPHIC SUPPLIER** University of Washington, Print Plant **AGENCY** Ozubko Design
**STUDIO** Ozubko Design **CLIENT** Henry Art Gallery, University of Washington **PRINCIPAL TYPE** Univers 65 **DIMENSIONS** 9 × 10 in. (23 × 25.5 cm)

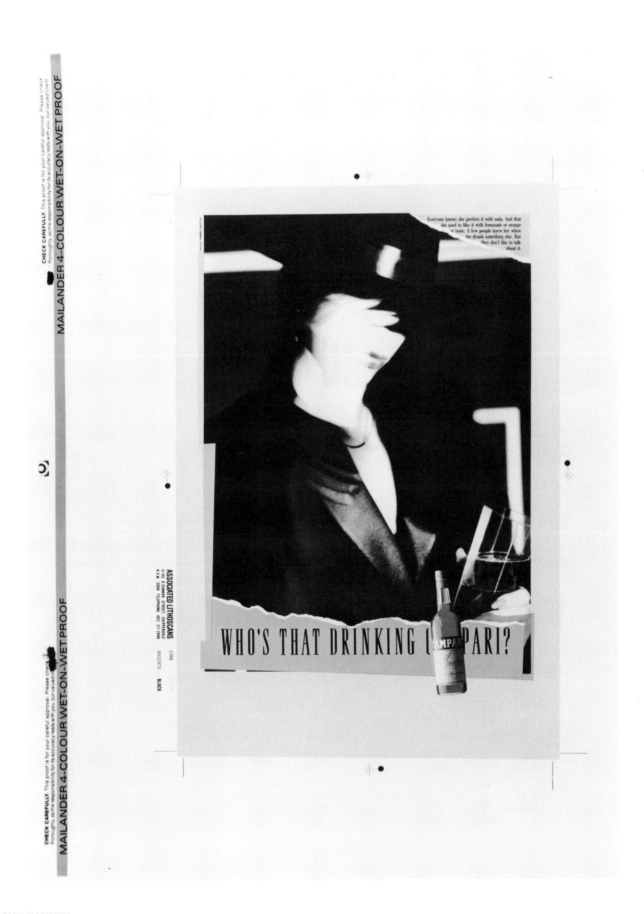

**ADVERTISEMENT**
**TYPOGRAPHY/DESIGN** Rod Button/Hans Hulsbosch  **TYPOGRAPHIC SUPPLIER** Captions Co.  **AGENCY** John Clemenger (NSW) Pty. Ltd.
**STUDIO** John Clemenger (NSW) Pty. Ltd.  **CLIENT** Swift & Moore  **PRINCIPAL TYPE** Spire  **DIMENSIONS** 8.3 × 10.4 in. (21 × 27 cm)

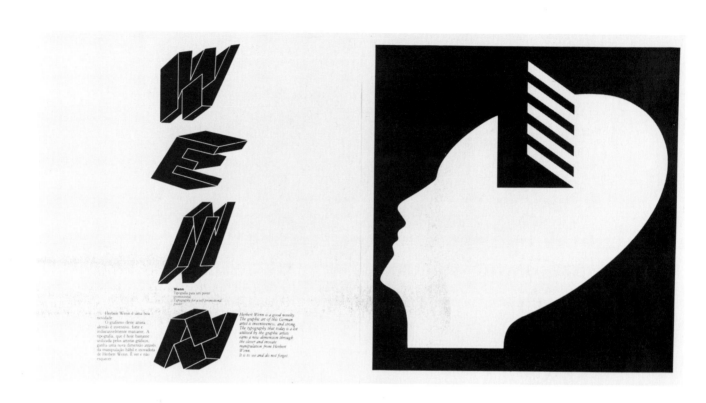

**Wenn**
Tipografia para um poster
promocional
Typography for a self-promotional
poster

Herbert Wenn é uma boa
novidade.
O grafismo deste artista
alemão é inventivo, forte e
indiscutivelmente marcante. A
tipografia, que é hoje bastante
utilizada pelos artistas gráficos,
ganha uma nova dimensão através
da manipulação hábil e inovadora
de Herbert Wenn. É ver e não
esquecer.

Herbert Wenn is a good novelty.
The graphic art of this German
artist is inventiveness, and strong.
The typography that today is a lot
utilized by the graphic artists
earns a new dimension through
the clever and innovate
manipulation from Herbert
Wenn.
It is to see and do not forget.

**EDITORIAL**
**DESIGN** Oswaldo Miranda  **CALLIGRAPHER** Herbert Wenn  **TYPOGRAPHIC SUPPLIER** Fonte Fotocomp  **STUDIO** Miran Studio
**CLIENT** Gráfica Magazine  **DIMENSIONS** 20.8 × 70.5 in. (54 × 27 cm)

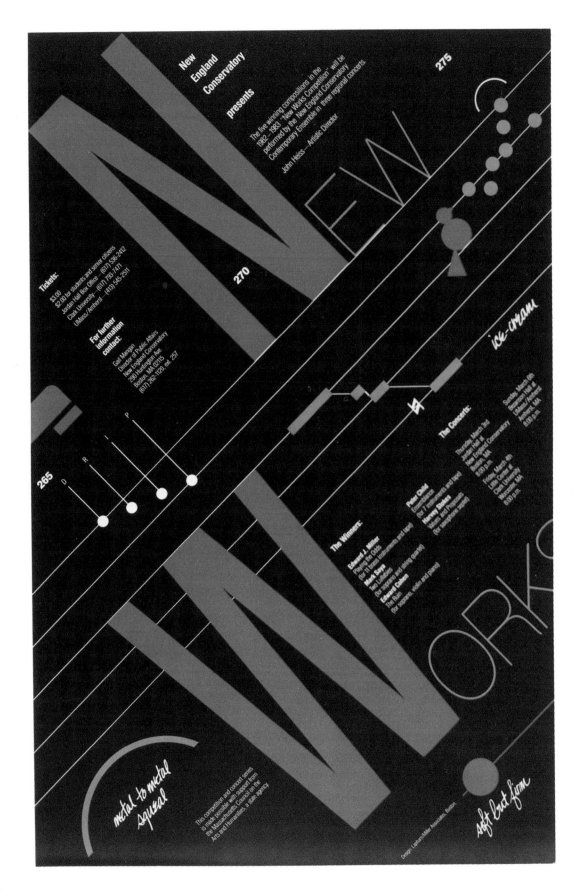

**POSTER**
**DESIGN** *Ralph Lapham* **CALLIGRAPHER** *Ralph Lapham* **TYPOGRAPHIC SUPPLIER** *Wrightson Typographers* **AGENCY** *Lapham/Miller Associates*
**STUDIO** *Lapham/Miller Associates* **CLIENT** *New England Conservatory* **PRINCIPAL TYPE** *Helvetica Light Condensed*
**DIMENSIONS** *11 × 17 in. (28 × 43 cm)*

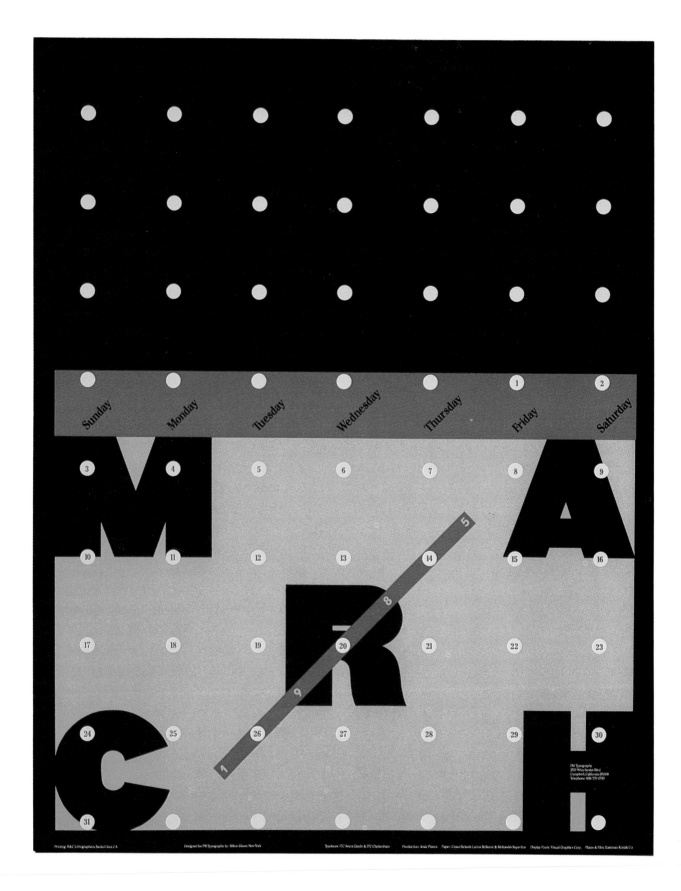

**CALENDAR**
**DESIGN** *Milton Glaser* **TYPOGRAPHIC SUPPLIER** *PM Typography* **STUDIO** *Milton Glaser, Inc.* **CLIENT** *Ray Morrone/PM Typography*
**PRINCIPAL TYPE** *ITC Avant Garde/ITC Cheltenham* **DIMENSIONS** *17 × 22 in. (43.2 × 55.9 cm)*

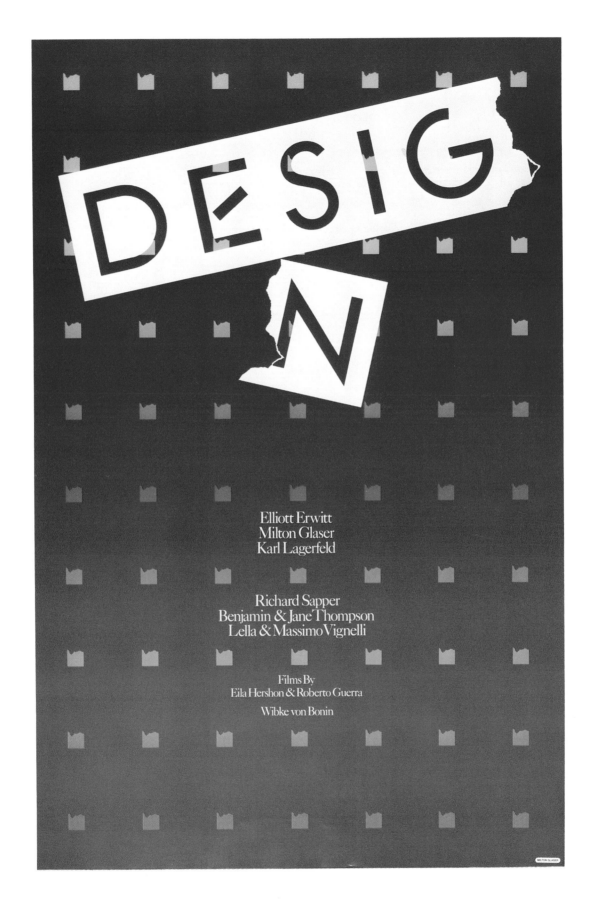

**POSTER**
**DESIGN** Milton Glaser **LETTERING** George Leavitt **TYPOGRAPHIC SUPPLIER** Innovative Graphics International **STUDIO** Milton Glaser, Inc.
**CLIENT** Eila Hershon/Roberto Guerra **PRINCIPAL TYPE** Times Roman **DIMENSIONS** 24 × 36 in. (61 × 91.4 cm)

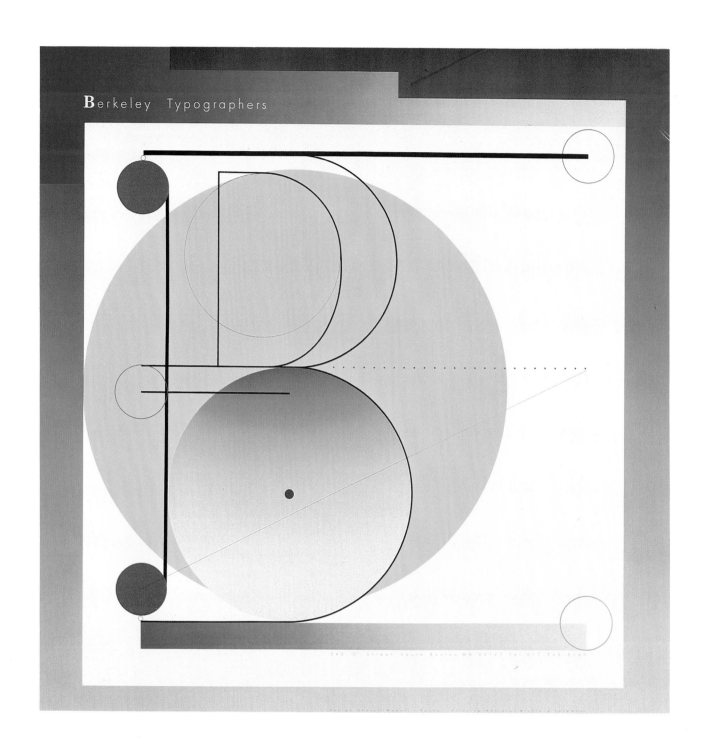

**POSTER**
**DESIGN** *Nancy Skolos* **TYPOGRAPHIC SUPPLIER** *Berkeley Typographers, Inc.* **STUDIO** *Skolos, Wedell & Raynor*
**CLIENT** *Berkeley Typographers, Inc.* **PRINCIPAL TYPE** *Futura* **DIMENSIONS** *25 × 25 in. (93.5 × 63.5 cm)*

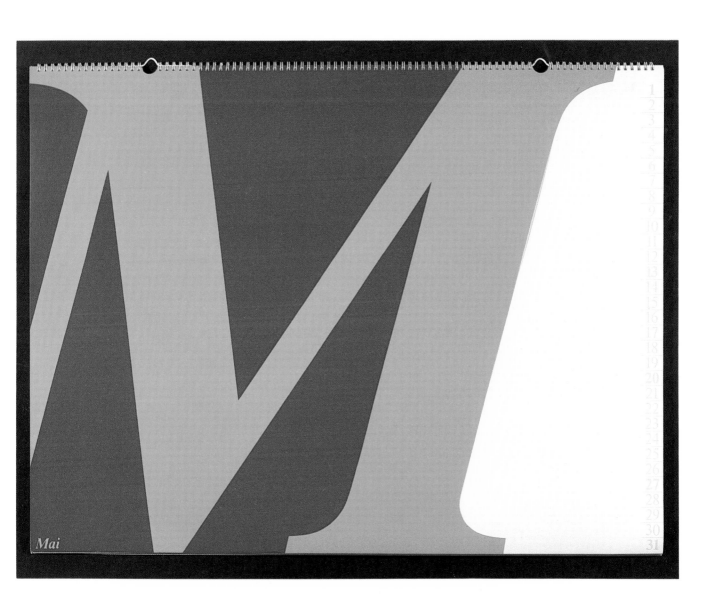

Mai

**CALENDAR**
**DESIGN** *Klaus Richter/Angelika Güntermann* **TYPOGRAPHIC SUPPLIER** *Satzatelier Michael-G. Seffrin* **CLIENT** *Klaus Richter*
**PRINCIPAL TYPE** *Times Roman* **DIMENSIONS** *31.5 × 23.6 in. (80 × 60 cm)*

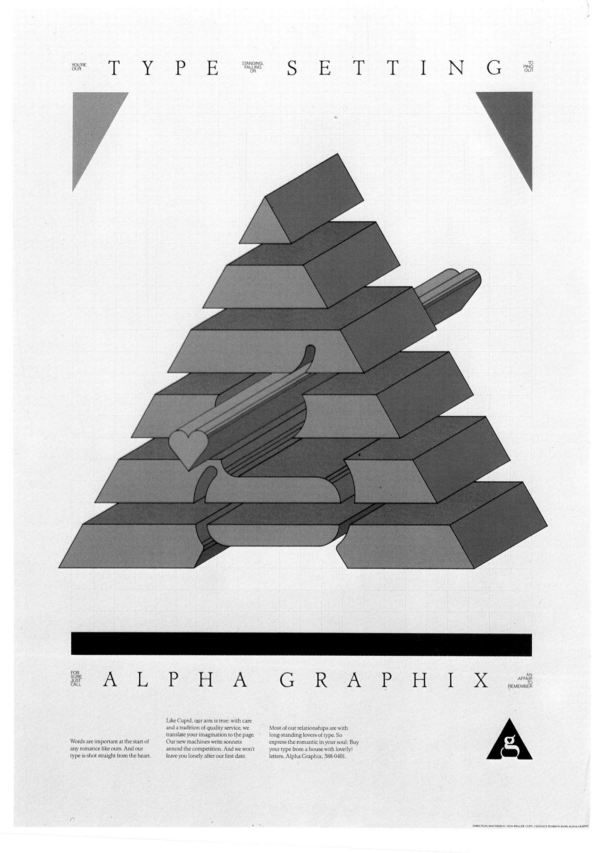

POSTER
**DESIGN** Don Weller **TYPOGRAPHIC SUPPLIER** Alpha Graphix Inc. **AGENCY** The Weller Institute for the Cure of Design, Inc.
**STUDIO** The Weller Institute for the Cure of Design, Inc. **CLIENT** Alpha Graphix **PRINCIPAL TYPE** Administer **DIMENSIONS** 13 × 18 in. (33 × 46 cm)

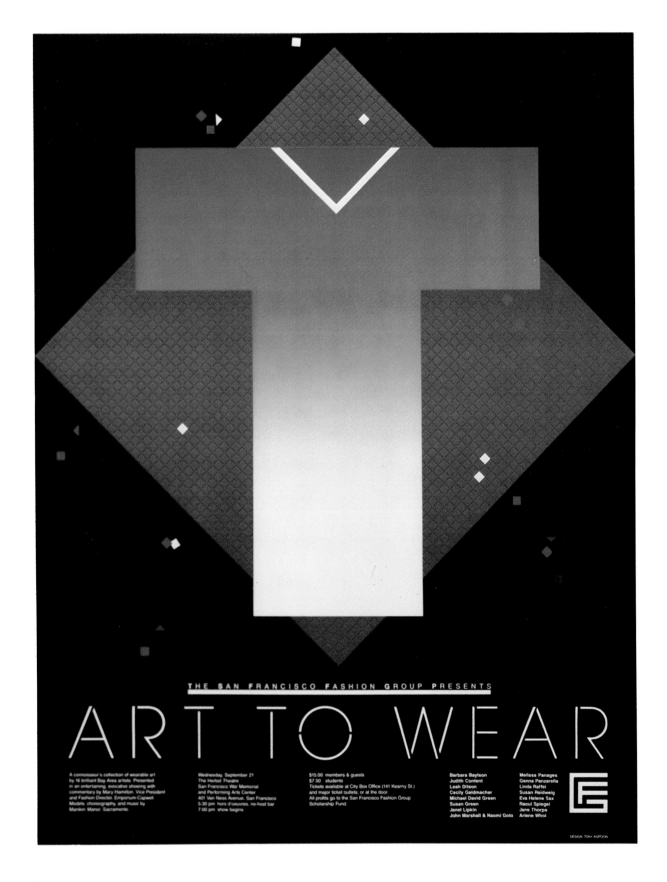

**POSTER**
**DESIGN** Tony Agpoon  **TYPOGRAPHIC SUPPLIER** Design & Type  **STUDIO** Tony Agpoon Design  **CLIENT** San Francisco Design Group, Inc.
**PRINCIPAL TYPE** Avant Garde/Helvetica  **DIMENSIONS** 18 × 24 in. (45.7 × 60 cm)

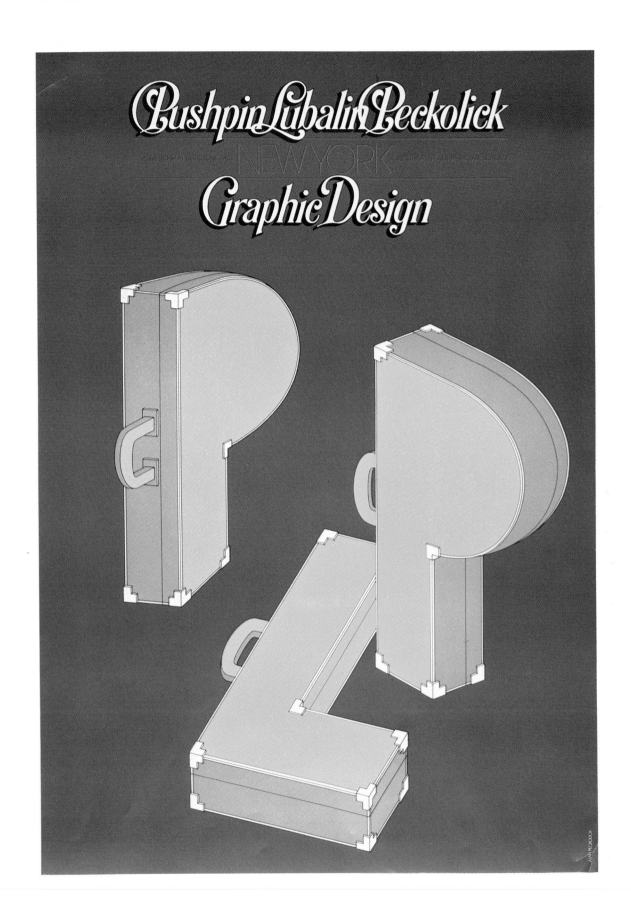

**POSTER**
**DESIGN** *Alan Peckolick* **CALLIGRAPHER** *Pushpin Logo: Tony Di Spigna* **TYPOGRAPHIC SUPPLIER** *Pushpin Lubalin Peckolick*
**AGENCY** *Pushpin Lubalin Peckolick* **STUDIO** *Pushpin Lubalin Peckolick* **CLIENT** *Pushpin Lubalin Peckolick*
**DIMENSIONS** *23.5 × 16.5 in. (59.7 × 41.9 cm)*

**POSTER**
**DESIGN** *Chris Rovillo* **TYPOGRAPHIC SUPPLIER** *Southwestern Typographics* **AGENCY** *The Richards Group*
**STUDIO** *Richards, Brock, Miller, Mitchell, & Assoc.* **CLIENT** *Dallas Society of Visual Communications* **PRINCIPAL TYPE** *Century Schoolbook*
**DIMENSIONS** *24 × 29.5 in. (61 × 74.9 cm)*

POSTER
**DESIGN** *Brent Croxton/Chris Rovillo* **TYPOGRAPHIC SUPPLIER** *Southwestern Typographics/Chiles & Chiles* **AGENCY** *The Richards Group*
**STUDIO** *Richards, Brock, Miller, Mitchell & Associates* **CLIENT** *The Rouse Company*
**PRINCIPAL TYPE** *Girder Heavy/Helvetica/Century Schoolbook* **DIMENSIONS** *14 × 29 in. (35.6 × 73.7 cm)*

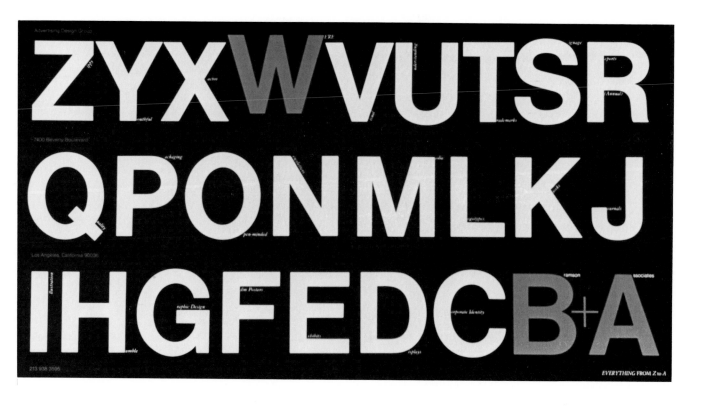

**POSTER**
**DESIGN** Harold Burch **TYPOGRAPHIC SUPPLIER** Lieberman Typographics **AGENCY** Bramson + Associates
**CLIENT** Bramson + Associates **PRINCIPAL TYPE** Helvetica/Garamond Italic **DIMENSIONS** 24.5 × 13 in. (62.2 × 33 cm)

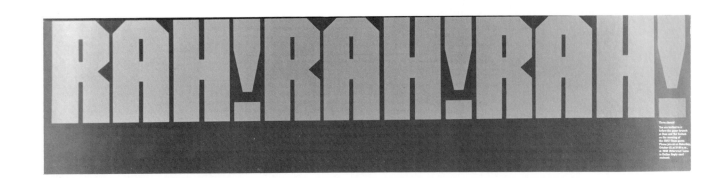

**INVITATION**
**DESIGN** *Chris Rovillo* **TYPOGRAPHIC SUPPLIER** *Southwestern Typographers* **AGENCY** *The Richards Group*
**STUDIO** *Richards, Brock, Miller, Mitchell & Associates* **CLIENT** *Ted & Bess Enloe* **PRINCIPAL TYPE** *Machine Bold/Century Schoolbook*
**DIMENSIONS** *36 × 8.5 in. (91.4 × 21.6 cm)*

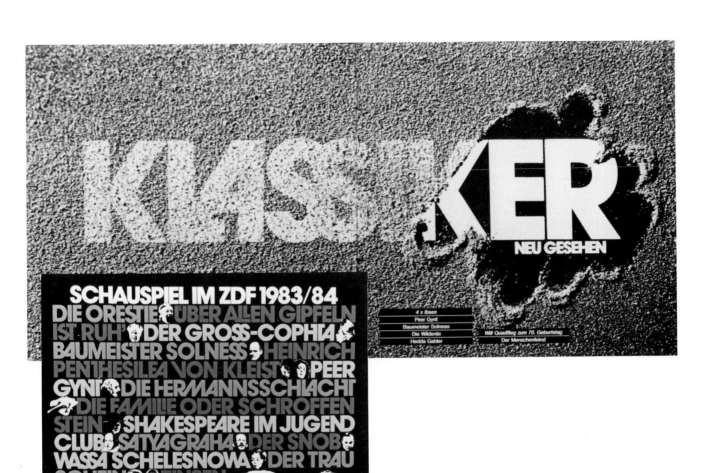

**BROCHURE**
**DESIGN** *Christof Gassner* **TYPOGRAPHIC SUPPLIER** *Koehler & Hennemann* **STUDIO** *Christof Gassner Grafik-Design*
**CLIENT** *ZDF • Zweites Deutsches Fernsehen* **PRINCIPAL TYPE** *Helvetica Light/Avant Garde Bold* **DIMENSIONS** *8.3 × 7.8 in. (21 × 19.7 cm)*

**POCKET FOLDER/LETTERHEAD**
**DESIGN** *Arthur Boden/Jerry Manoini* **CALLIGRAPHER** *Arthur Boden* **TYPOGRAPHIC SUPPLIER** *Just Your Type* **AGENCY** *Arthur Boden Inc.*
**STUDIO** *Arthur Boden Inc.* **CLIENT** *IBM Corporation* **PRINCIPAL TYPE** *Univers* **DIMENSIONS** *9 × 11 in. (23 × 28 cm)*

**LOGOTYPE**
**DESIGN** *Ken Parkhurst* **CALLIGRAPHER** *Denis Parkhurst* **AGENCY** *National Semiconductor Corporation, Marketing Communications Department*
**STUDIO** *Ken Parkhurst & Assoc. Inc.* **CLIENT** *National Semiconductor Corp.* **DIMENSIONS** *4.8 × 5.5 in. (12 × 14 cm)*

# YELLOW PERIL?

Wright's Coal Tar Soap has been around for well over a century.

Every year we've put a little bit aside and now we've saved enough to mount a television advertising campaign!

Commencing on Monday 17th October we'll be spending a national equivalent of £1·2m in three TV areas (Yorkshire, TVS and London) rolling out nationally after Christmas.

As you can see we've also repackaged Wright's Coal Tar Soap to reflect a little more of its very respectable heritage.

And Remember, Monday 17th October is the day. Be sure that you're sufficiently stocked up by then.

**NEWSPAPER ADVERTISEMENT**

**DESIGN** *Stephen Legate/Stuart Wilson* **TYPOGRAPHIC SUPPLIER** *Typographic Vision* **AGENCY** *Michael Bungey DFS Limited*
**STUDIO** *The Bull Pen Ltd.* **CLIENT** *Wright's Coal Tar Soap* **PRINCIPAL TYPE** *Beton Bold Condensed* **DIMENSIONS** *11 × 15.8 in. (28 × 40 cm)*

# THE FIRST TIME YOU DRIVE AN EXPENSIVE LUXURY CAR SHOULDN'T BE WHEN YOU DRIVE IT HOME.

733i

BMW contends that only by taking a luxury car out onto the often unforgiving roadways of the real world can you accurately assess whether or not it's worth the expense.

It's there that other luxury cars' flaws find amplification and the virtues of BMW engineering become most apparent.

Which is why Car and Driver magazine observed that the 533i delivers "the brand of overall performance that made the BMW name a legend in the first place."

The same publication appropriately described the BMW 528e as "roomy, agile and arrogantly self-assured on any kind of road."

AutoWeek wrote of the 7-Series, "in performance and comfort, the BMW 733i is truly a superior machine... nearly above criticism."

Car and Driver further lauded the 633CSi as "beautifully crafted...seriously efficient yet pleasing, laid out with the same ergonomic care that characterizes all of BMW's cars, blended as usual with elegance and fine leathers."

528e

533i

Of course there's only one way to experience what these journalists have already experienced.

And that's by driving a BMW yourself. Which is why we invite you to take a thorough test drive in the six-cylinder BMW of your choice.

**THE ULTIMATE DRIVING MACHINE.**

633CS

POSTER
**DESIGN** *Peter Rauch/Brandt Wilkins* **TYPOGRAPHIC SUPPLIER** *Typographic Innovations, Inc.* **AGENCY** *Ammirati & Puris, Inc.*
**STUDIO** *Ammirati & Puris Art Studio* **CLIENT** *BMW of North America* **PRINCIPAL TYPE** *Futura Extra Bold Condensed/News Gothic Light*
**DIMENSIONS** *25.5 × 35.5 in. (64.5 × 90 cm)*

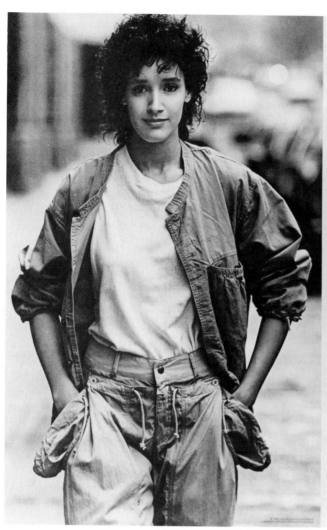

**ADVERTISEMENT**
**DESIGN** *Stan Schofield/Barbara Bowman/Bruce Sanelli* **TYPOGRAPHIC SUPPLIER** *Headline: Ad Agency/Headliners, Inc.;*
*Body Text: Typographic Innovations, Inc.* **AGENCY** *Ammirati & Puris, Inc.* **STUDIO** *Ammirati & Puris Art Studio* **CLIENT** *Marithe & Francois Girbaud*
**PRINCIPAL TYPE** *Morgan #27 Condensed Primer* **DIMENSIONS** *27.8 × 21.5 in. (70.5 × 54 cm)*

PM TYPOGRAPHY'S (FIFTEEN MONTH) ALL OF 1984 THROUGH PART OF 1985 BOOK OF DAYS FEATURING TIM GIRVIN JOHN PETER HERBERT SPENCER GENE FEDERICO SEYMOUR CHWAST HENRY WOLF MILTON GLASER WILLIAM TAUBIN ALDO NOVARESE HERMANN ZAPF TONY DiSPIGNA ALAN PECKOLICK BRADBURY THOMPSON TONY STAN MO LEBOWITZ RUDOLPH deHARAK JOSEPH ESSEX IVAN CHERMAYEFF SIT BACK IN YOUR FAVORITE CHAIR & ENJOY:

**CALENDAR SERIES**
**DESIGN** Patti Morrone/Tony Di Spigna/Bradbury Thompson/Alan Peckolick/Mo Lebowitz/Gene Federico/Ivan Chermayeff/Seymour Chwast/Henry Wolf/Tony Stan/Joseph Essex/Bill Taubin/Hermann Zapf/John Peter/Tim Girvin/Rudolph deHarak/Aldo Novarese/Milton Glaser/Herbert Spencer/Mark Galarneau **TYPOGRAPHIC SUPPLIER** PM Typography **CLIENT** PM Typography **DIMENSIONS** 17 × 22 in. (43.2 × 56 cm)

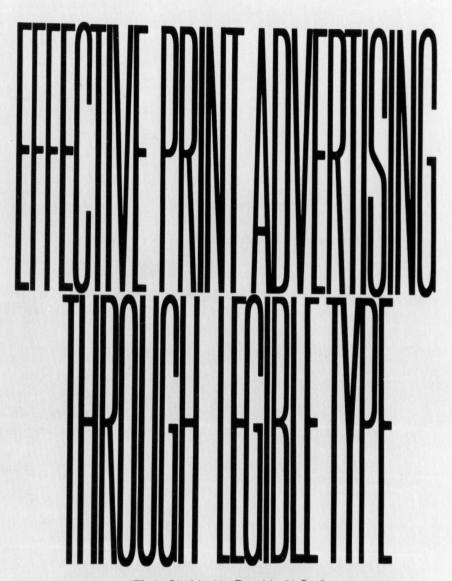

"Effective Print Advertising Through Legible Type"
will be the first Y&RNY seminar on typography. Wednesday, March 23, at 12:30
in the third floor conference room. This will be the first of five unique seminars on effective typography.
All art directors are urged to attend.
You know who you are.

**POSTER**
**DESIGN** *Roy Zucca/Chuck Anderson/Alan Zwiebel* **TYPOGRAPHIC SUPPLIER** *Photo-Lettering, Inc./Young & Rubicam, In-House*
**AGENCY** *Young & Rubicam, New York* **CLIENT** *Young & Rubicam, New York* **PRINCIPAL TYPE** *News Gothic Triple Condensed & 48% Condensed*
**DIMENSIONS** *16 × 21.3 in. (40.6 × 54 cm)*

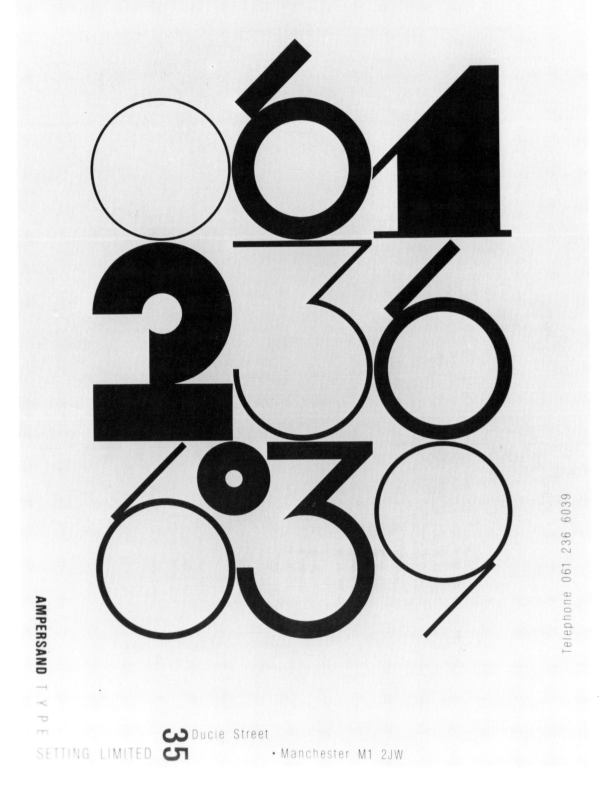

**POSTER**
**DESIGN** *Lionel Hatch* **CALLIGRAPHER** *Lionel Hatch* **TYPOGRAPHIC SUPPLIER** *Ampersand Typesetters* **STUDIO** *Typographics, England*
**CLIENT** *Ampersand Typesetters* **PRINCIPAL TYPE** *Olympian Condensed* **DIMENSIONS** *23.5 × 16.5 in. (60 × 42 cm)*

**DESIGN** *Philip Waugh* **TYPOGRAPHIC SUPPLIER** *Jaggers, Chiles & Stovall* **STUDIO** *Eisenberg, Inc.* **CLIENT** *Eisenberg, Inc.*
**PRINCIPAL TYPE** *Helvetica Light* **DIMENSIONS** *4.6 × 4.6 × .3 in. (11.8 × 11.8 × 8 cm)*

**ANNOUNCEMENT**
**DESIGN** *Jeff Pienkos* **CALLIGRAPHER** *Jeff Pienkos* **TYPOGRAPHIC SUPPLIER** *RyderTypes, Inc.* **STUDIO** *Jeff Pienkos Design* **CLIENT** *Jeff Pienkos*
**DIMENSIONS** *5.5 × 5.5 in. (14 × 14 cm)*

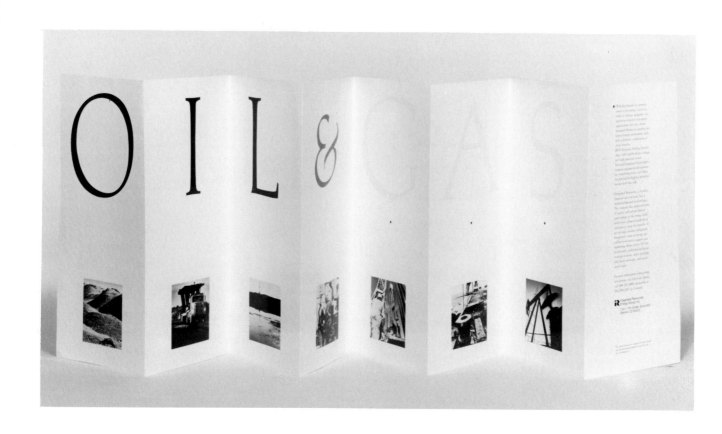

**BROCHURE/FOLDER**
**TYPOGRAPHY/DESIGN** *Mark Hamilton Hanger* **CALLIGRAPHER** *Mark Hamilton Hanger* **TYPOGRAPHIC SUPPLIER** *Typography Plus*
**AGENCY** *Interface Communications* **STUDIO** *Interface Communications* **CLIENT** *Integrated Resources Energy Group, Inc.*
**PRINCIPAL TYPE** *Michelangelo/Bodoni* **DIMENSIONS** *9 × 36 in. (23 × 45 cm)*

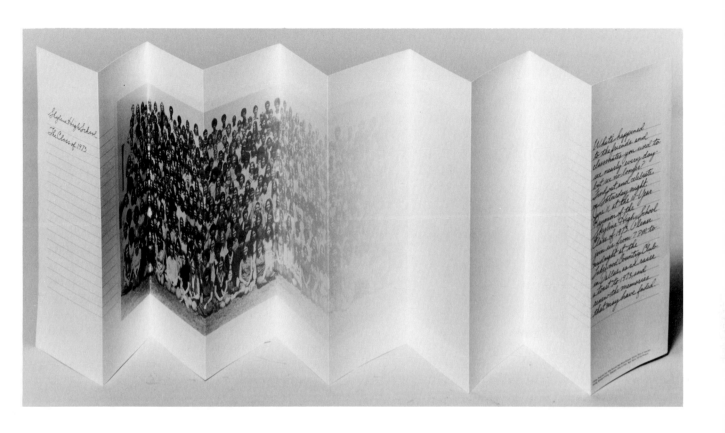

**INVITATION**
**DESIGN** *Brian Boyd* **CALLIGRAPHER** *Brian Boyd* **TYPOGRAPHIC SUPPLIER** *Chiles & Chiles* **AGENCY** *The Richards Group*
**STUDIO** *Richards, Sullivan, Brock & Associates* **CLIENT** *Skyline High School Class of '73* **DIMENSIONS** *33.5 × 9 in. (85.1 × 22.9 cm)*

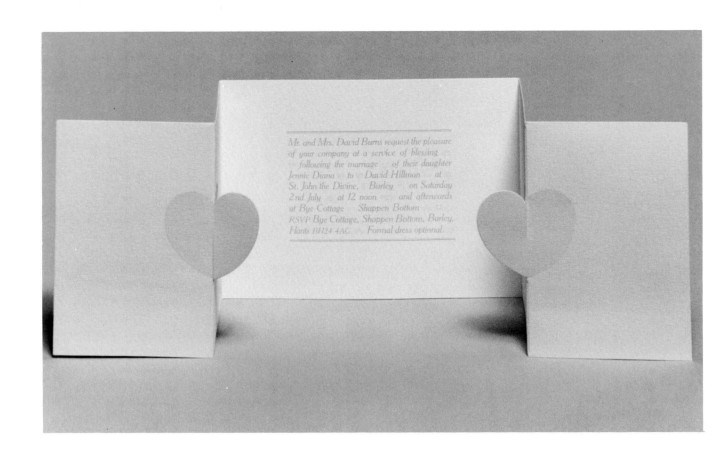

**INVITATION**
**DESIGN** *Michael Peters/Jackie Cobb* **TYPOGRAPHIC SUPPLIER** *Conway's* **STUDIO** *Michael Peters & Partners* **CLIENT** *Jennie Burns*
**PRINCIPAL TYPE** *Cheltenham Italic* **DIMENSIONS** *4.3 × 5.8 in. (14.7 × 10.5 cm)*

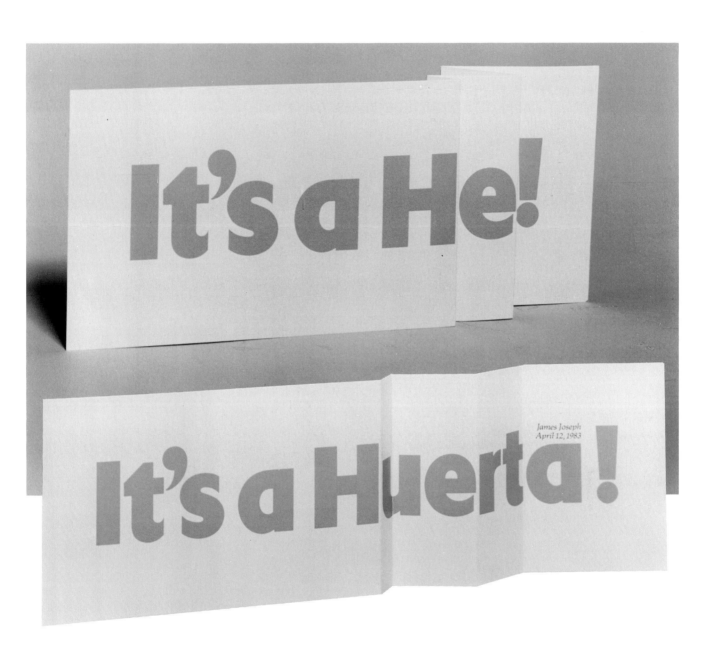

**BIRTH ANNOUNCEMENT**
**DESIGN** Gerard Huerta **TYPOGRAPHIC SUPPLIER** Haber Typographers **STUDIO** Gerard Huerta Design, Inc.
**CLIENT** Gerard & Debra Huerta **PRINCIPAL TYPE** Palatino Italic **DIMENSIONS** 8.5 × 3.8 in. (21.5 × 9.5 cm)

**STATIONERY**
**DESIGN** *Mel Hioki/Roy Zucca* **TYPOGRAPHIC SUPPLIER** *Typographic Innovations, Inc.* **AGENCY** *Hioki Design* **CLIENT** *Frank Tedesco*
**PRINCIPAL TYPE** *News Gothic Bold* **DIMENSIONS** *8.5 × 11 in. (21.5 × 28 cm)*

**STATIONERY**
**DESIGN** David Barnett/Dennis Barnett  **CALLIGRAPHER** David Barnett  **TYPOGRAPHIC SUPPLIER** Gerard  **STUDIO** Barnett Design
**CLIENT** Barnett Design  **PRINCIPAL TYPE** Bodoni  **DIMENSIONS** 8.5 × 11 in. (22 × 28 cm)

**INVITATION**
**DESIGN** *Takaaki Matsumoto* **TYPOGRAPHIC SUPPLIER** *Susan Schecter* **STUDIO** *Takaaki Matsumoto* **CLIENT** *Gallery 91*
**PRINCIPAL TYPE** *Helvetica Condensed* **DIMENSIONS** *16.6 × 11.6 in. (50 × 29.5 cm)*

**RSVP**

THE · COMPUTER · ART · COMPANY

29 COURT

WORDS AND PICTURES

Q B

25 TO 28 OCTOBER

19 83

F

'QUICK BROWN FOX IN WORDS AND PICTURES.' ¶ That's the title of a series of open days we are holding between the 25th and 28th of October. ¶ Obviously, we wouldn't be going to such lengths unless we thought we had something worth showing. ¶ And something worth saying. After all, we made our name in words. ¶ But what we have to show will, we suspect, be more of an eye opener. ¶ These days, you see, pictures are just as important to us. ¶ Our open days are from 11am to 8pm on Tuesday 25th, Wednesday 26th and Thursday 27th. ~ 5pm on Friday 28th. ¶ You'll be welcome any time you fancy ~ think you'll find 'Quick Brown Fox in Words and ~ an excellent chance to catch up ~ has seen recently. ~ with the

THE QUICK

BROWN FOX

W O R D S
I N
P
A N D
I
C T U
R E S

**INVITATION**
**DESIGN** Lionel Hatch/Malcolm Wood **TYPOGRAPHIC SUPPLIER** The Quick Brown Fox Co. **STUDIO** Typographics, England
**CLIENT** The Quick Brown Fox Co. **PRINCIPAL TYPE** Goudy Old Style **DIMENSIONS** 8.3 × 4 in. (21 × 10.2 cm)

MARCOLINA BROS. INC. 133 EAST MERMAID LANE, CHESTNUT HILL, PHILA., PA. 19118. TEL. CH 7-2252

**LOGOTYPE**
**DESIGN** *Dan Marcolina* **TYPOGRAPHIC SUPPLIER** *Letraset* **CLIENT** *Marcolina Brothers* **PRINCIPAL TYPE** *Palatino*
**DIMENSIONS** *2 × 1.8 in. (5 × 4.5 cm)*

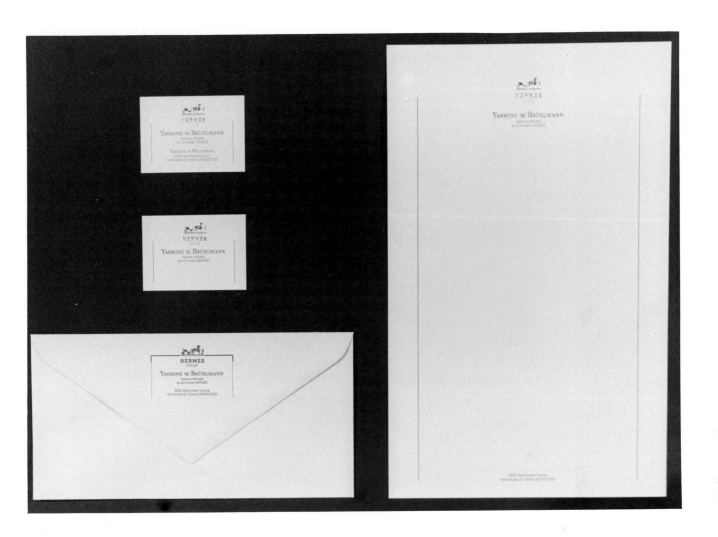

**STATIONERY**
**DESIGN** *Fritz Hofrichter* **ENGRAVING** *Bölling GmbH & Co. KG, Offizin für Prägedruck* **TYPOGRAPHIC SUPPLIER** *Christian Grützmacher GmbH*
**STUDIO** *Olaf Leu Design & Partner* **CLIENT** *Hermès* **PRINCIPAL TYPE** *Times Roman/Helvetica Light* **DIMENSIONS** *7.5 × 11.7 in. (19 × 29.6 cm)*

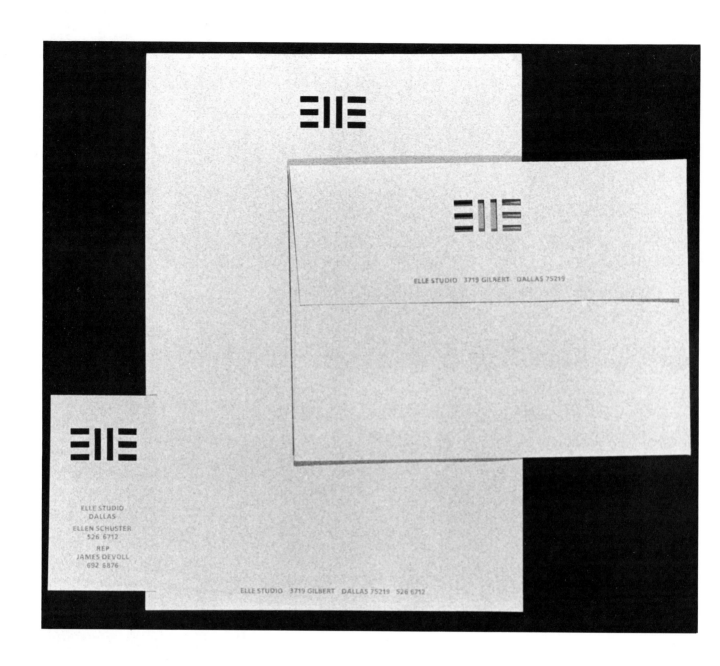

STATIONERY
**DESIGN** *David Kampa* **CALLIGRAPHER** *David Kampa* **TYPOGRAPHIC SUPPLIER** *Southwestern Typographics Inc.* **STUDIO** *Don Crum & Co.*
**CLIENT** *ELLE Studio* **PRINCIPAL TYPE** *Frutiger Bold 65* **DIMENSIONS** *7 × 10 in. (18 × 25 cm)*

**STATIONERY**
**DESIGN** *Michael Gericke* **TYPOGRAPHIC SUPPLIER** *E.B. Typecrafter* **CLIENT** *Michael Gericke* **PRINCIPAL TYPE** *Helvetica Light/Helvetica Heavy*
**DIMENSIONS** *7.3 × 10.5 in. (18.4 × 26.7 cm)*

**STATIONERY**
**DESIGN** Linda Eissler **TYPOGRAPHIC SUPPLIER** Jaggars, Chiles & Stovall **STUDIO** Eisenberg, Inc. **CLIENT** Webb & Sons Incorporated
**PRINCIPAL TYPE** Goudy Old Style **DIMENSIONS** 8.5 × 11 in. (22 × 28 cm)

A NEWSLETTER OF THE SOURCE/NBC RADIO'S YOUNG ADULT NETWORK

ISSUED BY THE ADVERTISING AND PROMOTION DEPARTMENT, THE SOURCE, NBC RADIO, 30 ROCKEFELLER PLAZA, NEW YORK, NEW YORK 10020

**LETTERHEAD**
**DESIGN** Charles Blake/Bill Grant **CALLIGRAPHER** Izumi **TYPOGRAPHIC SUPPLIER** Pro-Type **CLIENT** NBC Source Radio
**PRINCIPAL TYPE** Avant Garde **DIMENSIONS** 8.5 × 11 in. (22 × 28 cm)

**STATIONERY**
**DESIGN** Joseph Michael Essex  **REDRAWING** Joseph Michael Essex  **TYPOGRAPHIC SUPPLIER** Master Typography
**AGENCY** Burson·Marsteller  **STUDIO** SX-2  **CLIENT** Horwitz-Matthews  **PRINCIPAL TYPE** T.S. Martin  **DIMENSIONS** 8.5 × 11 in. (22 × 28 cm)

**STATIONERY SYSTEM**
**DESIGN** *April Greiman* **TYPOGRAPHIC SUPPLIER** *Vernon Simpson* **STUDIO** *April Greiman, Inc.* **CLIENT** *April Greiman*
**PRINCIPAL TYPE** *Garamond Bold Italic* **DIMENSIONS** *8.5 × 11 in. (21.6 × 27.9 cm)*

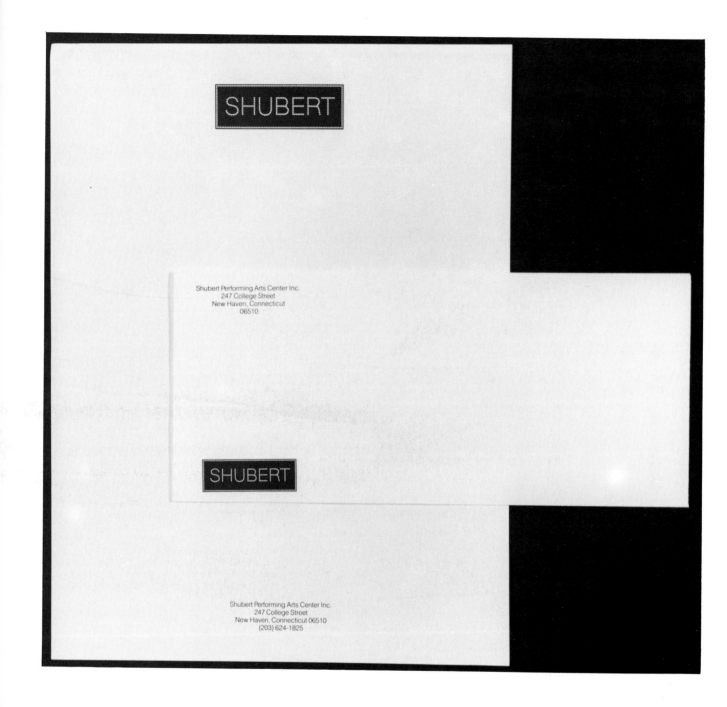

**CORPORATE IDENTITY**
**DESIGN** *Nathan Garland* **TYPOGRAPHIC SUPPLIER** *Southern New England Typographic Service* **STUDIO** *Nathan Garland Graphic Design & Film*
**CLIENT** *Shubert Performing Arts Center, Inc.* **PRINCIPAL TYPE** *Helvetica Light* **DIMENSIONS** *8.5 × 11 in. (22 × 28 cm)*

**96**

**EDITORIAL**
**DESIGN** *Bob Farber* **ILLUSTRATOR** *Barbara Nessim* **TYPOGRAPHIC SUPPLIER** *M.J. Baumwell* **STUDIO** *ITC* **CLIENT** *U&lc*
**PRINCIPAL TYPE** *ITC Avant Garde Gothic/ITC Bookman/ITC Galliard* **DIMENSIONS** *22 × 14.8 in. (56 × 37.5 cm)*

**SELF-PROMOTION**
**DESIGN** *Lou Fiorentino* **TYPOGRAPHIC SUPPLIER** *CT Typographix, Inc.* **AGENCY** *Lou Fiorentino Visual Communications*
**STUDIO** *Lou Fiorentino Visual Communications* **CLIENT** *Lou Fiorentino* **PRINCIPAL TYPE** *Garamond* **DIMENSIONS** *8 × 12.5 in. (20.3 × 31.8 cm)*

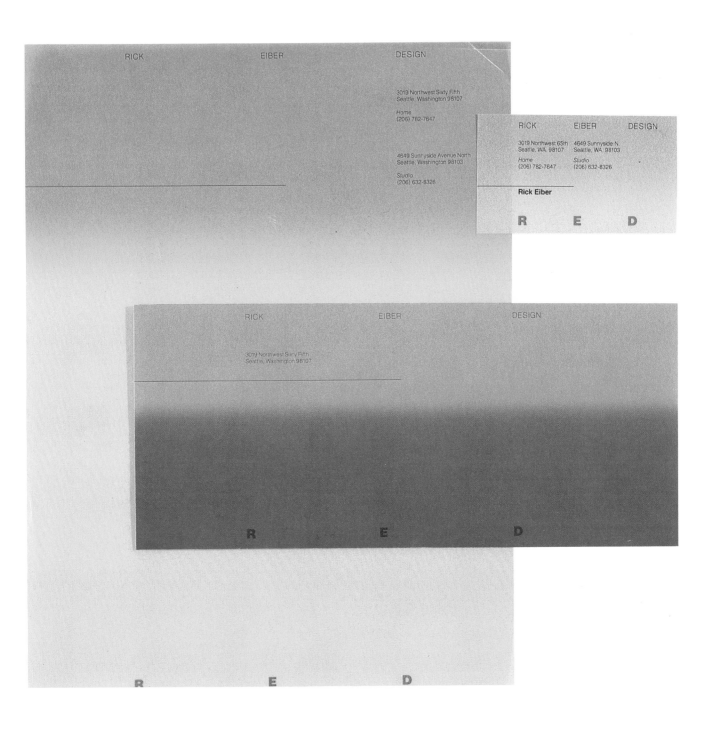

**STATIONERY**
**DESIGN** *Rick Eiber* **TYPOGRAPHIC SUPPLIER** *The Type Gallery* **STUDIO** *Rick Eiber Design (RED)* **CLIENT** *Rick Eiber Design (RED)*
**PRINCIPAL TYPE** *Helvetica Black & Light* **DIMENSIONS** *8.5 × 11 in. (22 × 28 cm)*

# INTERACTION

The use of interactive graphics systems has become state-of-the-art in engineering. Computer-assisted design, computer-aided manufacturing, computer-generated drawings—these and other applications provide convincing evidence of the value of interactive computing to designers and engineers. With the IBM 5080 Graphics System, users can now have all the time-saving advantages of interactive design, calculation, and analysis—plus enhancements—right in their own office. The 5080 system offers displays of remarkable resolution and steadiness, in monochrome or color. It is compatible with the existing IBM 3250 Graphics Display System. A special option permits the user to access 3270 applications and to display graphics and 3270 data, alternately, on the same graphics terminal. Everything is within reach. Interaction with the system is easier, making the engineer's work simpler, less time-consuming, more productive.

**BROCHURE**
**DESIGN** B. Martin Pedersen  **TYPOGRAPHIC SUPPLIER** Boro Typographers  **AGENCY** IBM Corporation, International Division
**STUDIO** Jonson Pedersen Hinrichs & Shakery Inc.  **CLIENT** IBM Corporation  **PRINCIPAL TYPE** Helvetica Bold Condensed
**DIMENSIONS** 7 × 11 in. (17.8 × 27.9 cm)

POSTER
**DESIGN** Hal Apple/Kris Rodammer/Michael Morris  **CALLIGRAPHER** Rodammer Morris Associates, Inc.
**TYPOGRAPHIC SUPPLIER** Robert J. Hilton Inc.  **AGENCY** Rodammer Morris Associates, Inc.  **STUDIO** Rodammer Morris Associates, Inc.
**CLIENT** Rodammer Morris Associates, Inc./Harp Press/Robert J. Hilton, Inc./Monarch Paper  **PRINCIPAL TYPE** Univers/Ultra Bodoni/
Garamond Italic  **DIMENSIONS** 22.5 × 18 in. (57.2 × 45.7 cm)

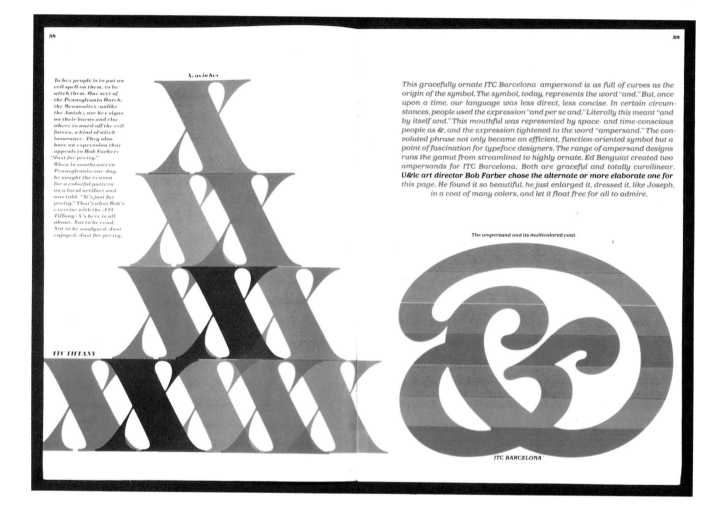

X. as in hex

To hex people is to put an evil spell on them, to bewitch them. One sect of the Pennsylvania Dutch, the Mennonites (unlike the Amish), use hex signs on their barns and elsewhere to ward off the evil forces, a kind of witch insurance. They also have an expression that appeals to Bob Farber: "Just for pretty." When in southeastern Pennsylvania one day, he sought the reason for a colorful pattern on a local artifact and was told, "It's just for pretty." That's what Bob's exercise with the (ITC Tiffany) X's here is all about. Not to be read. Not to be analyzed. Just enjoyed. Just for pretty.

ITC TIFFANY

This gracefully ornate ITC Barcelona ampersand is as full of curves as the origin of the symbol. The symbol, today, represents the word "and." But, once upon a time, our language was less direct, less concise. In certain circumstances, people used the expression "and per se and." Literally this meant "and by itself and." This mouthful was represented by space- and time-conscious people as &, and the expression tightened to the word "ampersand." The convoluted phrase not only became an efficient, function-oriented symbol but a point of fascination for typeface designers. The range of ampersand designs runs the gamut from streamlined to highly ornate. Ed Benguiat created two ampersands for ITC Barcelona. Both are graceful and totally curvilinear. **U&lc art director Bob Farber chose the alternate or more elaborate one for** this page. He found it so beautiful, he just enlarged it, dressed it, like Joseph, in a coat of many colors, and let it float free for all to admire.

The ampersand and its multicolored coat.

ITC BARCELONA

**EDITORIAL**
**DESIGN** *Bob Farber* **TYPOGRAPHIC SUPPLIER** *M.J. Baumwell* **STUDIO** *ITC* **CLIENT** *U&lc* **PRINCIPAL TYPE** *ITC Tiffany/Barcelona*
**DIMENSIONS** *22 × 14.8 in. (56 × 37.5 cm)*

**SALES PROMOTION**
**DESIGN** *Arthur Beckenstein* **TYPOGRAPHIC SUPPLIER** *Photo-Lettering, Inc.* **AGENCY** *Time, Inc.* **STUDIO** *People Promotion*
**CLIENT** *People Magazine* **PRINCIPAL TYPE** *Benguiat Montage* **DIMENSIONS** *6 × 42 in. (15 × 106.7 cm)*

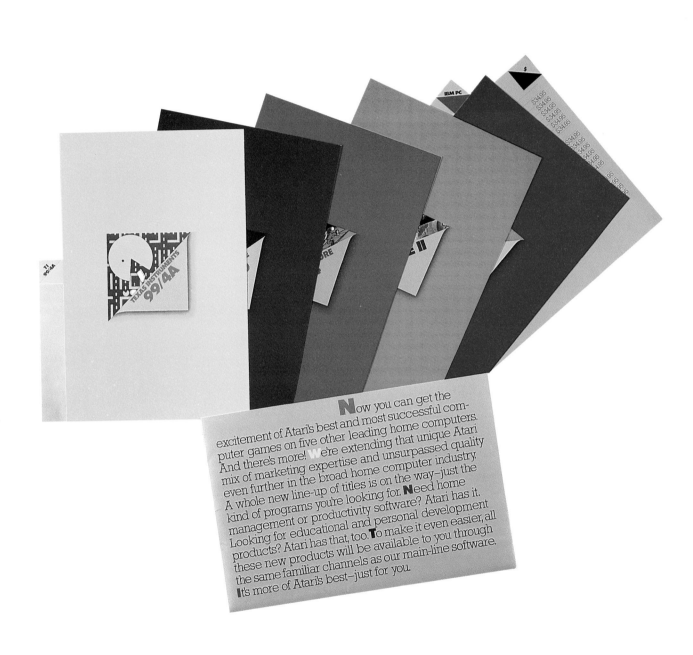

**N**ow you can get the excitement of Atari's best and most successful computer games on five other leading home computers. And there's more! **W**e're extending that unique Atari mix of marketing expertise and unsurpassed quality even further in the broad home computer industry. A whole new line-up of titles is on the way–just the kind of programs you're looking for. **N**eed home management or productivity software? Atari has it. Looking for educational and personal development products? Atari has that, too. **T**o make it even easier, all these new products will be available to you through the same familiar channels as our main-line software. **I**t's more of Atari's best–just for you.

**BROCHURE**
**DESIGN** *Kit Hinrichs* **TYPOGRAPHIC SUPPLIER** *Reardon & Krebs* **AGENCY** *Jonson Pedersen Hinrichs & Shakery Inc.* **CLIENT** *Atari*
**PRINCIPAL TYPE** *Futura Extra Bold & Light/Rockwell Light* **DIMENSIONS** *9 × 12 in. (22.9 × 30.5 cm)*

**STATIONERY**
**DESIGN** Michael Skjei/Colin Shay **TYPOGRAPHIC SUPPLIER** Phototype House **STUDIO** Shay, Shea and Skjei **CLIENT** Kay Skjei
**PRINCIPAL TYPE** Helvetica Condensed **DIMENSIONS** 7.3 × 10.5 in. (18.5 × 26.7 cm)

WILLOWAY · YORKTOWN HEIGHTS · NEW YORK 10598
TELEPHONE (914) 245-6900

**CORPORATE IDENTITY**
**DESIGN** *Paul Zasada/Faye Parsons* **CALLIGRAPHER** *Paul Zasada* **TYPOGRAPHIC SUPPLIER** *Foley's Graphic Center*
**AGENCY** *Pilkington Packaging* **CLIENT** *Pilkington Packaging* **PRINCIPAL TYPE** *Cheltenham Roman* **DIMENSIONS** *8.5 × 11 in. (21.6 × 28 cm)*

STATIONERY
**DESIGN** *Dianne Carchedi* **CALLIGRAPHER** *Dianne Carchedi* **TYPOGRAPHIC SUPPLIER** *Brockton Typographers* **STUDIO** *Carchedi Design*
**CLIENT** *Be Our Guest/Bed & Breakfast* **PRINCIPAL TYPE** *ITC Garamond* **DIMENSIONS** *8.5 × 11 in. (22 × 28 cm)*

**107**

**STATIONERY**
**DESIGN** *James Nance Kivell* **TYPOGRAPHIC SUPPLIER** *Alphagraphics One* **AGENCY** *Krogstad Design Associates Inc.* **CLIENT** *Nancy Wellinger*
**PRINCIPAL TYPE** *Bodoni* **DIMENSIONS** *8.5 × 11 in. (22 × 28 cm)*

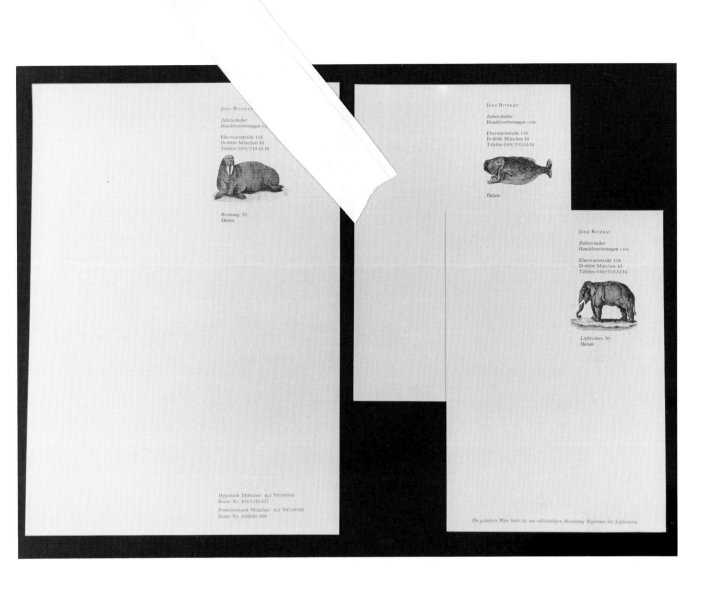

**STATIONERY**
**DESIGN** Irmgard Voigt  **TYPOGRAPHIC SUPPLIER** Typostudio Schumacher–Gebler  **STUDIO** Irmgard Voigt Graphic Design  **CLIENT** Jörg Ritzkat
**PRINCIPAL TYPE** Bell (Monotype)  **DIMENSIONS** 8.3 × 11 in. (21 × 29, 14.8 × 21 cm)

**PROMOTION**
**DESIGN** *John Weber* **CALLIGRAPHER** *John Weber* **STUDIO** *One-B-Design* **CLIENT** *Long's Commercial Art Supply*
**DIMENSIONS** *3 × 5 in. (7.6 × 12.7 cm)*

**POSTER**
**DESIGN** *Jan Solpera* **TYPOGRAPHIC SUPPLIER** *Jan Solpera* **CLIENT** *Arts & Crafts Museum, Prague*
**PRINCIPAL TYPE** *Echo/Avant Garde Gothic Light* **DIMENSIONS** *38.5 × 26.7 in. (98 × 68 cm)*

**LOGOTYPE**
**DESIGN** *Ed Benguiat* **CALLIGRAPHER** *Ed Benguiat* **STUDIO** *Photo-Lettering, Inc.* **CLIENT** *Plinc*

THANK YOU
LORAINE ALLEN
LEROY ANDERSON
PHINEAS T. BARNUM
BECKETT PAPER CO.
SARAH BERNHARDT
DAVID L. BELEW
ROGER BLACK
ENCYCLOPAEDIA BRITANNICA
MR. CHRISTIAN
COBBLE HILL
JIMMY DURANTE
M. FRANCONI
DIANE GRAHAM
BRETT HARPER
MOE LEBOWITZ
CITY OF NEW YORK
ALAN PECKOLICK
PHOTO-LETTERING, INC.
MR. PLINC
EMILY W. ROEBLING
JOHN A. ROEBLING
ERNIE SMITH
R. STERLING
VANESSA AND FRIENDS
JESSICA WEBER
RICHARD WILDE
HENRY WOLF
AND THE MANY
OTHERS WHO HAVE
ASSISTED WITH
THEIR HELP
AND ADVICE.
PLINC
HAS BEEN
PRODUCED AND
DIRECTED AND
EDITED
AND
CREATED BY
ED BENGUIAT

**MAGAZINE COVER**
**DESIGN** *Ed Benguiat* **CALLIGRAPHER** *Ed Benguiat* **TYPOGRAPHIC SUPPLIER** *Photo-Lettering, Inc.* **STUDIO** *Photo-Lettering, Inc.*
**CLIENT** *Plinc* **PRINCIPAL TYPE** *Helvetica* **DIMENSIONS** *12 × 12 in. (30.5 × 30.5 cm)*

LOGOTYPE
**DESIGN** David Quay **CALLIGRAPHER** Paul Gray **CLIENT** Quay & Gray **PRINCIPAL TYPE** Augustea Nova

**STATIONERY**
**DESIGN** David Quay **CALLIGRAPHER** Paul Gray **TYPOGRAPHIC SUPPLIER** Face Photosetting Ltd. **CLIENT** Quay & Gray
**PRINCIPAL TYPE** Augustea Nova **DIMENSIONS** 8.3 × 11.6 in. (21 × 29 cm)

THE NEWSLETTER OF THE TYPE DIRECTORS CLUB
VOL.1 NO.1 NOVEMBER 1983

**LOGOTYPE**
**DESIGN** *Minoru Morita/John Luke* **CALLIGRAPHER** *Minoru Morita* **STUDIO** *Creative Center Inc.* **CLIENT** *Type Directors Club*

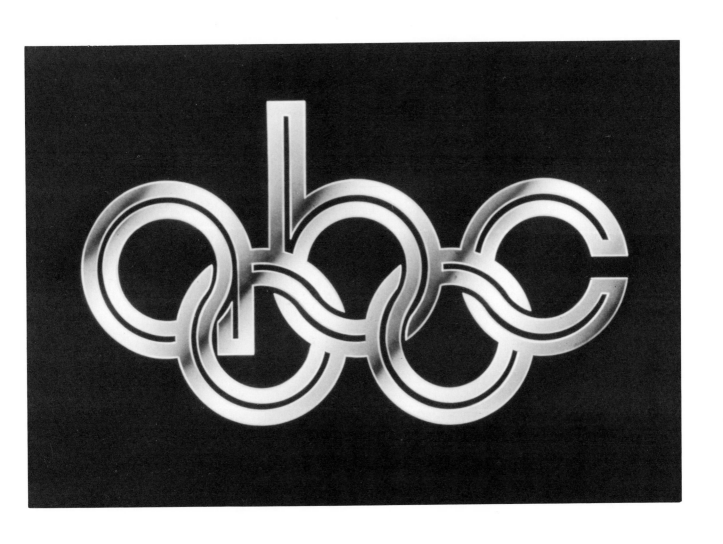

**LOGOTYPE**
**DESIGN** *Joe Caroff Associates, Inc.* **CALLIGRAPHER** *Joe Caroff Associates, Inc.* **AGENCY** *Joe Caroff Associates, Inc.*
**STUDIO** *Joe Caroff Associates, Inc.* **CLIENT** *ABC Sports* **DIMENSIONS** *8 in. (20 cm)*

**PROMOTION**
**DESIGN** *Jan Wilson* **TYPOGRAPHIC SUPPLIER** *Southwestern Typographics* **STUDIO** *Dennard Creative* **CLIENT** *Pizza Inn, Inc.*
**PRINCIPAL TYPE** *ITC Cheltenham Light* **DIMENSIONS** *1.3 × 2 in. (3 × 4.7 cm)*

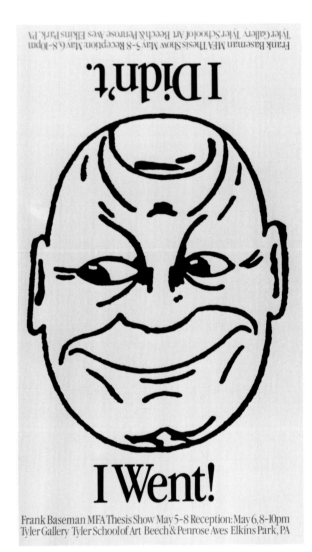

**POSTER**
**DESIGN** *Frank Baseman* **TYPOGRAPHIC SUPPLIER** *International Typeface Corporation* **STUDIO** *Frank Baseman Graphic Design*
**CLIENT** *Frank Baseman* **PRINCIPAL TYPE** *ITC Garamond Bold Condensed* **DIMENSIONS** *8.5 × 15 in. (21.6 × 38 cm)*

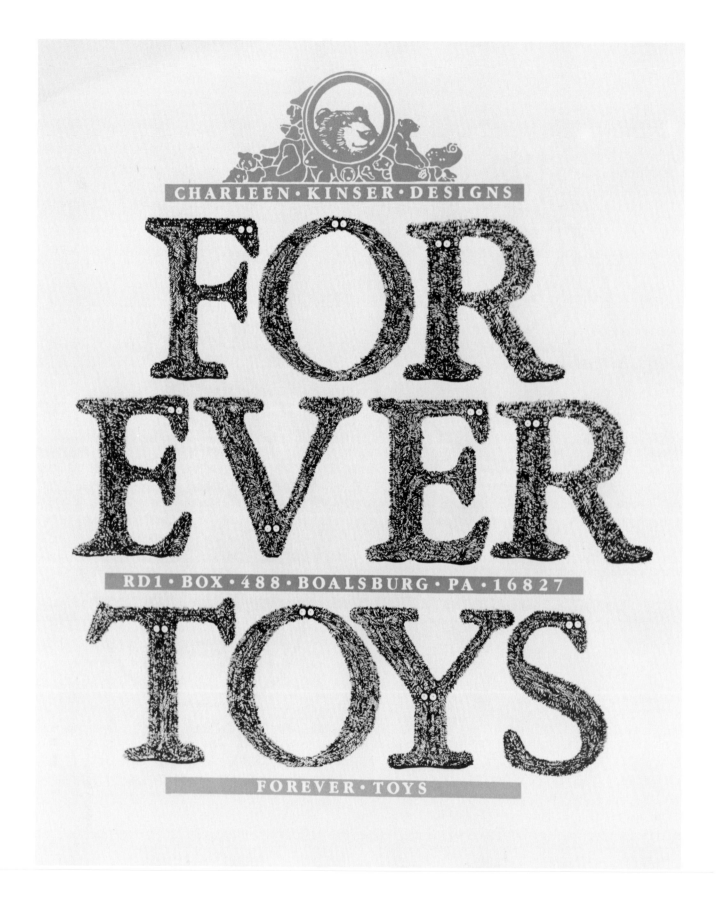

POSTER
**DESIGN** *Leslie Strother* **TYPOGRAPHIC SUPPLIER** *Commercial Printing* **STUDIO** *Bill Kinser Design* **CLIENT** *Forever Toys*
**PRINCIPAL TYPE** *Garamond Bold* **DIMENSIONS** *23 × 35 in. (58.4 × 88.9 cm)*

**EDITORIAL**
**DESIGN** *Mark Lichtenstein* **CALLIGRAPHER** *Mark Lichtenstein* **TYPOGRAPHIC SUPPLIER** *Pro-Type* **AGENCY** *Lichtenstein Marketing Communications*
**CLIENT** *RSCA* **PRINCIPAL TYPE** *Berling Italic* **DIMENSIONS** *9 × 14 in. (23 × 35.6 cm)*

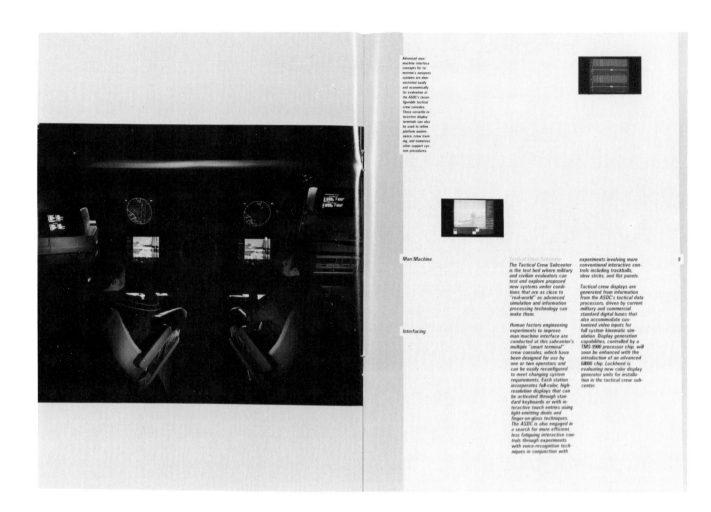

**BROCHURE**
**DESIGN** Doug Joseph  **TYPOGRAPHIC SUPPLIER** Composition Type  **AGENCY** Robert Miles Runyan & Associates
**STUDIO** Robert Miles Runyan & Associates  **CLIENT** Lockheed-California Company  **PRINCIPAL TYPE** Univers 76
**DIMENSIONS** 8.8 × 11.8 in. (22 × 30 cm)

**CORPORATE IDENTITY MANUAL**
**DESIGN** *David Barnett/Dennis Barnett* **CALLIGRAPHER** *Ray Barber* **TYPOGRAPHIC SUPPLIER** *Gerard Associates* **STUDIO** *Barnett Design*
**CLIENT** *D'Arcy MacManus Masius* **PRINCIPAL TYPE** *Bauer Bodoni* **DIMENSIONS** *8.5 × 11.8 in. (21.6 × 29.8 cm)*

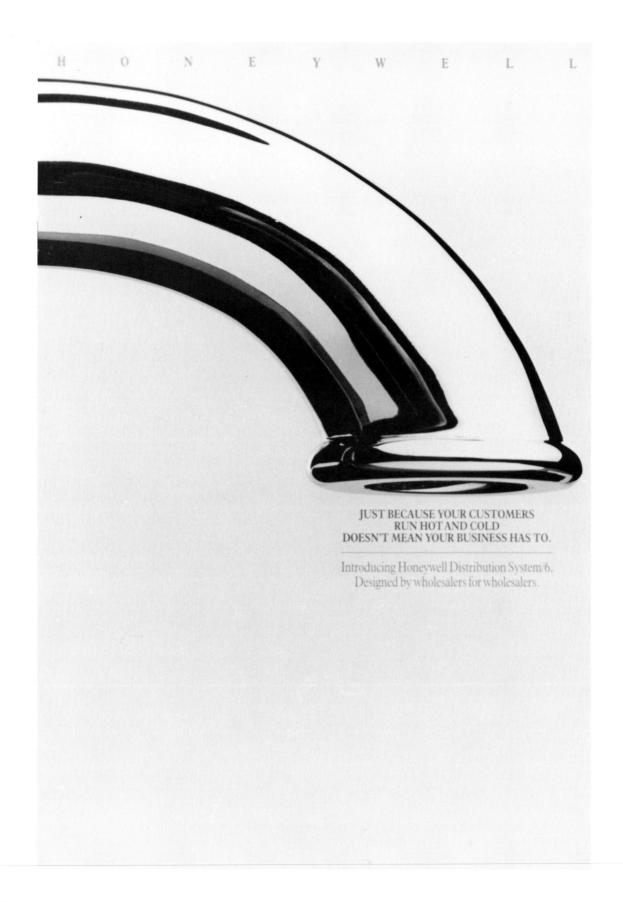

JUST BECAUSE YOUR CUSTOMERS
RUN HOT AND COLD
DOESN'T MEAN YOUR BUSINESS HAS TO.

Introducing Honeywell Distribution System 6.
Designed by wholesalers for wholesalers.

**BROCHURE**
**DESIGN** *Mark Kent* **TYPOGRAPHIC SUPPLIER** *Typographic House* **AGENCY** *Cipriani Advertising Inc.* **CLIENT** *Honeywell Information Systems*
**PRINCIPAL TYPE** *Plantin* **DIMENSIONS** *8.5 × 11.8 in. (21 × 29.8 cm)*

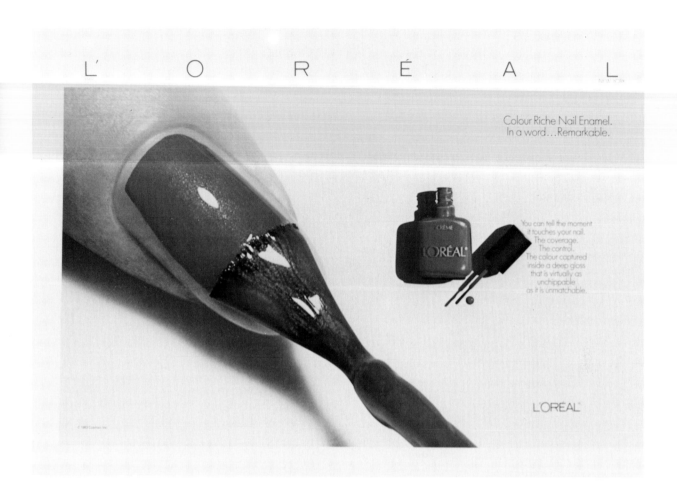

Colour Riche Nail Enamel.
In a word…Remarkable.

You can tell the moment
it touches your nail.
The coverage.
The control.
The colour captured
inside a deep gloss
that is virtually as
unchippable
as it is unmatchable.

L'ORÉAL

**ADVERTISEMENT**
**DESIGN** *Bonnie Hazelton/George D'Amato* **TYPOGRAPHIC SUPPLIER** *Ad Agencies Service Co., Inc.* **AGENCY** *McCann-Erickson, Inc.*
**CLIENT** *Cosmair/L'Oréal* **PRINCIPAL TYPE** *Futura Light* **DIMENSIONS** *16.5 × 11.1 in. (41.9 × 28.2 cm)*

H    O    T

**POSTER**
**DESIGN** *Linda Eissler* **TYPOGRAPHIC SUPPLIER** *Jaggars, Chiles & Stovall* **AGENCY** *The Cherri Oakley Company* **STUDIO** *Eisenberg, Inc.*
**CLIENT** *Uncle Tai's Hunan Yuan* **PRINCIPAL TYPE** *Gill Sans Condensed* **DIMENSIONS** *14 × 25 in. (35.5 × 63.5 cm)*

SURFACE

is more than
meets the eye. Beneath the
smooth surface of a billiard
ball are unseen elements of
strength, solidity, and bal-
ance. Beneath the smooth
surface of S. D. Warren
Cameo Dull are all the
elements needed to rack
up superb printed results.

**TRADE ADVERTISEMENT**
**DESIGN** Cheryl Heller **TYPOGRAPHIC SUPPLIER** Typographic House **AGENCY** HBM/Creamer Advertising, Inc. **STUDIO** HBM Design Group
**CLIENT** S.D. Warren Paper Co. **PRINCIPAL TYPE** Bodoni **DIMENSIONS** 8.5 × 11 in. (21.6 × 27.9 cm)

BRILLIANCE

can display even an ordinary subject in a whole new light...like incandescent apples, by the bushel. To transmit your message brilliantly, without glare, we recommend S. D. Warren Cameo Dull.

**TRADE ADVERTISEMENT**
**DESIGN** *Cheryl Heller* **TYPOGRAPHIC SUPPLIER** *Typographic House* **AGENCY** *HBM/Creamer Advertising, Inc.* **STUDIO** *HBM Design Group*
**CLIENT** *S.D. Warren Paper Co.* **PRINCIPAL TYPE** *Bodoni* **DIMENSIONS** *8.5 × 11 in. (21.6 × 27.9 cm)*

HOLDOUT

is a protective screen keeping out un-
wanted elements. To maintain the sharpness
and intensity of your printed impres-
sion, we suggest the outstanding ink hold-
out qualities of S. D. Warren Cameo Dull.

**TRADE ADVERTISEMENT**
**DESIGN** *Cheryl Heller* **TYPOGRAPHIC SUPPLIER** *Typographic House* **AGENCY** *HBM/Creamer Advertising, Inc.* **STUDIO** *HBM Design Group*
**CLIENT** *S.D. Warren Paper Co.* **PRINCIPAL TYPE** *Bodoni* **DIMENSIONS** *8.5 × 11 in. (21.6 × 27.9 cm)*

**EDITORIAL**
**DESIGN** *Bob Farber* **TYPOGRAPHIC SUPPLIER** *Photo-Lettering, Inc.* **STUDIO** *ITC* **CLIENT** *U&lc* **PRINCIPAL TYPE** *ITC Benguiat Condensed*
**DIMENSIONS** *11 × 14.8 in. (28 × 37.5 cm)*

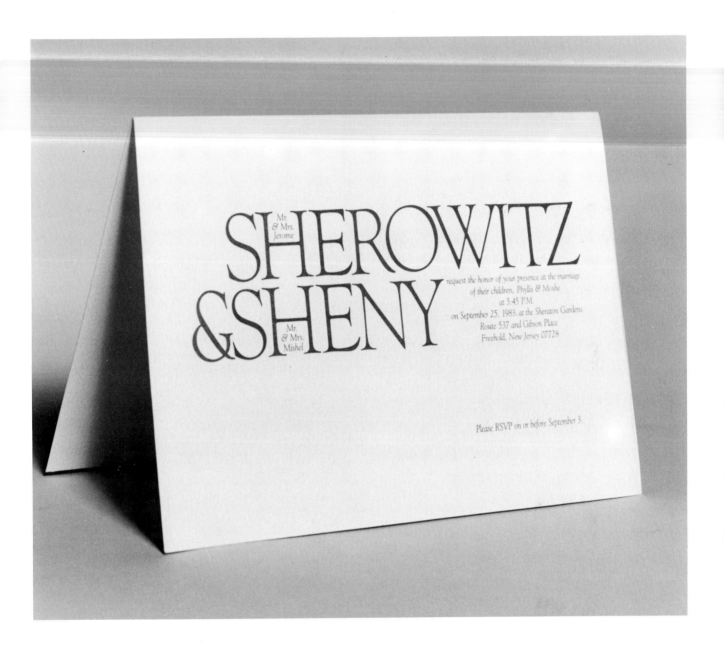

**INVITATION**
**DESIGN** Phyllis J. Sherowitz/David Brier  **CALLIGRAPHER** David Brier  **TYPOGRAPHIC SUPPLIER** All-American/Photo-Lettering, Inc./Arnold & Debel
**AGENCY** Brier Sherowitz Design Associates  **STUDIO** Brier Sherowitz Design Associates  **CLIENT** Phyllis & Moshe Sheny
**PRINCIPAL TYPE** WTC Goudy Light & Old Style  **DIMENSIONS** 5.3 × 7.8 in. (13.3 × 19.8 cm)

CHURCH SERVICES

TENNIS & GOLF

ATTENDEES

SCHEDULE

NBC TELEVISION AFFILIATES BOARD OF DIRECTORS MEETING MAUI HAWAII 1983

**PACKAGING**
**DESIGN** *Charles Blake* **CALLIGRAPHER** *Tom Carnase* **TYPOGRAPHIC SUPPLIER** *Pro-Type* **CLIENT** *NBC Affiliate Relations*
**PRINCIPAL TYPE** *Andrich Minerva* **DIMENSIONS** *8.5 × 11.5 in. (21.6 × 29.2 cm)*

L I F E   F L I G H T

A   F I F T H   A N N I V E R S A R Y   R E P O R T

**The Evolution of Helicopter EMS**

The beginning of formal ambulance transport can be pinpointed in the Napoleonic Wars, when Frenchman Dominique Jean Larrey specially designed a horse-drawn wagon to evacuate wounded soldiers. Much of the progress of emergency services has occurred in the military, where large numbers of injured people must be cared for quickly.

Statistics from the period around World War II show that for every 100 battle casualties there were 4.5 fatalities. This period saw the first use of air transport of the injured, primarily by airplane.

The system of care that EMS is modeled after evolved during the Korean conflict. In this rudimentary system, care was brought directly to the wounded soldier in the battlefield, followed by rapid evacuation to a mobile army surgical hospital (MASH) unit. From there, soldiers could be transported to specialty care facilities as far away as the United States.

By the Vietnam War era, a sophisticated system of immediate care, evacuation and rapid transport to specialty care units had reduced fatalities to 0.5 per 100 battlefield casualties. Recently, a research study showed that only half of those trauma patients transported by helicopter who were expected to die actually expired.

In the fall of 1978, this successful military model was instituted in Pittsburgh as Life Flight, the regional emergency medical helicopter transportation program. Only eight similar helicopter programs were in existence throughout America at that time. There are now 53.

As medical care matures and becomes more sophisticated, so too does Pittsburgh's Life Flight.

**Five Years of Service to the Region**

**1978**
Life Flight is inaugurated in the autumn at Allegheny General Hospital, in cooperation with the Emergency Medical Service Institute, for the purpose of transporting critically ill and injured patients to specialty hospitals, as well as to other medical facilities within a 130 air mile radius of Pittsburgh.

In late 1978, the Life Flight crew conducts its first of many scene runs — a motor vehicle accident in Robinson Township.

With a flight crew, dispatchers and one helicopter based at Allegheny's helipad, 105 flights were recorded during the first four months of operation.

**1979**

The first hospital-based helicopter transportation program to be instituted in the northeastern United States, Life Flight exceeds all expectations for medical transport. With 9 flight nurses, 2 pilots and 3 dispatchers, 389 flights are recorded, more than half of which involved transferring patients to regional referral institutions other than Allegheny General Hospital.

Radio communications for Life Flight and Allegheny General Hospital are enhanced by the installation of new hardware at the WPXI-TV transmitting station on North Side.

By the end of 1979, Life Flight averages 33 flights per month.

**1980**
The initial start-up work in getting a helicopter program "off the ground" is completed. A regional approach to providing emergency medical transport begins to take root in the area, with increasing numbers of flights going to places other than the City of Pittsburgh.

Fixed-wing airplane services, as a limited capacity, are added to Life Flight's capabilities.

Several large industries write Life Flight agreements into their medical evacuation plans in the event of an industrial accident or disaster. An agreement is reached with the Pennsylvania Turnpike Commission for Life Flight to cover the western 100 miles of the Turnpike for the evacuation of serious motor vehicle accident victims from that roadway.

Monthly flights now average 53 and growing.

**1981**
Life Flight expands. A second helicopter is leased from Rocky Mountain Helicopters, Inc., and based at Allegheny County Airport to accommodate steady increases in flight requests. By this time, monthly flight averages have jumped to 93 and staffing has doubled.

Life Flight enters into an agreement with the Organ Procurement Foundation at the University of Pittsburgh for transporting donated organs and surgical teams to transplant centers.

Life Flight's Regional Advisory Committee, comprised of administrative and medical staff representatives from several area hospitals and agencies, is formed as a consulting body for the program.

**1982**
Fixed-wing, airplane services are expanded to accommodate flight requests during inclement weather and for distances beyond the 130 mile radius. Access to three types of aircraft, including a Lear Jet, is now available. Effective service range now includes the eastern half of the United States and Canada.

Life Flight's educational and safety programs, in cooperation with area hospitals and ambulance/rescue services and industries, continues to grow with frequent visits to facilities within a 60-mile radius of Pittsburgh.

Monthly flight average jumps to 116.

**1983**
The Allegheny General Hospital helipad is upgraded and expanded so that all helicopter operations are centralized in one location. On-site fueling is included in the upgrading, thus eliminating additional trips to County Airport for fueling and crew change. This improvement helps contain program costs and keeps response time to a minimum. New fire suppression units are added to enhance safety on the helipad.

Rocky Mountain Helicopters, Inc. provides Life Flight with a third helicopter, to be used as a back-up service during the busy summer months. Provided on an "as used" basis, the third ship supplies a cost-effective means of meeting escalating demands for service. A record number of flights is recorded in August with 174 missions.

Life Flight continues to grow, with monthly flight averages now at 127.

**BROCHURE**
**DESIGN** Rick Landesberg  **TYPOGRAPHIC SUPPLIER** Superior Litho, Inc.  **STUDIO** Rick Landesberg Communication Design, Inc.
**CLIENT** Life Flight/Allegheny General Hospital  **PRINCIPAL TYPE** Memphis Extra Bold/Bembo  **DIMENSIONS** 8.5 × 11 in. (22 × 28 cm)

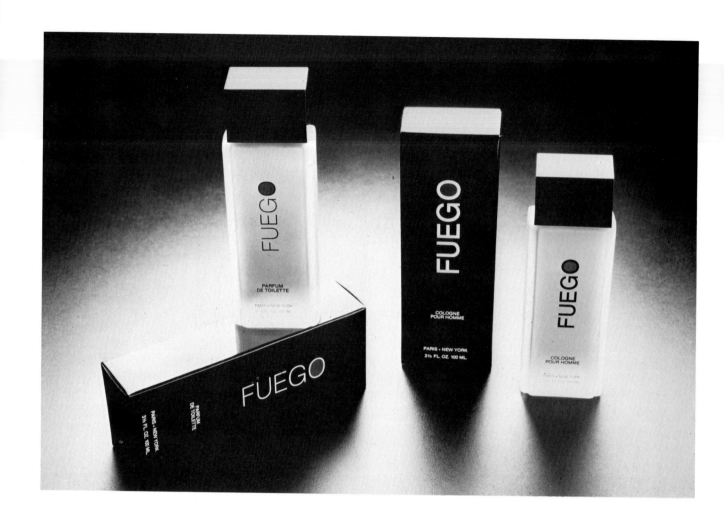

**PACKAGING**
**DESIGN** *Patrick Florville* **TYPOGRAPHIC SUPPLIER** *Mar-X Myles Graphics* **AGENCY** *Florville Design & Analysis* **STUDIO** *Florville Design & Analysis*
**CLIENT** *Fuego Cosmetics Inc.* **PRINCIPAL TYPE** *Helvetica Light & Bold* **DIMENSIONS** *4.8 × 1.2 × 1.8 in. (12 × 3 × 4.5 cm)*

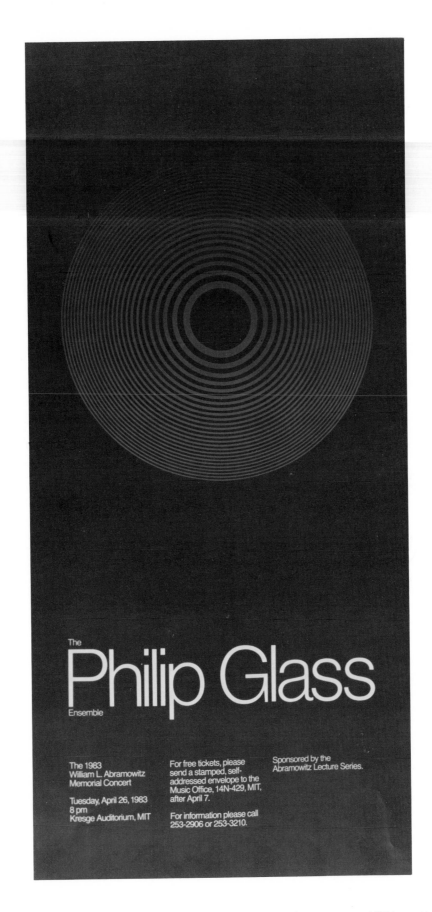

POSTER
**DESIGN** *Ralph Coburn* **TYPOGRAPHIC SUPPLIER** *Typographic House* **STUDIO** *MIT Design Services* **CLIENT** *MIT Humanities Department*
**PRINCIPAL TYPE** *Helvetica* **DIMENSIONS** *15 × 32 in. (38 × 81 cm)*

**BROCHURE**
**DESIGN** *David Baker/Scott Hueting* **TYPOGRAPHIC SUPPLIER** *National Typographers, Inc.* **STUDIO** *Hellmuth, Obata & Kassabaum*
**CLIENT** *Boldt Development Corp.* **PRINCIPAL TYPE** *Century Old Style* **DIMENSIONS** *8.8 × 11.1 in. (22.2 × 28.3 cm)*

The best
locations are born.
Then made.

Trefoil Park.
Your move.

No amount of effort by man can
match the splendor of nature's
work. One can only strive to
maintain it. That may seem an
unusual statement for a devel-
oper. Until you realize the unique
character of Trefoil Park.

Trefoil Park, over 200 acres in
Trumbull, Connecticut, is situat-
ed on what most predict will be
the next center of prestigious
corporate office development
in Fairfield County. Trefoil Park
will not only satisfy the aesthetic
demands of the most exacting
corporate clients, but also their
more practical needs as well.

Excellent personal transportation
facilities, on both land and sea,
are matched by equally good
freight services. There is ready
access to all urban support facili-
ties, a large pool of skilled labor
and all the necessary amenities.
Aside from Trumbull itself,
Trefoil Park is close to some of
the most coveted residential
communities in the state of
Connecticut.
One more reason to make Trefoil
Park your move.

Trefoil Development Company
500 Sylvan Avenue
Bridgeport Connecticut 06606
203 372 1200

**ADVERTISING**
**DESIGN** *Frank C. Lionetti/Diane McNamme/Ciaran McCabe* **TYPOGRAPHIC SUPPLIER** *Southern New England Typesetting*
**STUDIO** *Frank C. Lionetti Design* **CLIENT** *Trefoil Development Company* **PRINCIPAL TYPE** *Frutiger* **DIMENSIONS** *16.5 × 11 in. (41.9 × 27.9 cm)*

# CITIZENS FOR AMERICA

**PORTFOLIO**
**DESIGN** Doug Stroup  **TYPOGRAPHIC SUPPLIER** Unicomp  **STUDIO** Doug Stroup Associates  **CLIENT** Citizens For America
**PRINCIPAL TYPE** Modern #20  **DIMENSIONS** 8.8 × 11.8 in. (22 × 30 cm)

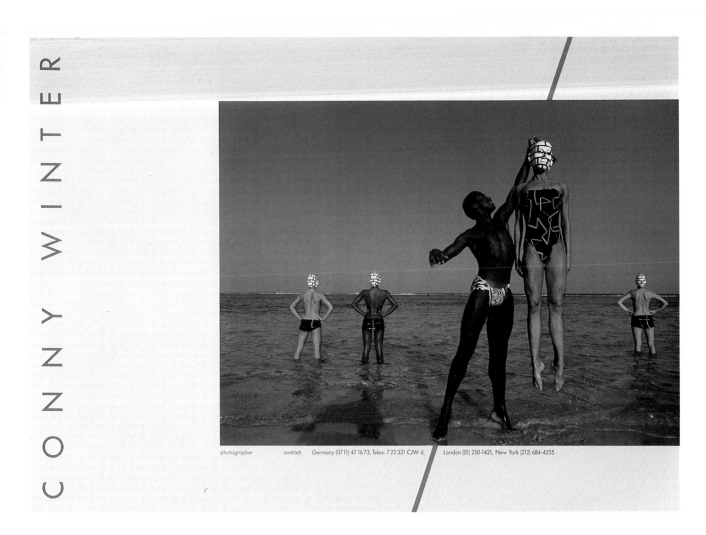

photographer     contact:     Germany (0711) 47 16 73, Telex: 7 22 331 CJW d,     London (01) 250-1421, New York (212) 684-4255

**POSTER**
**DESIGN** Conny J. Winter **TYPOGRAPHIC SUPPLIER** Stulle Layoutsatz **STUDIO** Studio Conny J. Winter **CLIENT** Studio Conny J. Winter
**PRINCIPAL TYPE** Futura Buch **DIMENSIONS** 13.4 × 18.7 in. (34 × 47.5 cm)

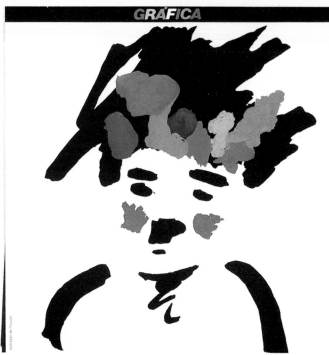

Gráfica é uma revista de fazer
inveja às melhores publicações
estrangeiras. Nela você encontra
tudo sobre estúdios, fotógrafos,
ilustradores, diretores de tipos,
designers e diretores de arte. Do
Brasil e do mundo.
    Em cada uma das áreas
acima, Gráfica mostra, no mínimo,
o trabalho de um artista brasileiro.
E a cada profissional estrangeiro
entra um brasileiro da mesma
especialidade.
    A revista publica também,
pela primeira vez na América do
Sul, artigos em portfólio
apresentando o artista
individualmente. Suas obras, sua
visão da arte, sua filosofia de
trabalho. Tudo como você se
acostumou a ver em Graphis, CA,
Print e Idea.
    O formato é uma loucura:
27×26, com 100 páginas, 12
profissionais representados e
textos em português e inglês.
Circulação trimestral. No número
de dezembro, Gráfica vai trazer
tudo sobre "Gráfia", a mostra
internacional de artes tipográficas,
ilustração e editorial.

Agências e estúdios também
têm seu espaço, mas sem aquele
bla-bla-bla de número de
funcionários, faturamento, anos de
trabalho ou quantidade de prêmios.
O que importa é a qualidade
gráfica, o talento, a inovação.
    Os resultados dos concursos
do Clube de Criação de São Paulo,
os premiados no salão do Clube
dos Ilustradores do Brasil, Type
Directors Club de Nova Iorque e da
Society Publication Designers
também estão em Gráfica. Tudo
em primeira mão.
    Gráfica. A primeira revista
brasileira de comunicação visual
com padrão internacional.
    Faça já sua assinatura. Você
merece uma revista assim.

**FOLDER**
**DESIGN** Oswaldo Miranda  **CALLIGRAPHER** Oswaldo Miranda/Tim Girvin  **TYPOGRAPHIC SUPPLIER** Typograph  **STUDIO** Miran Studio
**CLIENT** Gráfica Magazine  **PRINCIPAL TYPE** Garamond Italic/Helvetica Bold  **DIMENSIONS** 70.2 × 10.5 in. (26 × 27 cm)

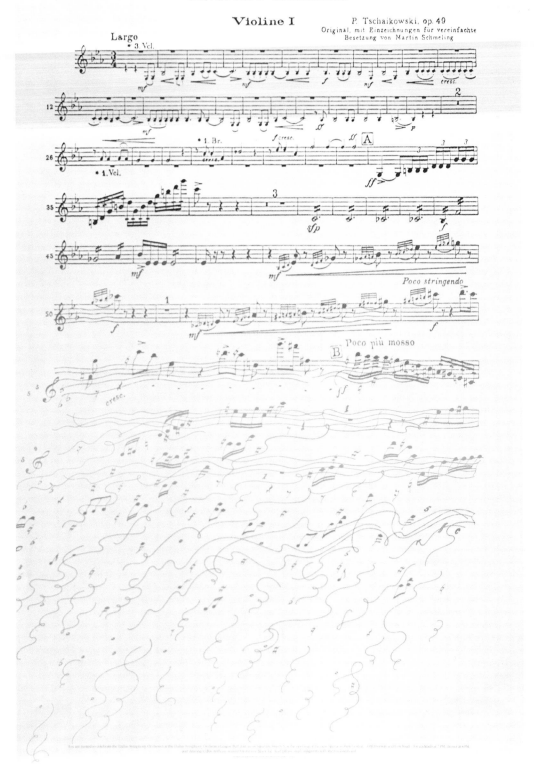

**POSTER**
**DESIGN** Brian Boyd **TYPOGRAPHIC SUPPLIER** Chiles & Chiles **AGENCY** The Richards Group **STUDIO** Richards, Sullivan, Brock & Associates
**CLIENT** Dallas Symphony Orchestra League **PRINCIPAL TYPE** Garamond Light Italic **DIMENSIONS** 22 × 34.5 in. (55.8 × 87.6 cm)

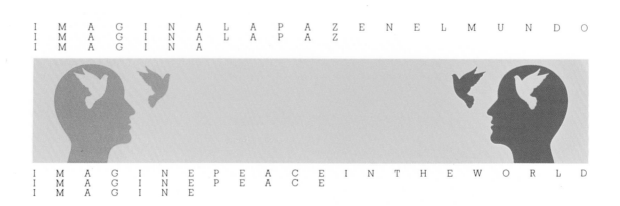

```
I  M  A  G  I  N  A  L  A  P  A  Z  E  N  E  L  M  U  N  D  O
I  M  A  G  I  N  N  A  L  A  P  A  Z
I  M  A  G  I  N  A
```

```
I  M  A  G  I  N  E  P  E  A  C  E  I  N  T  H  E  W  O  R  L  D
I  M  A  G  I  N  E  P  E  A  C  E
I  M  A  G  I  N  E
```

**POSTER**
**DESIGN** Fernando Medina **TYPOGRAPHIC SUPPLIER** Letra Madrid **AGENCY** Fernando Medina Design **STUDIO** Fernando Medina Design
**CLIENT** Fernando Medina **PRINCIPAL TYPE** Rockwell Light **DIMENSIONS** 36 × 20 in. (91.4 × 50.8 cm)

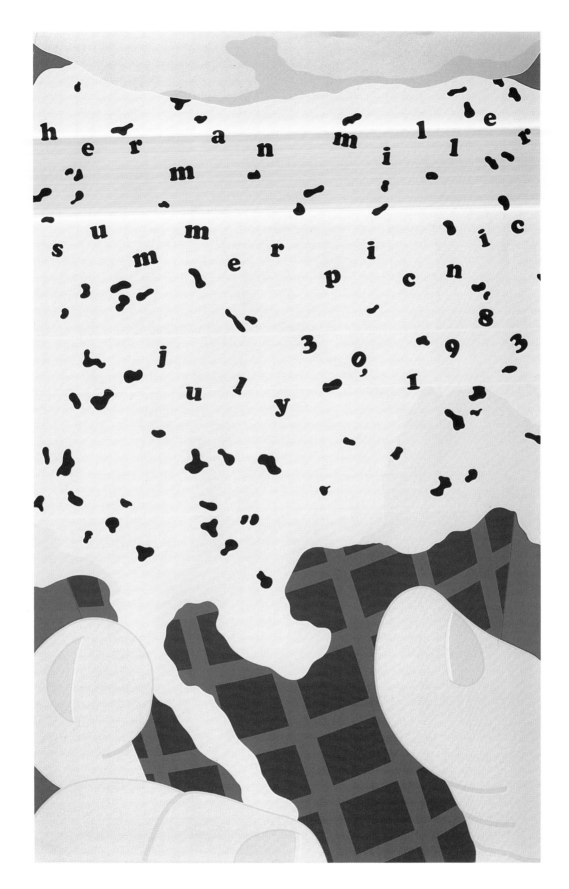

**POSTER**
**DESIGN** *Stephen Frykholm* **TYPOGRAPHIC SUPPLIER** *Type House* **CLIENT** *Herman Miller, Inc.* **PRINCIPAL TYPE** *Cooper Black*
**DIMENSIONS** *25 × 39.5 in. (63.5 × 100.3 cm)*

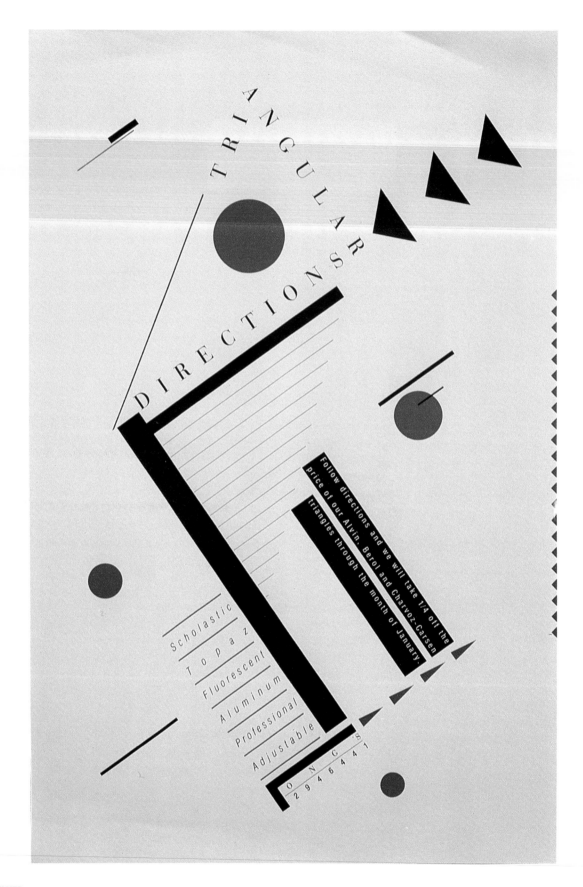

**SALES FLYER**
**DESIGN** John Weber **TYPOGRAPHIC SUPPLIER** Dwight Yaeger Typographers **STUDIO** One-B-Design **CLIENT** Long's Commercial Art Supply
**PRINCIPAL TYPE** Bauer Bodoni/Helvetica **DIMENSIONS** 8.5 × 13 in. (22 × 33 cm)

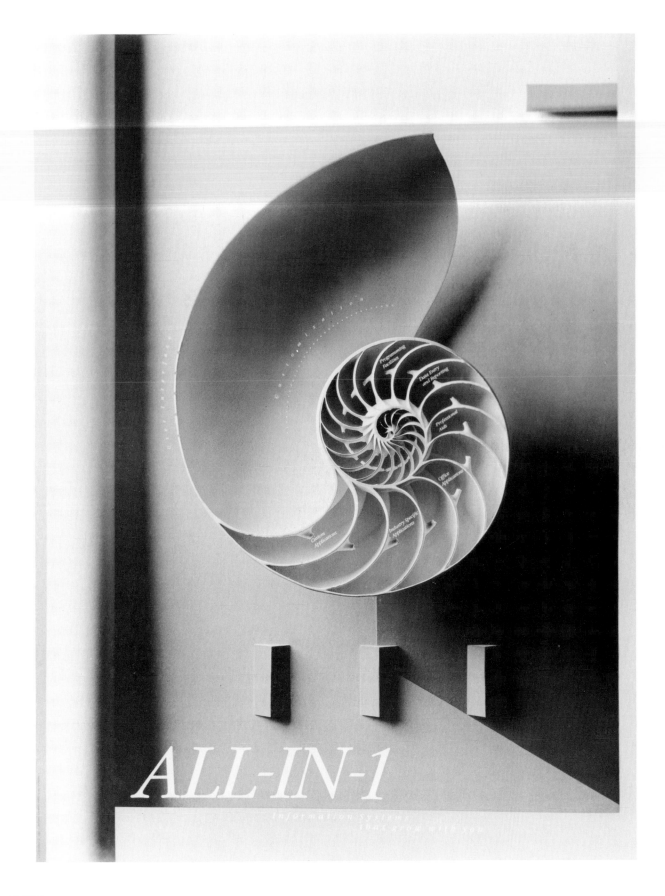

**POSTER**
**DESIGN** *Nancy Skolos* **TYPOGRAPHIC SUPPLIER** *Wrightson Typographers* **AGENCY** *Innovision* **STUDIO** *Skolos, Wedell & Raynor*
**CLIENT** *Digital Equipment Corp.* **PRINCIPAL TYPE** *Garamond* **DIMENSIONS** *24 × 32 in. (61 × 81.3 cm)*

POSTER
**DESIGN** Olaf Leu **TYPOGRAPHIC SUPPLIER** Christian Grützmacher GmbH **STUDIO** Olaf Leu Design & Partner
**CLIENT** Marktex Wohnen Kronberg **PRINCIPAL TYPE** Bodoni/Univers Italic **DIMENSIONS** 33.1 × 46.8 (84.1 × 118.9 cm)

**PEAT
MARWICK
INTERNATIONAL**

ANNUAL
REVIEW
1983

**ANNUAL REPORT**
**DESIGN** *Peter Harrison/Susan Hochbaum* **TYPOGRAPHIC SUPPLIER** *Peat Marwick International* **STUDIO** *Pentagram Design Ltd.*
**CLIENT** *Peat Marwick International* **PRINCIPAL TYPE** *Sabon* **DIMENSIONS** *11.8 × 8.3 in. (30 × 21 cm)*

It did not take long after the Mag-T™ bow was introduced for archers to see how well designed a bow it is. In fact, it's about as perfect a hunting bow as can be built. It's short, thanks to the short magnesium riser and laminated eastern maple limbs. The mag riser also makes the Mag-T very light to carry.

The ease of handling this short, light bow in the brush or in a tree is sensational. It's even more impressive when you discover it shoots as fast as a

accuracy plus practically unlimited adjustability with six different draw lengths and draw weights for each bow.

The durable, weight-relieved metal eccentrics provide maximum reliability with minimum weight. Remember that the lighter the eccentric wheels, the faster your bow, and the more accurately you will shoot.

The Mag-T limb design has a butt wedge to provide limb rigidity while the field-proven tip hangars offer outstanding durability and are maintenance-free. These features work together to

DRAW LENGTHS (Traditional)
AND DRAW WEIGHTS

| 25" | 26" | 27" | 28" |
|---|---|---|---|
| 40/65 | 45/60 | 50/65 | 50/65 |
| 30/55 | 35/50 | 40/55 | 45/60 |

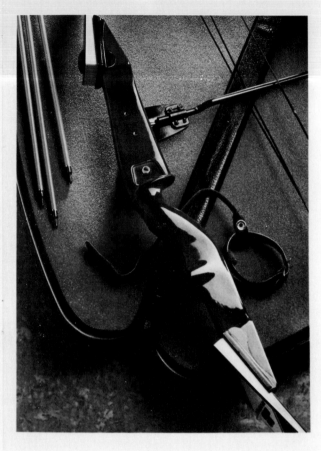

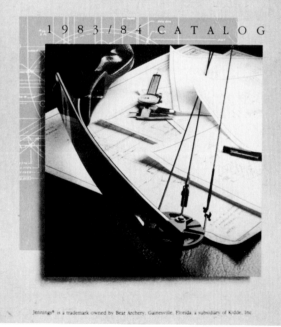

JENNINGS®
COMPOUND BOWS

A TRADITION OF TECHNOLOGY

1983/84 CATALOG

Jennings® is a trademark owned by Bear Archery, Gainesville, Florida, a subsidiary of Kidde, Inc.

**CATALOG**
**DESIGN** *Cris Dawson/Bill Maddox* **TYPOGRAPHIC SUPPLIER** *Tin Roof* **AGENCY** *Cris Dawson/Design* **STUDIO** *Cris Dawson/Design*
**CLIENT** *Bear Archery* **PRINCIPAL TYPE** *Garamond Light* **DIMENSIONS** *5.5 × 8.5 in. (14 × 22 cm)*

THE TORONTO-DOMINION BANK

128th Annual Report
1983

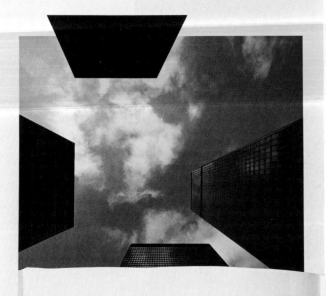

Combining the resources of the Corporate Banking Division's forest products group and TD's International Banking Group was the key to successful financing of a major international take-over last year.

The buyer was Fletcher Challenge Limited, New Zealand's largest and most diversified company. Fletcher's acquisition was Crown Zellerbach Canada Limited (now Crown Forest Industries Ltd.), one of the leading forest products companies in British Columbia.

In purchasing Crown from the B.C. company's American parent, Fletcher made its most significant overseas investment to date and gained one of the most modern forestry operations in the world.

For both companies, the move should prove beneficial. Each has expertise to offer the other in the production of newsprint and chemical pulp, resource development, silviculture, and management. Both stand to gain from the cross fertilization of people and ideas. Together, they should be able to strengthen their presence in Pacific Rim markets and increase their exports.

Financing the move was an intricate process. Currency transactions were complicated and negotiations spanned thousands of miles and extended to North American and New Zealand banks, Canadian and New Zealand governments and Fletcher's intermediate holding companies in the Netherlands, Hong Kong and the Bahamas.

Toronto Dominion arranged and led a syndicated loan for the take-over, with financing involving a number of Canadian and American banks.

Through its pivotal role in the financing and its ongoing administration of the loan package, TD has become one of Fletcher's major international banks, and has entered into an expanded banking relationship with Crown.

Working closely with the Corporate Banking Division and the Foreign Exchange group on the project was a new TD operation—the Merchant Banking Services Group.

Established last year, the Merchant Banking Group is primarily responsible for extending loan syndication services to domestic and foreign customers.

The loan syndication market has been developing rapidly here in Canada. Many larger Canadian companies have been expanding their banking relationships to meet the more varied needs of today's capital markets. Toronto Dominion is providing syndication service in response to these demands. From the point of view of the banks involved, syndication is an attractive service, as it spreads the lenders' loan exposure to single large companies.

In addition to negotiating syndications, the new group is monitoring trends and developments in the merchant banking field and in international capital markets, with a view to offering other products and services that may suit customers' changing needs.

As the world of international finance becomes increasingly complex, Toronto Dominion must continue to develop flexible and imaginative financing structures of the kind that helped Fletcher Challenge invest in the development of Canadian resources.

State of the art equipment and techniques have made Crown Forest Industries' plant in Campbell River, B.C. one of the most advanced pulp and newsprint production facilities in the world.

Roland Cardy and Michael Freeman of the Corporate Banking Division discuss Fletcher Challenge's venture in TD's trading room with Fletcher Treasurer Bruce Cooper (centre).

John Langley, Assistant General Manager, Merchant Banking Services, helped shape the loan syndication package behind Fletcher's acquisition of Crown Zellerbach.

"Flexibility and imagination are essential ingredients for service in the international sphere, because pre-packaged financing rarely fits."

John Langley
Assistant General Manager
Merchant Banking Services

12

13

**ANNUAL REPORT**
**DESIGN** *Roslyn Eskind* **TYPOGRAPHIC SUPPLIER** *Cooper & Beatty Ltd.* **STUDIO** *Eskind Waddell* **CLIENT** *The Toronto-Dominion Bank*
**PRINCIPAL TYPE** *Univers* **DIMENSIONS** *8.3 × 11.7 in. (21 × 29.7 cm)*

**CATALOG**
**DESIGN** Brad Copeland **TYPOGRAPHIC SUPPLIER** Swift Tom **STUDIO** Cooper-Copeland, Inc. **CLIENT** Habersham Plantation, Inc.
**PRINCIPAL TYPE** Garamond Book Condensed **DIMENSIONS** 10.3 × 14 in. (26 × 35.6 cm)

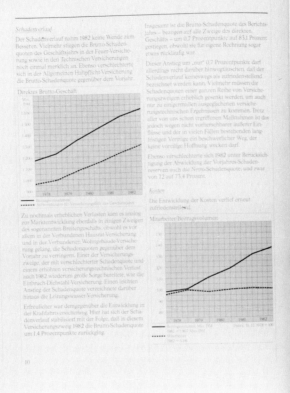

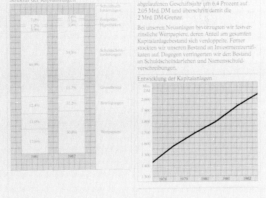

ANNUAL REPORT
**DESIGN** *Fritz Hofrichter/Olaf Leu* **TYPOGRAPHIC SUPPLIER** *Paul-Types* **STUDIO** *Olaf Leu Design & Partner* **CLIENT** *Colonia Versicherung AG*
**PRINCIPAL TYPE** *Life Antigua* **DIMENSIONS** *8.3 × 11.7 in. (21 × 29.7 cm)*

Management
Compensation:
The Carrot
is Mightier
than
the
Stick

Rollins Burdick Hunter Management Compensation Group

**BROCHURE**
**DESIGN** *Paul Scherfling* **TYPOGRAPHIC SUPPLIER** *Typographic Arts* **AGENCY** *Burson • Marsteller* **STUDIO** *Burson • Marsteller*
**CLIENT** *Rollins Burdick Hunter* **PRINCIPAL TYPE** *Garamond* **DIMENSIONS** *6.3 × 10 in. (16 × 25.5 cm)*

# People Technology

New York Stock Exchange
Annual Report 1982

**ANNUAL REPORT**
**DESIGN** Eugene J. Grossman/Richard Felton **TYPOGRAPHIC SUPPLIER** Print + Design Typography, Inc. **AGENCY** Anspach Grossman Portugal
**CLIENT** New York Stock Exchange **PRINCIPAL TYPE** Univers 57/Bodoni **DIMENSIONS** 8.3 × 11.8 in. (21 × 30 cm)

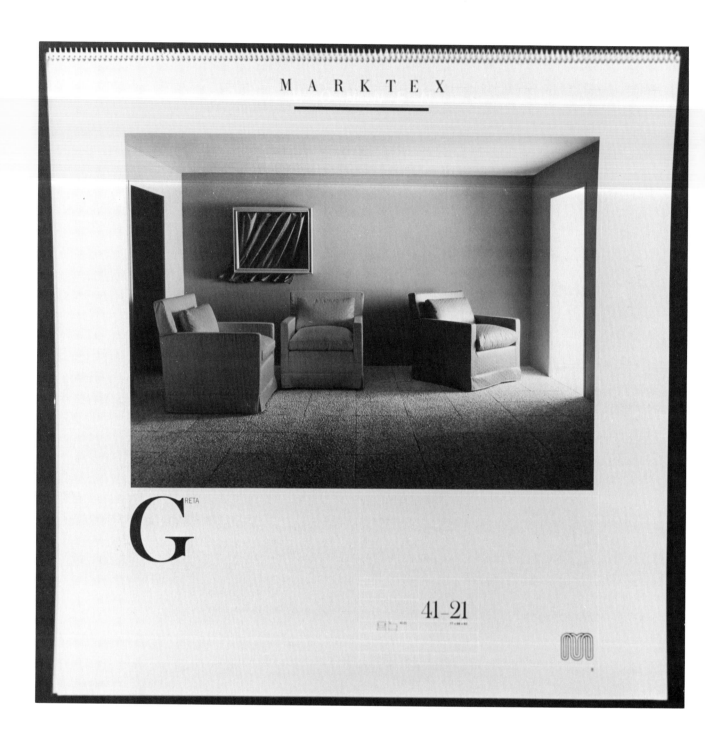

**MAGAZINE**
**DESIGN** *Olaf Leu* **TYPOGRAPHIC SUPPLIER** *Christian Grützmacher GmbH* **STUDIO** *Olaf Leu Design & Partner*
**CLIENT** *Marktex Wohnen Kronberg* **PRINCIPAL TYPE** *Baskerville Old Face/Univers* **DIMENSIONS** *23.4 × 23.4 in. (59.5 × 59.5 cm)*

# IMAGE

Volume 26 No. 3

**MAGAZINE**
**DESIGN** Robert Meyer/Julia Wyant **TYPOGRAPHIC SUPPLIER** Rochester Mono/Headliners **STUDIO** Robert Meyer Design, Inc.
**CLIENT** International Museum of Photography at George Eastman House **PRINCIPAL TYPE** Helvetica/Helvetica Condensed/Baskerville
**DIMENSIONS** 8.5 × 11 in. (22 × 28 cm)

# DEANGELIS

LOGOTYPE
**DESIGN** Olaf Leu **CALLIGRAPHER** Hans Frydrychowski **STUDIO** Olaf Leu Design & Partner **CLIENT** De Angelis **PRINCIPAL TYPE** Bodoni

Along time ago in the land of taxes, there was a travelling philanthropist named Hugh. Throughout his journies, Hugh came across the grizzly sight of people in need. From infants to elderly folks. ♥ So Hugh waged a war on all the bad things in life. He spread his wealth and warmth among more than 70 different battalions. He declared that people who gave of their own wealth could live much easier in the land of taxes. ♥ And for his kind efforts, Hugh was knighted "Lord of the Way". But there is more to our fair retale than a happy ending. There is a happier beginning. ♥ And thanks to Hugh and you it works for all of us. The Hugh Knighted Way. The heart of San Antonio.

United Way

Take heart. Give the United Way.

Creative Team: Lyle Bunch, Janis Koy, Dan Paulsick, Doug Rucker

---

**NEWSPAPER ADVERTISEMENT**
**DESIGN** *Janis Koy* **TYPOGRAPHIC SUPPLIER** *ProType of San Antonio* **STUDIO** *Koy Design, Inc.* **CLIENT** *United Way of San Antonio*
**PRINCIPAL TYPE** *Walbaum* **DIMENSIONS** *12 × 17 in. (30.5 × 43.2 cm)*

**BROCHURE**
**DESIGN** *Hermann Rapp* **TYPOGRAPHIC SUPPLIER** *Nagel Fototype* **CLIENT** *Bölling GmbH & Co. KG, Offizin für Prägedruck*
**PRINCIPAL TYPE** *Pontifex* **DIMENSIONS** *7.4 × 11.7 in. (18.7 × 29.6 cm)*

**BOOKLET**
**DESIGN** *Karlheinz Bölling* **TYPOGRAPHIC SUPPLIER** *Bölling GmbH & Co. KG.* **CLIENT** *Bölling GmbH & Co. KG, Offizin für Prägedruck*
**PRINCIPAL TYPE** *Helvetica Light/Clarendon Kursive* **DIMENSIONS** *5.8 × 8.6 in. (14.8 × 22 cm)*

**MAGAZINE ILLUSTRATION**
**DESIGN** *Guy Schum* **AGENCY** *Council for Advancement and Support of Education* **STUDIO** *Schum & Stober Design*
**DIMENSIONS** *7.3 × 11.3 in. (18.4 × 28.6 cm)*

SINN IN
WORT UND DING,
LAUT UND ZEICHEN:

*Rainer Maria Rilke*

Ich fürchte mich so vor der Menschen Wort.
Sie sprechen alles so deutlich aus:
Und dieses heißt Hund und jenes heißt Haus,
und hier ist Beginn, und das Ende ist dort.

Mich bangt auch ihr Sinn, ihr Spiel mit dem Spott,
sie wissen alles, was wird und war;
kein Berg ist ihnen mehr wunderbar;
ihr Garten und Gut grenzt grade an Gott.

Ich will immer warnen und wehren: Bleibt fern.
Die Dinge singen hör ich so gern.
Ihr rührt sie an: sie sind starr und stumm.
Ihr bringt mir alle die Dinge um.

*Herzliche Festtagsgrüße
verbunden mit den besten Wünschen
für das Jahr 1984
Bölling Prägedrucksachen · Bad Soden-Neuenhain*

**BROCHURE**
**DESIGN** *Hermann Rapp* **TYPOGRAPHIC SUPPLIER** *Schumacher-Gebler* **CLIENT** *Bölling GmbH & Co. KG, Offizin für Prägedruck*
**PRINCIPAL TYPE** *Poliphilus (Monotype)* **DIMENSIONS** *7.4 × 11.6 in. (19 × 29.6 cm)*

MERCANTILE

NATIONAL

BANK

AT

DALLAS

ANNUAL

REPORT

1982

**ANNUAL REPORT**
**DESIGN** *Dick Mitchell* **TYPOGRAPHIC SUPPLIER** *Chiles & Chiles* **AGENCY** *The Richards Group* **STUDIO** *Richards, Brock, Miller, Mitchell & Associates*
**CLIENT** *Mercantile Bank* **PRINCIPAL TYPE** *Palatino* **DIMENSIONS** *7.5 × 10.8 in. (19.1 × 27.3 cm)*

**BOOK**
**DESIGN** *Deborah Jay/Michael Mendelsohn* **CALLIGRAPHER** *Jeanne Greco* **TYPOGRAPHIC SUPPLIER** *York Graphics Services*
**CLIENT** *The Franklin Library* **PRINCIPAL TYPE** *Plantin* **DIMENSIONS** *6.2 × 9 in. (15.8 × 22.8 cm)*

**BOOK**
**DESIGN** *Susan Hood/Michael Mendelsohn* **ILLUSTRATOR** *Harry Pincus* **TYPOGRAPHIC SUPPLIER** *Progressive Typographers*
**CLIENT** *The Franklin Library* **PRINCIPAL TYPE** *Baskerville* **DIMENSIONS** *5.9 × 8.8 in. (15 × 22.4 cm)*

ood design is much more th[an]
visual appeal. At its best, it is a problem-solving process that starts by definin[g]
goals, exploring alternative strategies, selecting the right one, implementing [it,]
refining it, and following it through production to a successful completio[n.]
Viewed in this way, design is a practical extension of a company's everyday bu[si]
ness activities. While it depends on creativity, imagination, and innovation, desig[n]
is still a reasoned, manageable process that leads to measurable results. An effe[c]
tive design must capture the essential features that set a company apart from it[s]
competitors, and translate these into arresting visual forms and images. When
this happens, the uniqueness of a company is captured in the uniqueness of a
design. That's the point at which good design begins to work. ☐ Our busines[s]
philosophy is based on a dual commitment to quality and service. We believe it i[s]
false economy to aim for less than excellence. At the same time, our commitment
to service is a recognition of the realities of business: design must be accom-
plished within a framework of budgets and schedules. ☐ Our insistence on quality
and service is carried into every design effort. For small companies or large, for
established organizations and those just starting, for one-time design projects or
continuing, multi-faceted programs—our fundamental commitment to quality
and service remains unchanged. The ability to combine both, without compro-
mising either, makes Gunn Associates exceptional.

GUNN ASSOCIATES IN PERSPECTIV[E]

**BROCHURE**
**DESIGN** David A. Lizotte  **TYPOGRAPHIC SUPPLIER** Typographic House  **CLIENT** Gunn Associates  **PRINCIPAL TYPE** Galliard
**DIMENSIONS** 8.8 × 13 in. (22.2 × 33 cm)

*Selections From The*
*Miller-Plummer Collection Of Photography*

International Museum of Photography at George Eastman House

**CATALOG**
**DESIGN** *Robert Meyer/Julia Wyant* **TYPOGRAPHIC SUPPLIER** *Rochester Mono/Headliners* **STUDIO** *Robert Meyer Design, Inc.*
**CLIENT** *International Museum of Photography at George Eastman House* **PRINCIPAL TYPE** *Sabon* **DIMENSIONS** *8.5 × 11 in. (22 × 28 cm)*

**POSTER**
**DESIGN** *Andreé Cordella* **TYPOGRAPHIC SUPPLIER** *Typographic House* **STUDIO** *Gunn Associates* **CLIENT** *InSpeech, Inc.*
**PRINCIPAL TYPE** *Bank Script/ITC Garamond Light Condensed* **DIMENSIONS** *24 × 36 in. (60.9 × 91.4 cm)*

BIBER                 SCHILDKRÖTE

ORION                            MUSCHEL

KÜRBIS

## COYOTE

BLAUVOGEL

WAPITI   MAIS                       WOLKE

MOND            ULME

FROSCH             RABE

AHORN

KREBS

## GRIZZLY                 BISON

ELSTER                       MOSKITO

ABENDSTERN   PLEJADEN         STACHELSCHWEIN

## ADLER    UHU

BOHNE                WIESEL

TABAK                   SPECHT

ELCH             WOLF    ROTZEDER

ROHRKOLBEN

ENTE

TLINGIT HEIDA TSIMSHIAN ATHABASCAN CHIPPEWA NASKAPI
SITKA BELLA COOLA COWLITZ CREE ALGONQUIN MICMAC
NISKA SHUSWAP SARSI HURON PENOBSCOT PASSAMAQUODDY
KWAKIUTL SALISH BLACKFOOT CREE OTTAWA MOHAWK ABNAKI
NOOTKA COMOX LILLOET PIEGAN ASSINIBOIN OJIBWAY MOHEGAN
MAKAH COWICHAN KUTENAI GROS VENTRE MENOMINEE IROQUOIS
SKOKOMISH KLIKITAT COEUR D'ALENE HIDATSA SENECA DELAWARE
CHINOOK FLATHEAD MANDAN SISSETON WINNEBAGO ONEIDA
WASCO WISHRAM NEZ PERCE CROW ARIKARA SANTEE SAUK FOX
TUTUTNI KLAMATH BANNOCK TETON POTOWATOMI SUSQUEHANNA
SHASTA SHOSHONE CHEYENNE IOWA ILLINOIS MIAMI PAMLICO
YUROK ACHOMAWI PAVIOTSO UTE ARAPAHO PONCA OMAHA OTO
KAROK WASHO MONO PAWNEE SHAWNEE CHEROKEE YAMASI CUSABO
HUPA PAIUTE WALAPAI NAVAHO KIOWA OSAGE CHICKASAW CREEK
POMO MIWOK CHEMEHUEVI HOPI ZUNI APACHE WICHITA CADDO
CAHUILLA MOHAVE YUMA JICARILLA LIPAN NATCHEZ CHOCTAW
COCOPA PAPAGO PIMA MESCALERO COMANCHE CHITIMACHA SEMINOLE
COCHIMI SERI OPATA CONCHO TOBOSO COAHUILTECO ATAKAPA

WASHAKIE KICKING BEAR YAHA-HAJO BLACK HAWK PUSHMATAHA
JOHN ROSS PETALESHARO BIG EAGLE TALL BULL CHIEF JOSEPH
RED THUNDER PERSUNE COCHISE TEN BEARS SEATTLE TECUMSEH
LITTLE TURTLE BLACK KETTLE WOVOKA ROMAN NOSE LITTLE WOLF
SEQUOYAH TWO MOONS POPE RED CLOUD JOSEPH BRANT LAME DEER
GERONIMO CORNPLANTER SATANTA HAS-NO-HORSE SET-IMKIA
SHORT BULL IRON SHELL YARATERA STANDING BEAR DENNIS BANKS
WHITE BULL NAWKAW PONTIAC LITTLE RAVEN LONE WOLF KEOKUK
WARLOUPE POWDER FACE CHATTO PESO POCAHONTAS PLENTY-COUPS
RUSSELL MEANS TEEDYUSCUNG ADOETTE RENVILLE BLACK ELK
JACOB SCOTT DULL KNIFE CAPTAIN JACK CRAZY HORSE VICTORIO
SPOTTED TAIL MANGAS COLORADAS SPOTTED EAGLE MAHTO-IOWA
OSCEOLA AMERICAN HORSE PABLO MONTOGA AUSTENACO TAVIBO
DEKANAWIDA SITTING BULL MANUELITO QUANNAH PARKER GALL
KICKING BIRD LOW DOG MATAGORAS OTTER BELT TOUNOCHICHI
HIAWATHA RED HORN CROW DOG TOMASITO RAIN-IN-THE-FACE
NACHENINGA LITTLE WOUND BIG BOW NANAWONGGABE OURAY
SACAGAWEA BIG FOOT NAHCHE ESSA-QUETA RED JACKET SATANK

**BOOK**
**DESIGN** Lothar Baumgarten **CALLIGRAPHER** Lothar Baumgarten **TYPOGRAPHIC SUPPLIER** Typostudio Schumacher-Gebler
**PRINCIPAL TYPE** Fournier Roman & Italic **DIMENSIONS** 20 × 25.5 in. (50 × 65 cm)

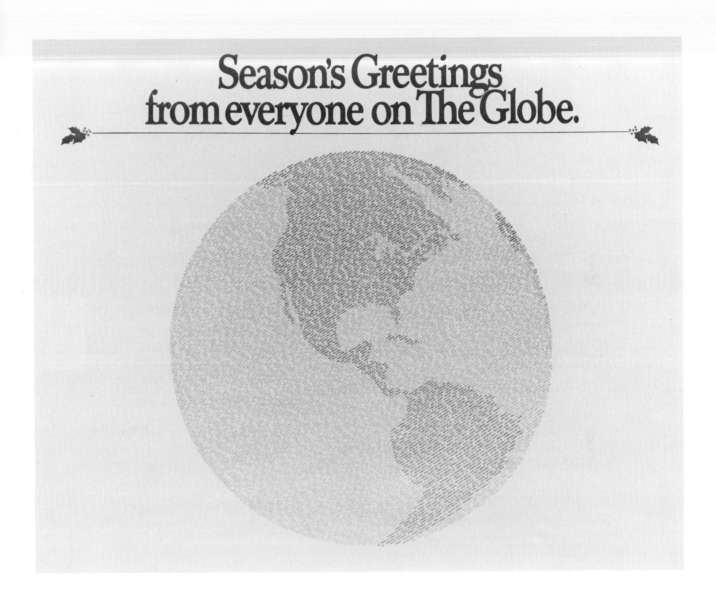

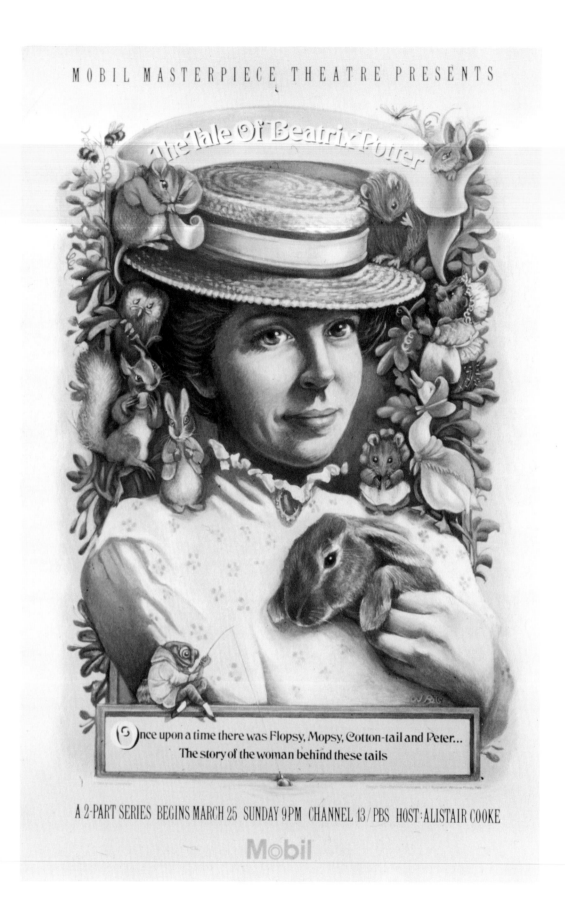

POSTER
**DESIGN** Philip Gips **TYPOGRAPHIC SUPPLIER** Latent Lettering **AGENCY** Gips + Balkind + Associates **STUDIO** Gips + Balkind + Associates
**CLIENT** Mobil Oil Corporation **PRINCIPAL TYPE** Columbus & Latin Elongated **DIMENSIONS** 30 × 46 in. (76.2 × 116.8 cm)

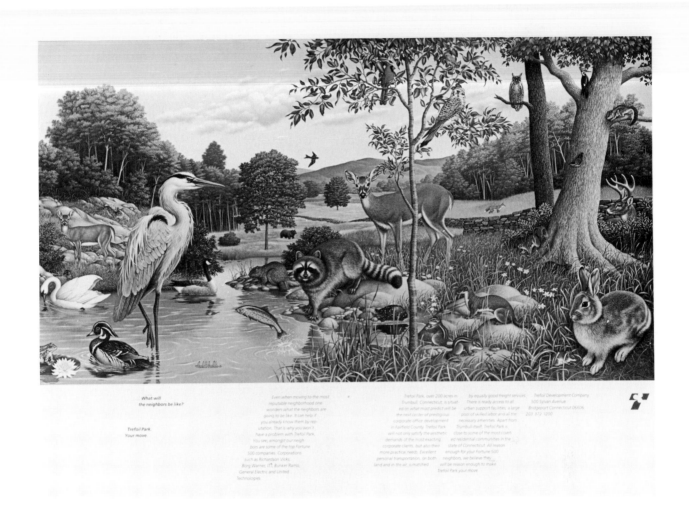

What will
the neighbors be like?

Trefoil Park.
Your move.

Even when moving to the most
reputable neighborhood one
wonders what the neighbors are
going to be like. It can help if
you already know them by rep-
utation. That is why you won't
have a problem with Trefoil Park.
You see, amongst our neigh-
bors are some of the top Fortune
500 companies. Corporations
such as Richardson Vicks,
Borg Warner, ITT, Bunker Ramo,
General Electric and United
Technologies.

Trefoil Park, over 200 acres in
Trumbull, Connecticut, is situat-
ed on what most predict will be
the next center of prestigious
corporate office development
in Fairfield County. Trefoil Park
will not only satisfy the aesthetic
demands of the most exacting
corporate clients, but also their
more practical needs. Excellent
personal transportation, or both
land and in the air, is matched

by equally good freight services.
There is ready access to all
urban support facilities, a large
pool of skilled labor and all the
necessary amenities. Apart from
Trumbull itself, Trefoil Park is
close to some of the most court-
ed residential communities in the
state of Connecticut. All reason
enough for your Fortune 500
neighbors, we believe they
will be reason enough to make
Trefoil Park your move.

Trefoil Development Company
500 Sylvan Avenue
Bridgeport Connecticut 06606
203 372 1200

**ADVERTISEMENT**
**DESIGN** *Frank C. Lionetti/Diane McNamee/Ciaran McCabe* **TYPOGRAPHIC SUPPLIER** *Southern New England Typesetting*
**STUDIO** *Frank C. Lionetti Design* **CLIENT** *Trefoil Development Company* **PRINCIPAL TYPE** *Frutiger* **DIMENSIONS** *16.5 × 11 in. (41.9 × 27.9 cm)*

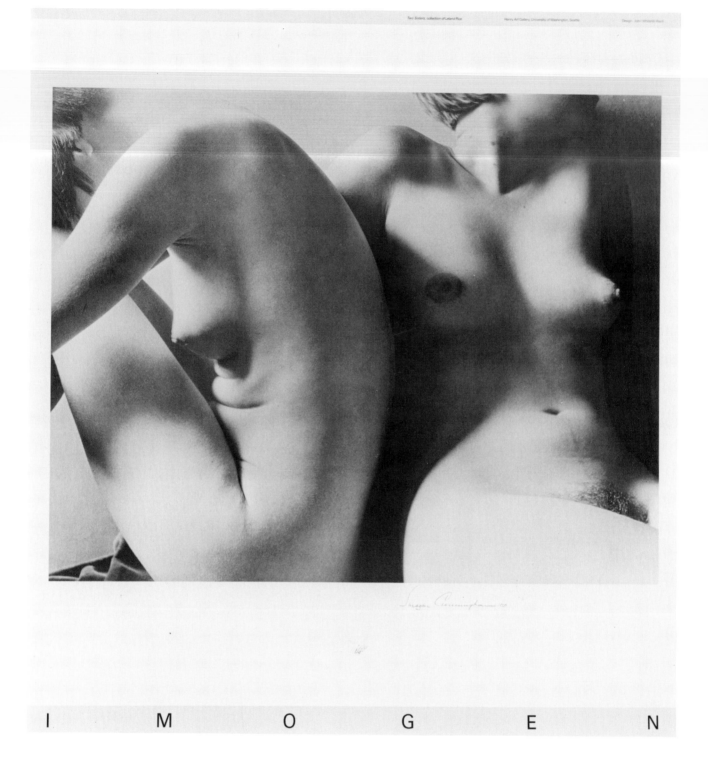

IMOGEN

**POSTER**
**DESIGN** *John Whitehill-Ward* **TYPOGRAPHIC SUPPLIER** *Thomas & Kennedy* **STUDIO** *Design Collaborative*
**CLIENT** *The Henry Gallery* **PRINCIPAL TYPE** *Univers* **DIMENSIONS** *24 × 26 in. (60.9 × 66 cm)*

SIEBDRUCK-KALENDER 1984

# GEOMETRIE EINES GARTENS

DEZEMBER
1 2 3 4 5 6 7 8 9 10 11 12 13 14 15 16 17 18 19 20 21 22 23 24 25 26 27 28 29 30 31

**CALENDAR**
**DESIGN** Friedrich Don **CALLIGRAPHER** Friedrich Don **TYPOGRAPHIC SUPPLIER** Friedrich Don/Franz Wagner **AGENCY** Wagner-Siebdruck
**STUDIO** Wagner-Siebdruck **CLIENT** Wagner-Siebdruck **PRINCIPAL TYPE** Futura Book **DIMENSIONS** 19.7 × 19.7 in. (50 × 50 cm)

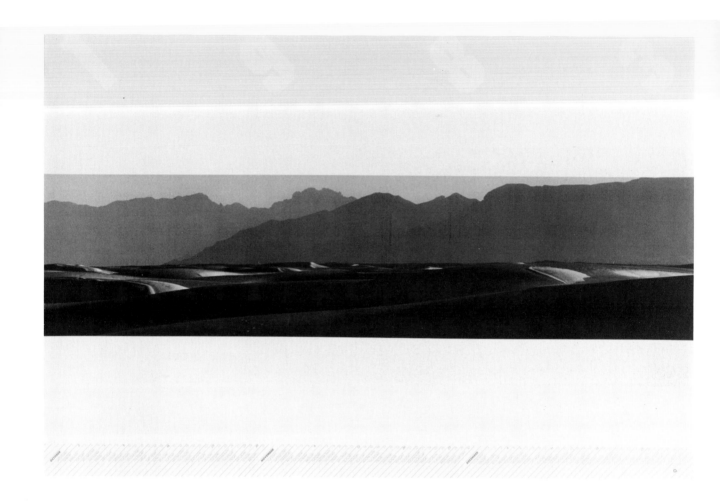

**POSTER**
**DESIGN** *Lou Fiorentino/Mike Reinitz* **TYPOGRAPHIC SUPPLIER** *CTT Typography* **STUDIO** *Lou Fiorentino Visual Communications*
**CLIENT** *ESR Graphics, Inc.* **PRINCIPAL TYPE** *Machine Bold/Univers 56* **DIMENSIONS** *37.8 × 24.8 in. (96 × 63 cm)*

**CALENDAR**
**DESIGN** Lou Fiorentino **TYPOGRAPHIC SUPPLIER** Tri-Arts Press **AGENCY** Lou Fiorentino Visual Communications **STUDIO** Lou Fiorentino
**CLIENT** Tri-Arts Press **PRINCIPAL TYPE** Garamond **DIMENSIONS** 6.5 × 9.5 in. (16.5 × 24 cm)

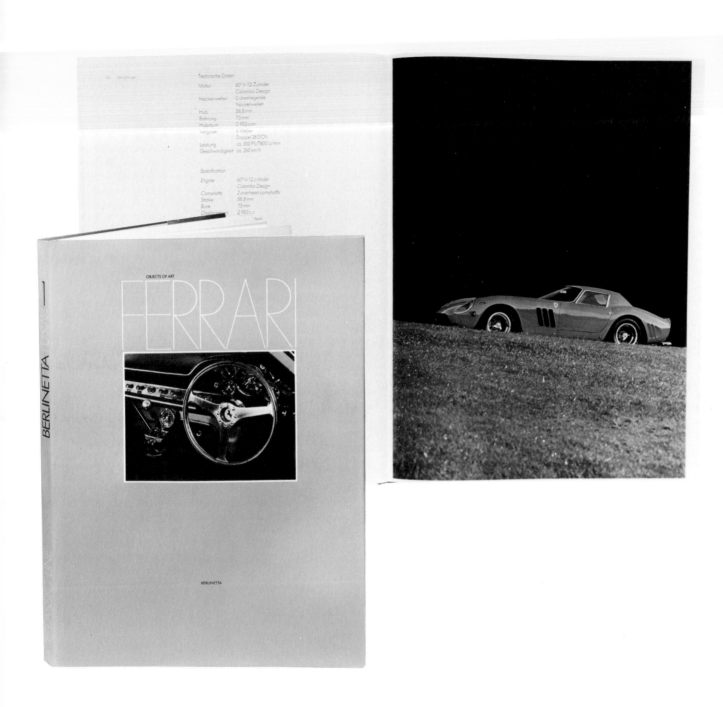

**BOOK**
**DESIGN** Conny J. Winter **TYPOGRAPHIC SUPPLIER** F.W. Wesel **CLIENT** Classic Line Publishing Co.
**PRINCIPAL TYPE** Futura Book Condensed **DIMENSIONS** 15.7 × 11.8 in. (40 × 30 cm)

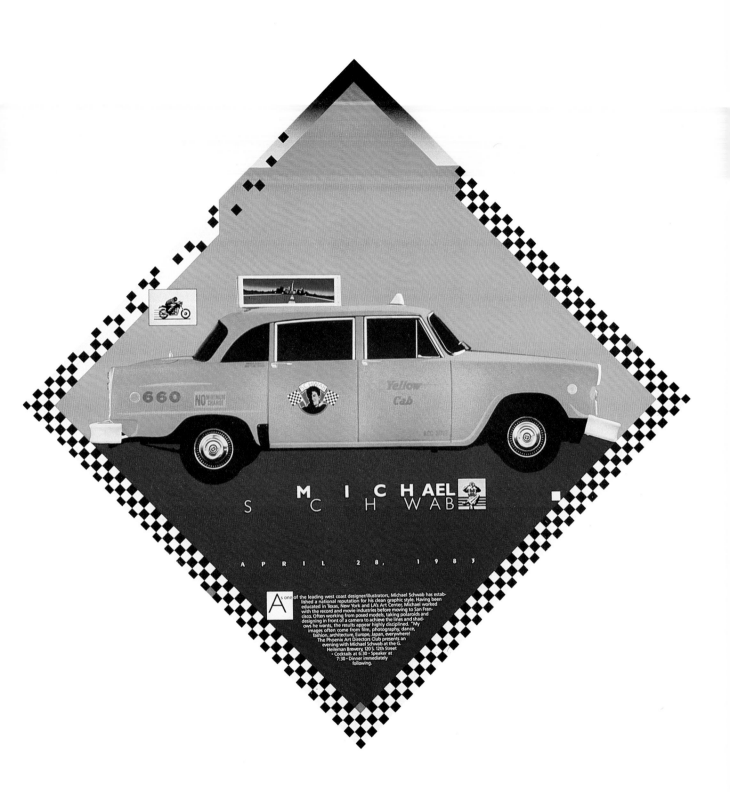

**INVITATION**
**DESIGN** *Lotis Freeman/Michael Swaine* **TYPOGRAPHIC SUPPLIER** *DigiType* **STUDIO** *Michael Swaine Design* **CLIENT** *Phoenix Art Directors Club*
**PRINCIPAL TYPE** *Gill Sans/Frutiger* **DIMENSIONS** *15 × 15 in. (38 × 38 cm)*

It's by far the biggest and most complicated artifact man has ever created.

Its different parts are owned, operated and constantly extended by thousands of diverse organizations. Yet, for millions of users, the global telecommunications network functions as one, single, gigantic precision machine.

It's vitally important that it really does function the way it should, both for you as a private individual and for your business. It's going to be increasingly important as more and more of the world's computers become part of this network (which in fact, is gradually turning into one worldwide digital computer).

Out of the many companies that are constantly extending and improving it, Ericsson ranks number four in size, with eight percent of the world's market for public telecommunications systems.

However, our contributions to the world's mightiest machine are far greater than these figures indicate. In 1977, we introduced a totally new way of thinking about telecommunications systems.

Using our AXE system of modular building blocks, telephone companies can now extend, modernize and digitalize their networks—at their own pace—without ever interrupting service. In the process, they often cut cost for construction and operation by as much as 25%.

Almost overnight, these features made our AXE system the hottest-selling product line on the world market. Seventy telephone companies in 46 countries have chosen it since its introduction. No other system in the history of telecommunications ever achieved such spectacular success.

It will still take a long time before any other manufacturer can match our experience with a complete digital systems family, including the stages that digitalize the network right up to the subscriber. It will take even longer for our competitors to catch up, now that we're putting more than 5,000 people and eight percent of our annual sales figure into research and development.

Another, even faster-growing market is also within our current scope—corporate information systems. The expertise gained from public networks has made us extremely competitive in intra-company communications, office automation and data processing—including customized software.

Another of our product lines is growing faster still—mobile telephone systems, built on the cellular concept. Even here we're world leaders.

In the U.S. we're well equipped to serve the multi-billion dollar telecommunications and office automation market. We're also one of the country's leading manufacturers of wire and cable, including fiber optics.

Next time you catch the world's mightiest machine performing another new trick—give us a thought.

**ERICSSON**

THE ERICSSON GROUP IS COMMUNICATIONS,
DATA PROCESSING AND OFFICE AUTOMATION.
Over 65,000 employees, more than $2.5 billion in sales, a century of
experience in telecommunications.
World headquarters: L.M. Ericsson, S-126 25 Stockholm, Sweden.
In the U.S.: The Ericsson Corp.,100 Park Avenue, New York, N.Y. 10017.

**ADVERTISEMENT**
**DESIGN** Erik Grönlund  **TYPOGRAPHIC SUPPLIER** Set-To-Fit, Inc.  **AGENCY** Anderson, Lembke Welinder, Inc.  **CLIENT** Ericsson, Inc.
**PRINCIPAL TYPE** Goudy Old Style  **DIMENSIONS** 11 × 17 in. (27.9 × 43.2 cm)

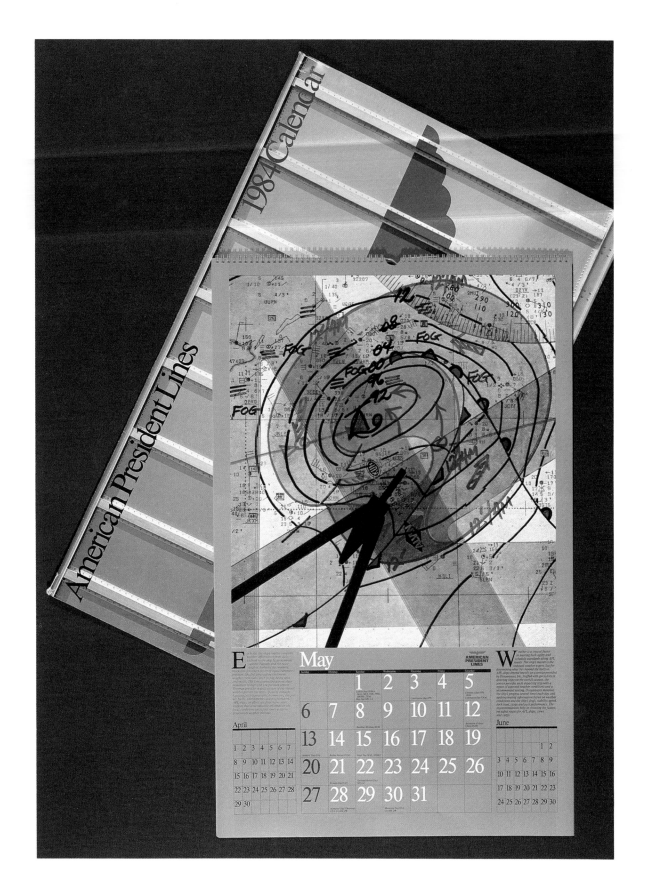

**CALENDAR**
**DESIGN** *Kit Hinrichs* **TYPOGRAPHIC SUPPLIER** *Reardon & Krebs* **AGENCY** *Jonson Pedersen Hinrichs & Shakery Inc.*
**CLIENT** *American President Lines* **PRINCIPAL TYPE** *Times Roman* **DIMENSIONS** *16 × 25 in. (40.6 × 63.5 cm)*

INVITATION/PROGRAM
**DESIGN** *Ron Sullivan* **TYPOGRAPHIC SUPPLIER** *Chiles & Chiles* **STUDIO** *Richards, Sullivan, Brock & Associates*
**CLIENT** *Seaport Marketplace/The Rouse Company* **PRINCIPAL TYPE** *Goudy Old Style* **DIMENSIONS** *6.3 × 9 in. (15.8 × 22.9 cm)*

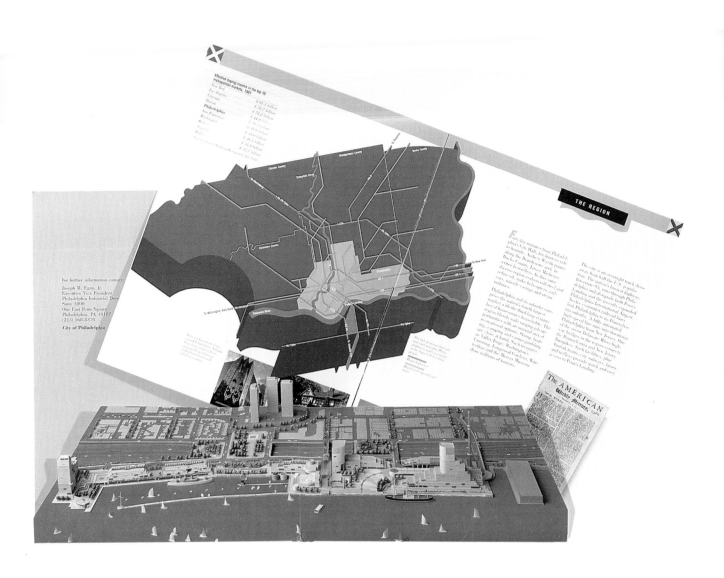

**BROCHURE**
**DESIGN** Joel Katz  **TYPOGRAPHIC SUPPLIER** PHP Typography, Philadelphia  **STUDIO** Katz Wheeler Design
**CLIENT** Philadelphia Industrial Development Corporation, City of Philadelphia  **PRINCIPAL TYPE** Bodoni Book
**DIMENSIONS** 9 × 11.5 in. (23 × 28 cm)

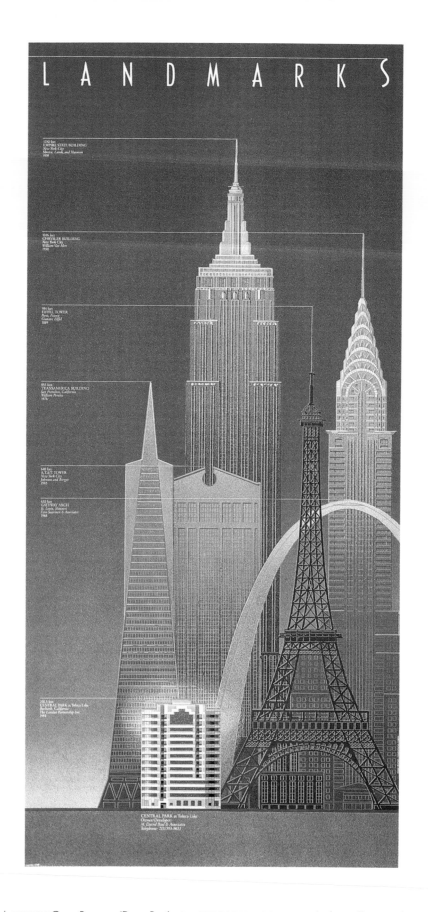

**POSTER**
**TYPOGRAPHY** *Harold Burch* **DESIGN** *Gene Bramson/Doug Brotherton* **TYPOGRAPHIC SUPPLIER** *Andresen Typography*
**AGENCY** *Bramson & Associates* **CLIENT** *M. David Paul & Associates* **PRINCIPAL TYPE** *Stempel Garamond/Casablanca*
**DIMENSIONS** *19 × 39 in. (48.3 × 99.1 cm)*

BROCHURE
**DESIGN** Olaf Leu/Jürgen Bumiller **TYPOGRAPHIC SUPPLIER** Christian Grützmacher GmbH **STUDIO** Olaf Leu Design & Partner
**CLIENT** De Angelis Milan **PRINCIPAL TYPE** Bodoni **DIMENSIONS** 6.3 × 11.8 in. (16 × 30 cm)

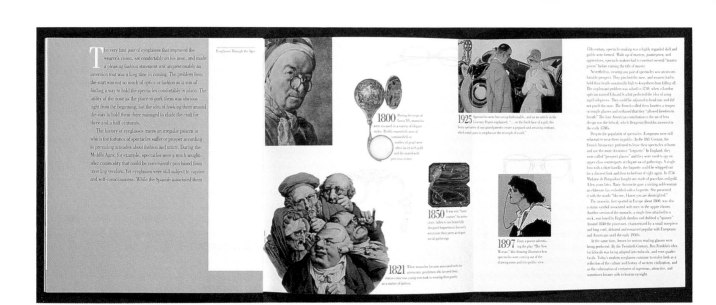

**BROCHURE**
**DESIGN** Linda Hinrichs/Karen Berndt  **TYPOGRAPHIC SUPPLIER** Spartan Typographers  **AGENCY** Jonson Pedersen Hinrichs & Shakery Inc.
**CLIENT** Logo Paris  **PRINCIPAL TYPE** Bodoni Bold  **DIMENSIONS** 9.5 × 10.5 in. (24.1 × 26.7 cm)

and is established by regular interim reviews with contractor, construction manager, or professional estimator.

Services include: programming, zoning and feasibility studies, master planning, site planning, interior and space planning, building design, value engineering and energy studies, scheduling and CPM, construction documents, bid administration, contract management and execution. These services are available for all building types and building related master planning.

PRINCIPALS

MAX ABRAMOVITZ, FAIA, SENIOR PARTNER. University of Illinois, BS, Columbia University, M. Arch. NCARB Registration and licensed in 21 states. As a partner in the firm of Harrison & Abramovitz he was part of the planning for the U.N. Headquarters. He has directed the design of Rockefeller Center Buildings, Philharmonic Hall at Lincoln Center, Phoenix Mutual in Hartford, the U.S. Steel Building in Pittsburgh, and the Banque Rothschild in Paris as well as numerous other projects. A Fellow of the American Institute of Architects,  Mr. Abramovitz is a member of the American Society of Civil Engineers, a Trustee of Mt. Sinai Medical Center in New York and on the Board of the N.Y. Regional Plan Association.

BANQUE ROTHSCHILD
RUE LAFFITTE
PARIS 1970

**BROCHURE**
**DESIGN** *Peter Bradford/Lorraine Johnson* **TYPOGRAPHIC SUPPLIER** *Photogenic Graphics* **AGENCY** *Spencer Wood*
**STUDIO** *Peter Bradford & Associates* **CLIENT** *Abramovitz Harris Kingsland* **PRINCIPAL TYPE** *Baskerville* **DIMENSIONS** *9.3 × 11 in. (23.5 × 27.9 cm)*

University
of Pittsburgh

Graduate
School of Business

Master of
Business Administration
Program
1981-1982

M
B
A

**BOOK**
**DESIGN** *Eddie Byrd* **TYPOGRAPHIC SUPPLIER** *Davis & Warde, Inc.* **STUDIO** *Byrd Graphic Design, Inc.*
**CLIENT** *University of Pittsburgh, Graduate School of Business* **PRINCIPAL TYPE** *Univers 55 & 75* **DIMENSIONS** *7.8 × 11.8 in. (20 × 30 cm)*

**PROMOTION/SALES KIT**
**DESIGN** *Clement Mok* **TYPOGRAPHIC SUPPLIER** *Mercury* **AGENCY** *Apple Computer/Creative Services* **STUDIO** *Apple Computer/Creative Services*
**CLIENT** *Apple Computer, Sales* **PRINCIPAL TYPE** *ITC Garamond Light Condensed* **DIMENSIONS** *9 × 12 in. (22.9 × 30.5 cm)*

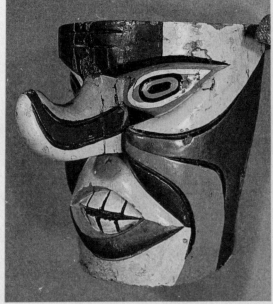

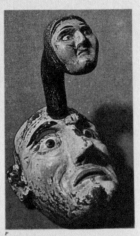

O   YACATECUHTLI MASK. *In pre-conquest days, the Aztec god of travel was depicted with a turned-up nose. Today, it is a symbol for merchants and commerce. The mask is from the region of Michoacán (Tarascan).*

P   DANCE OF THE NATIVITY MASK. *The significance of the ruddy-faced projection from the forehead of the mask is unknown, but the mask itself is a very rare old specimen, used in the celebration of the Nativity or The Dance of the Pastorela, as it is called. The dance is unusual for the preponderance of female participants. Area of Axixintla, Guerrero.*

Q   TIGRE MASK. *Every carver has his own version of the tiger. Some work out of imagination, never having seen the real animal. This mask is a fairly naive, benign version, that has been repainted over the original. Tanquancin, Guerrero (Nahua).*

MATERIALS. Most modern day masks are made of wood. It is simply the most practical choice. Wood is easy to come by, easy to carve and requires simple tools. In pre-Hispanic times, wood was the material of choice, because it was believed to have spirits residing in it, and the masks made from certain woods would derive special powers from their source. With this mystical background, it is understandable that other rituals evolved relating to the harvesting of trees and carving the wood. In some areas, wood must be cut during the waning of the moon, preferably at sunrise. In other areas, wood is best cut during a full moon. Still others believe the optimum time is during the rainy season. There are also prescribed ceremonies to be performed before chopping down a tree. One such ritual involves sprinkling the base of the tree with hen's blood and a litre of mescal—as a token of homage to the spirit of the tree. Furthermore, before attempting to make even a single cut in a mask, some carvers look for visionary guidance by downing a shot of hallucinogenic juices.

Of the trees used for making wood masks, the zompantle is the most common. It is a soft, lightweight wood with a cork-like center which makes it ideal for carving. It grows easily and abundantly. In fact, a few branches stuck in the ground will take root and produce a whole new stand of saplings, giving credence to the notion that it has magical, immortal qualities. Other woods used in mask-making throughout Mexico are poplar, pine, willow,

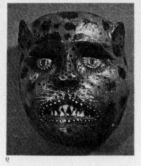

ash, pochote, avocado, copal and a number of indigenous varieties.

Although wood is the most extensively used material, and has been in the recent past, earlier masks were fashioned from a variety of resources. Bone, clay, stone, leather, gourds and wax were all used as far back as pre-Hispanic times. In the early 1900s certain metalworking communities produced copper and silver masks,

hammered out in a repoussé technique.

The finishing and decorative details on Mexican masks are entirely consistent with the primitive concepts that inspire these creations. The simplest cutting and burnishing tools are used. The colors derive from nature—from the earth, minerals and plants—not from chemicals or sophisticated color theories. And the decorative teeth, hair, horns, tusks are never fabricated; they all come from their natural source.

Ultimately, someone poses the question: Are these masks works of art or craft? In the sense that they are useful objects, and that certain rules, symbols, techniques, colors, etc., have been handed down from generation to generation, purists may prefer to call them handicrafts. On the other hand, these masks are hardly the work of deft, exacting, finely-tuned craftsmen. There is nothing routine, schematic or slavishly meticulous about them. They are vigorous, spiritual, expressive visions—more concerned with purpose than with process—and carved more

with passion than with calculated esthetic principles in mind. Considering the carvers' quest for "vision," the hallucinogenic lengths they go to to procure their visions, and the visceral responses these masks evoke from their audience, we have to allow they are something beyond "handicraft."

I, for one, am content to leave the argument to the academicians. Wherever you see Mexican masks—in art museums, in anthropological exhibits, in craft museums or in the pages of Donald Cordry's book, MEXICAN MASKS, they are surely something to marvel at.

**MARION MULLER**

THIS PAGE WAS SET IN ITC CUSHING® AND ITC NEW BASKERVILLE®

**EDITORIAL**
**DESIGN** *Bob Farber* **TYPOGRAPHIC SUPPLIER** *M.J. Baumwell* **STUDIO** *ITC* **CLIENT** *U&lc* **PRINCIPAL TYPE** *Various*
**DIMENSIONS** *22 × 14.8 in. (56 × 37.5 cm)*

**BOOK COVER**
**DESIGN** Carin Goldberg  **TYPOGRAPHIC SUPPLIER** Haber Typographers  **STUDIO** Carin Goldberg Design  **CLIENT** Alfred A. Knopf
**PRINCIPAL TYPE** Gill Sans Bold Extra Condensed  **DIMENSIONS** 5.8 × 8.5 in. (15 × 22 cm)

# SHOCKOE SLIP

Winner
1983 Historic Richmond Foundation
Annual Award for Preservation

The watering fountain "in memory of one who loved animals" is located on a cobblestone piazza in the heart of Shockoe Slip. It was carved in 1909 by Ferruccio Legnaioli, an Italian immigrant whose sculptured detail decorates several Richmond theaters, as a monument to Capt. Charles Morgan. Shockoe Slip - a 19th century warehouse and commercial district which has been renovated and developed for office, retail, residential and restaurant use - is an important example of successful downtown revitalization. Most of the area's buildings, rich in architectural and historical significance, were erected following the Evacuation Fire of 1865, but Shockoe Slip has been a major commercial center since William Byrd established his trading post there in the 1670's.

In recognition of his early and active promotion and leadership in the development of the Shockoe Slip area, and his sensitivity and skill in preserving several of these historic structures, Historic Richmond Foundation honors Andrew J. Asch, Jr. with its second annual Award for Historic Preservation.

**POSTER**
**DESIGN** Meredith Davis/Robert Meganck  **TYPOGRAPHIC SUPPLIER** Riddick Advertising Art  **STUDIO** Communication Design, Inc.
**CLIENT** Historic Richmond Foundation  **PRINCIPAL TYPE** Garamond  **DIMENSIONS** 20.5 × 34 in. (52 × 86.4 cm)

## The Enduring Challenge

By Franklin Russell

**W**ithin the rock walls of a Baffin Island fjord, a single snowflake, gossamer fine, drifts from a leaden sky and gently falls into itself in the mirrored waters. A small flock of male Common Eiders floats motionless in the middle of the fjord as if painted in place in a still landscape of grays, browns, and steely blues. At the edge of a precipice stands an unblinking Snowy Owl.

The fall of the snowflake is a sign of one season seeking to overcome another. In this month, late September, the North American winter has begun. But it has not yet achieved enough authority to take control.

The waiting owl, a lustrous and imperial figure in his speckled white plumage, is looking south with large yellow eyes. Soon he must fly into that sunward unknown, for here in the Arctic his main food supply of lemmings has dwindled drastically in one of the rodents' cyclical population crashes. The owl has no choice but to migrate, to intrude deeper into a continent where hundreds of species of birds are already wintering over—migrants and residents, shorebirds and waterfowl, desert dwellers and woodland foragers, beach prowlers and prairie wanderers, seed eaters and meat hunters—and there find food in strange new surroundings.

Tundra born, the owl has never seen a tree. Yet he will have to accustom himself to forests, lakes, rivers, then farms, towns, cities. He will be harassed by birds flocked to drive him away. He will be seen flaring away from airplane landing lights, a limp rodent dangling from

*A Short-eared Owl finds shelter amid cedars in upstate New York. By Michael Jacob Hopiak.*

190

**BOOK**
**DESIGN** David M. Seager  **CALLIGRAPHER** Tom Carnase  **TYPOGRAPHIC SUPPLIER** NGS Photographic Services
**CLIENT** National Geographic Society  **PRINCIPAL TYPE** Primer  **DIMENSIONS** 9.5 × 11.25 in. (24 × 28.6 cm)

**PACKAGING**
**DESIGN** *Ross Carron/Ann Schwiebinger* **CALLIGRAPHER** *Peter Soe, Jr.* **TYPOGRAPHIC SUPPLIER** *Gestype* **STUDIO** *Ross Carron Design*
**CLIENT** *Pepperwood Springs Vineyards* **PRINCIPAL TYPE** *Garamond Italic* **DIMENSIONS** *4.3 × 4.3 in. (10.8 × 10.8 cm)*

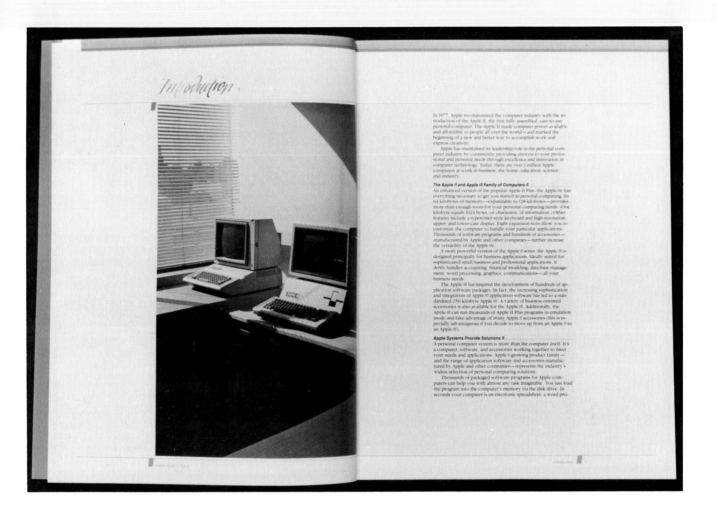

**CATALOG**
**DESIGN** Gary Maddocks  **CALLIGRAPHER** Georgia Deaver  **TYPOGRAPHIC SUPPLIER** Mercury Typography, Inc.
**AGENCY** Apple Computer/Creative Services  **CLIENT** Apple Computer Inc.
**PRINCIPAL TYPE** ITC Garamond Book/Helvetica Regular Italic  **DIMENSIONS** 8.5 × 10.9 in. (21.6 × 27.6 cm)

**Quality**
**Art and Drafting**
**Materials**

$3.50

25 W 45th Street
New York, NY 10036
212 575-0200

**A.I. Friedman**

**CATALOG**
**DESIGN** *Tobias Moss/Willi Kunz/Steve Orant* **TYPOGRAPHIC SUPPLIER** *Typogram* **STUDIO** *Willi Kunz Associates Inc./A.I. Friedman Inc.*
**CLIENT** *A.I. Friedman* **PRINCIPAL TYPE** *Helvetica* **DIMENSIONS** *9.3 × 11 in. (23.5 × 27.9 cm)*

Deaths temporarily enhanced Mercy's mission as World War I and a swine flu epidemic broke out within a year of each other. In 1917, the U.S. War Department drafted Mercy to assist in the care of military personnel. In 1918, Mercy was totally consumed with the care of 1,500 swine flu victims at the request of the U.S. Public Health Service.

The stock market had plunged, but Mercy continued to build, expanding to 275 beds in 1931. Just ten years later, when the hospital was once again debt free, the price of freedom escalated as the U.S. plunged into World War II. Many former nurses returned to Mercy to replace nurses who went overseas.

---

*Critical Care Nursing*

The highest standards of patient care are backed by ultra modern patient data management systems in Mercy's Critical Care Unit. Acuity systems structured by each department help ensure proper patient care as well as an optimum nursing environment. Cross training opportunities are abundant, ranging from formal bi-weekly inservice classes to individualized preceptor programs.

Disciplines:

Highlands Ranch Emergency Center
Telemetry
ICU/CCU
Emergency
Cardiac Rehabilitation

*Alcohol • Substance Abuse Rehabilitation*

A holistic approach to wellness is effectively offered in Mercy's Adolescent and Adult Comprehensive Alcoholic Rehabilitation Environment (C.A.R.E.) Units. A multi-disciplinary approach to treatment involves nurses in all phases of recovery for patients who have voluntarily sought treatment for substance abuse. The 56-bed Adult C.A.R.E. Unit focuses primarily on alcohol abuse recovery, while the 20-bed Adolescent C.A.R.E. Unit deals with problems with substances in addition to alcohol. Both programs provide for all levels of care from detoxification through recovery.

CONTINUING EDUCATION

Mercy's commitment to helping our employees reach their fullest potential enables us to provide a full complement of educational programs and career development opportunities.

As a teaching medical center, Mercy provides the clinical experience needed for entry into Nursing practice as well as continuing Nursing education programs. Professional growth is encouraged with a clinical ladder which enables nurses with demonstrated skills to be promotionally advanced within the clinical setting. For professional growth within management, courses are offered in-house, providing approximately 50 hours of developmental seminars on a full range of topics. The promotional options available at Mercy have increased the caliber of our patient care while satisfying the professional needs and preferences of those nurses demonstrating leadership capabilities.

FOUR

FIVE

**BROCHURE**
**DESIGN** Mark Hamilton Hanger **CALLIGRAPHER** Mark Hamilton Hanger **TYPOGRAPHIC SUPPLIER** Cynthia Coval
**AGENCY** Markham Design Office **STUDIO** Markham Design Office **CLIENT** Mercy Medical Center **PRINCIPAL TYPE** Bodoni
**DIMENSIONS** 6 × 10 in. (15 × 15 cm)

**BROCHURE**
**DESIGN** *Bobbi Long* **TYPOGRAPHIC SUPPLIER** *Custom Graphics* **AGENCY** *3D/International* **STUDIO** *3D/International*
**CLIENT** *L'Alliance Francaise de Houston* **PRINCIPAL TYPE** *Helvetica* **DIMENSIONS** *Folded: 8.1 × 8.1 in. (20.6 × 20.6 cm);*
*Spread: 11.5 × 23 in. (29.3 × 58.5 cm)*

There can be no definitive interpretation of the creative process. To be sure, it calls for style, imagination, experience, invention as well as a sense of colour and of form. But each innovator will bring something of his or her own individual dimension to the ultimate creation. The basics, however, remain universal. The enclosed origami kit invites you to engage, light-heartedly, in this fascinating process. Each piece of paper represents a different facet of our company's activities: packaging, new products, retail design, annual and employee reports, and general business communication. In essence, what you will be doing in abstract follows similar procedures by which the designer translates concept into a finished, high-quality product. For in the end quality is the launch-pad to profitability. Follow the instructions and for a few moments share the fun (and perhaps the frustration) of the creative designer's experience. Fold away!

MICHAEL PETERS GROUP PLC
PLACING BY HENDERSON CROSTHWAITE & CO

**PROSPECTUS**
**DESIGN** *Jackie Vicary* **TYPOGRAPHIC SUPPLIER** *Apex Photosetting* **STUDIO** *Michael Peters Group PLC* **CLIENT** *Michael Peters Group PLC*
**PRINCIPAL TYPE** *Bodoni Book* **DIMENSIONS** *10 × 8.3 in. (25.3 × 21 cm)*

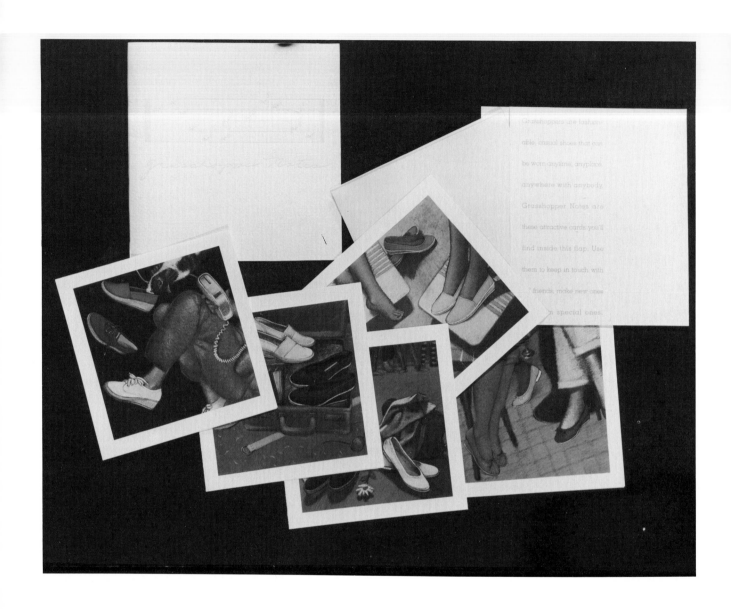

**PROMOTIONAL GIFT**
**DESIGN** *Cheryl Heller* **CALLIGRAPHER** *Cheryl Heller* **TYPOGRAPHIC SUPPLIER** *Typographic House* **AGENCY** *HBM/Creamer Advertising, Inc.*
**STUDIO** *HBM Design Group* **CLIENT** *Keds Corp.* **PRINCIPAL TYPE** *Memphis* **DIMENSIONS** *6.3 × 6.3 in. (15.8 × 15.8 cm)*

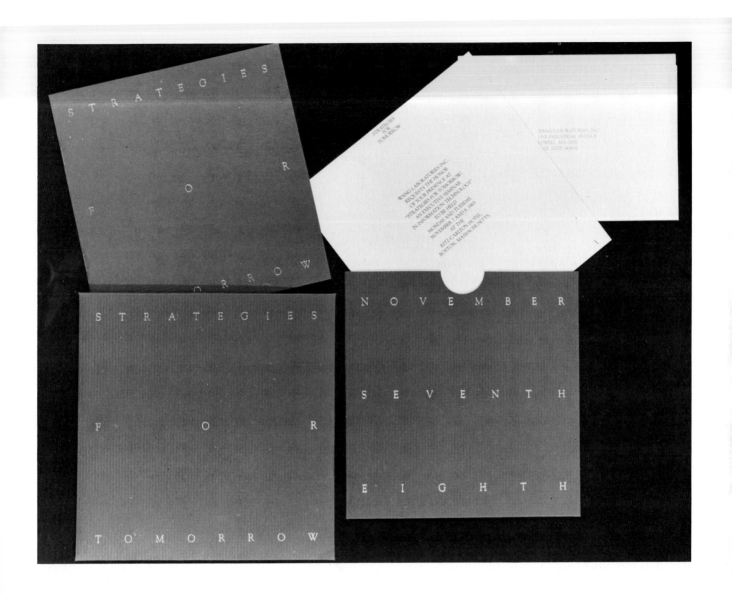

**INVITATION**
**DESIGN** *Roy Hughes* **TYPOGRAPHIC SUPPLIER** *Typographic House* **STUDIO** *Hughes Associates* **CLIENT** *Wang Laboratories*
**PRINCIPAL TYPE** *Goudy Old Style* **DIMENSIONS** *7.4 × 7.4 in. (18.8 × 18.8 cm)*

**PROMOTIONAL ANNOUNCEMENT**
**DESIGN** Lou Fiorentino  **TYPOGRAPHIC SUPPLIER** CT Typografix, Inc.  **AGENCY** Lou Fiorentino Visual Communications
**STUDIO** Lou Fiorentino Visual Communications  **CLIENT** ESR Graphics  **PRINCIPAL TYPE** Univers/Machine Bold
**DIMENSIONS** 7.3 × 39 in. (18.4 × 99 cm)

The computer revolution has happened less quickly in some areas of engineering than in others, primarily because of the complexity and expense of developing integrated engineering applications software. It is only happening now. Its success, however, is assured. The ability to increase productivity 500% to 1,000% makes failure unacceptable.

**ANNUAL REPORT**
**DESIGN** Michael Barile/Richard Garnas/Gene Clark **TYPOGRAPHIC SUPPLIER** Spartan Typography **AGENCY** Barile/Garnas Design
**STUDIO** Barile/Garnas Design **CLIENT** Impell Corporation **PRINCIPAL TYPE** Caslon #224/Helvetica **DIMENSIONS** 8.5 × 11 in. (22 × 28 cm)

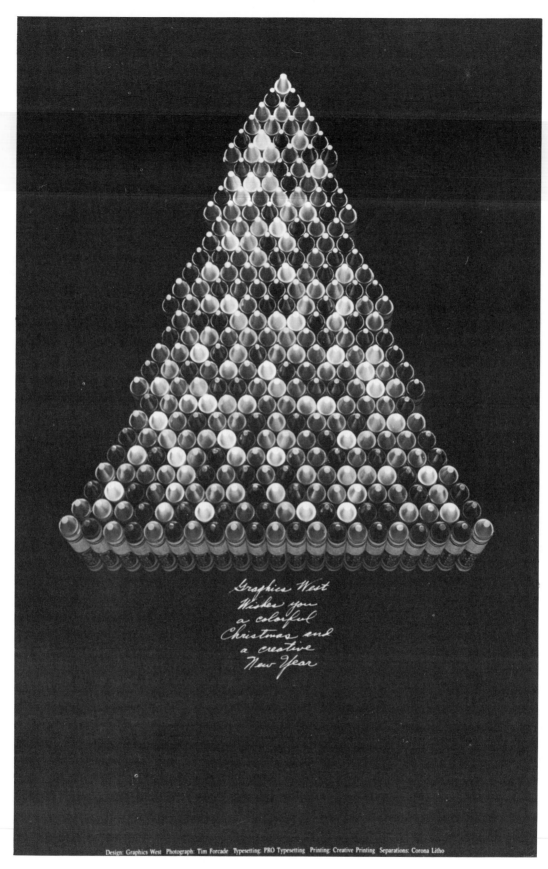

Design: Graphics West  Photograph: Tim Forcade  Typesetting: PRO Typesetting  Printing: Creative Printing  Separations: Corona Litho

**SELF-PROMOTION**
**DESIGN** Stan F. Chrzanowski/Frank Addington  **CALLIGRAPHER** Stan F. Chrzanowski  **TYPOGRAPHIC SUPPLIER** Phototype
**AGENCY** Graphics West Inc.  **STUDIO** Graphics West Inc.  **CLIENT** Graphics West Inc.  **PRINCIPAL TYPE** Garamond Condensed
**DIMENSIONS** 11 × 17 in. (27.9 × 43.2 cm)

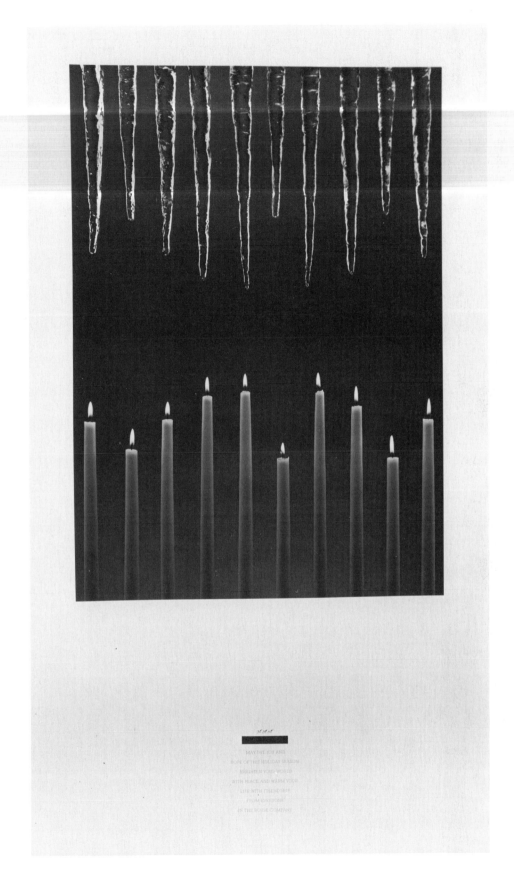

**POSTER**
**DESIGN** *Scott Eggers/Ron Sullivan* **TYPOGRAPHIC SUPPLIER** *Chiles & Chiles* **STUDIO** *Richards, Brock, Miller, Mitchell & Assoc.*
**CLIENT** *The Rouse Company* **PRINCIPAL TYPE** *Lubalin Graph Extra Light* **DIMENSIONS** *18 × 32 in. (45.7 × 81.3 cm)*

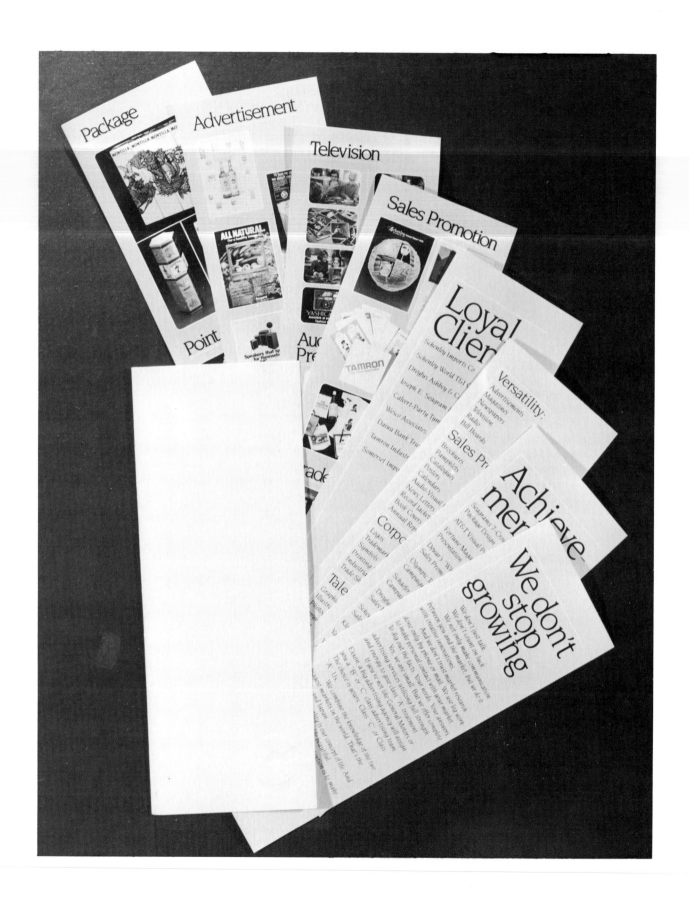

**BROCHURE**
**DESIGN** *Minoru Morita* **CALLIGRAPHER** *Minoru Morita* **TYPOGRAPHIC SUPPLIER** *Nassau Typographers* **STUDIO** *Creative Center Inc.*
**CLIENT** *Creative Center Inc.* **PRINCIPAL TYPE** *Novarese* **DIMENSIONS** *11 × 4.3 in. (27.9 × 10.9 cm)*

**POSTER**
**DESIGN** *Roger Black* **TYPOGRAPHIC SUPPLIER** *Innovative Graphics International* **STUDIO** *Roger Black, Inc.* **CLIENT** *Amnesty International*
**PRINCIPAL TYPE** *San Serif #1/Sabon* **DIMENSIONS** *33.5 × 79 in. (85 × 201 cm)*

# Macintosh

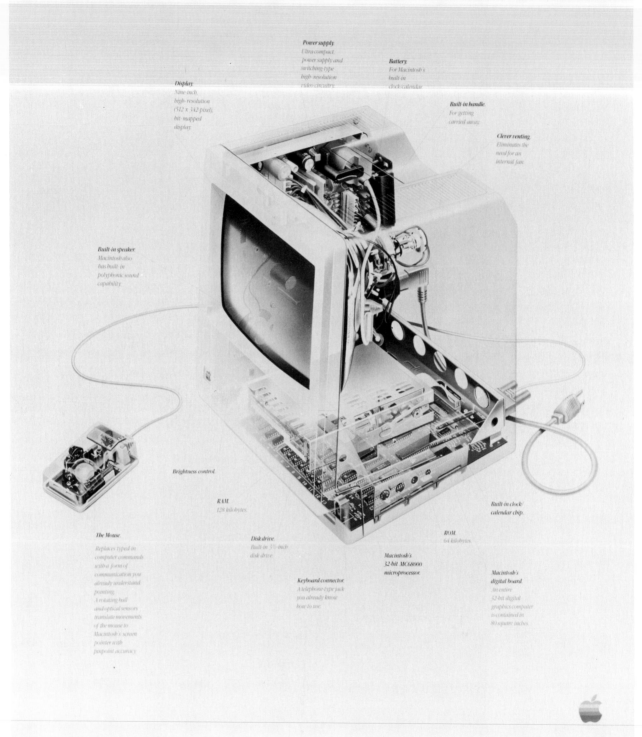

Power supply
Ultra-compact,
power supply and
switching-type
high-resolution
video circuitry.

Battery.
For Macintosh's
built-in
clock/calendar.

Display.
Nine-inch,
high-resolution
(512 x 342 pixel),
bit-mapped
display.

Built-in handle.
For getting
carried away.

Clever venting.
Eliminates the
need for an
internal fan.

Built-in speaker.
Macintosh also
has built-in
polyphonic sound
capability.

Brightness control.

RAM.
128 kilobytes.

Built-in clock/
calendar chip.

The Mouse.
Replaces typed-in
computer commands
with a form of
communication you
already understand
pointing.
A rotating ball
and optical sensors
translate movements
of the mouse to
Macintosh's screen
pointer with
pinpoint accuracy.

Disk drive.
Built-in 3½-inch
disk drive.

ROM.
64 kilobytes.

Macintosh's
32-bit MC68000
microprocessor.

Macintosh's
digital board.
An entire
32-bit digital
graphics computer
is contained in
80 square inches.

Keyboard connector.
A telephone-type jack
you already know
how to use.

**POSTER**
**DESIGN** Tom Hughes/Clement Mok/Ellen Romano **CALLIGRAPHER** Carnase, Inc. **TYPOGRAPHIC SUPPLIER** Vicki Takla
**AGENCY** Apple Computer/Creative Services **STUDIO** Apple Computer/Creative Services **CLIENT** Apple Computer/Creative Services
**PRINCIPAL TYPE** Garamond Light Condensed **DIMENSIONS** 22 × 28 in. (55.8 × 71.1 cm)

MIT GOTTES WORT LEBEN 450 JAHRE EVANGELISCHE LANDESKIRCHE IN WÜRTTEMBERG

**LOGOTYPE**
**DESIGN** *Olaf Leu* **CALLIGRAPHER** *Olaf Leu* **TYPOGRAPHIC SUPPLIER** *Christian Grützmacher GmbH* **STUDIO** *Olaf Leu Design & Partner*
**CLIENT** *Ev. Landeskirche, Württemberg* **PRINCIPAL TYPE** *Caslon*

**LOGOTYPE**
**DESIGN** Alan Wood  **CALLIGRAPHER** Alan Wood  **TYPOGRAPHIC SUPPLIER** Alan Wood  **AGENCY** Alan Wood Graphic Design, Inc.
**STUDIO** Alan Wood Graphic Design, Inc.  **CLIENT** The Buckley Group  **PRINCIPAL TYPE** Futura Extra Black

**LOGOTYPE**
**DESIGN** *D.C. Stipp* **CALLIGRAPHER** *D.C. Stipp* **STUDIO** *Richards, Brock, Miller, Mitchell & Associates* **CLIENT** *500 Inc.*

**A newsletter for type enthusiasts from Typographic Resource**

Contents
A brief history of Berthold, 1858-1983.
How Berthold adapts Monotype Plantin
from metal into phototype.
Typeface quality by Günter Gerhard
Lange, art director of Berthold.
Classification of typefaces by period.
Text and headline faces available from
Typographic Resource.
The new Tr. type gauge.

Copyright 1983
Typographic Resource Limited
1624A Central Street
Evanston, Illinois 60201-1597
Telephone 312 864 9444

**NEWSLETTER**
**DESIGN** *Bart Crosby* **TYPOGRAPHIC SUPPLIER** *Typographic Resource* **AGENCY** *Crosby Associates Inc.* **STUDIO** *Crosby Associates Inc.*
**CLIENT** *Typographic Resource* **PRINCIPAL TYPE** *Futura Extra Bold Condensed/Avant Garde Book Light* **DIMENSIONS** *11.8 × 11.8 in. (30 × 30 cm)*

ADVERTISEMENT
**DESIGN** *Erkki Ruuhinen* **TYPOGRAPHIC SUPPLIER** *Aapiset Oy* **AGENCY** *Erkki Ruuhinen Design* **CLIENT** *Finnish Furniture Exports*
**PRINCIPAL TYPE** *Futura Light* **DIMENSIONS** *19 × 12.5 in. (48 × 31 cm)*

# TYPE DIRECTORS CLUB

## TYPE DIRECTORS CLUB OFFICERS
### 1983–1984

| | |
|---|---|
| **President** | Jack George Tauss |
| **Vice President** | Klaus Schmidt |
| **Secretary/Treasurer** | Roy Zucca |
| **Directors-at-Large** | Freeman Craw |
| | John Luke |
| | Marilyn Marcus |
| | Minoru Morita |
| | Jack Odette |
| | Vic Spindler |
| | Ed Vadala |
| **Chairperson Board of Directors** | Bonnie Hazelton |

## TYPE DIRECTORS CLUB OFFICERS
### 1984–1985

| | |
|---|---|
| **President** | Klaus Schmidt |
| **Vice President** | John Luke |
| **Secretary/Treasurer** | Jack Odette |
| **Directors-at-Large** | Ed Benguiat |
| | Ed Brodsky |
| | Freeman Craw |
| | Tom Kerrigan |
| | Marilyn Marcus |
| | Vic Spindler |
| | Ed Vadala |
| **Chairman Board of Directors** | Jack George Tauss |

## COMMITTEE FOR TDC-30

| | |
|---|---|
| **Chairperson** | Vic Spindler |
| **Co-Chairperson, Design** | Martin Pedersen |
| **Coordinator** | Carol Wahler |
| **Printing** | EM Graphics |
| **Calligraphy** | Robert Boyajian |
| **Receiving Facilities** | Cardinal Type Service, Inc. |
| **Assistants to Judges** | Godfrey Biscardi, Kathie Brown, |
| | Cheryl Donovan, Bonnie Hazelton, |
| | John Luke, Marilyn Marcus, |
| | Minoru Morita, Richard Mullen, |
| | Leslie Nolan, Walter Pretzat, |
| | Ena Schmidt Solomon, Klaus Schmidt, |
| | Gertrude Spindler, Walter Stanton, |
| | Edward Vadala, Allan R. Wahler, |
| | Roy Zucca |

## INTERNATIONAL LIAISON COMMITTEE

Roy Zucca, Chairman
Type Directors Club
545 West 45th Street
New York, NY 10036

Japan Typography Association
Kanamori Bldg.    4th Floor
12-9, Sendagaya 1-chrome
Shibuya-ku, Tokyo 151
JAPAN

Jean Larcher
16 Chemin des Bourgognes
95000 Cergy
FRANCE

Professor Olaf Leu
Olaf Leu Design & Partner
Bettinastrasse 56
D-6000 Frankfurt/Main 1
WEST GERMANY

Fernando Medina
Fernando Medina Desena
Santiago Bernabeu 6
Madrid 16
SPAIN

Oswaldo Miranda (MIRAN)
Rua Amazonas 1207
Curitiba—PR.
80.000 BRAZIL

Keith Murgatroyd
Royle Murgatroyd
Design Associates Limited
24/41 Wenlock Road
London N1 7SR
ENGLAND

TYPE DIRECTORS CLUB
545 West 45 Street
New York, NY 10036
212-245-6300
Carol Wahler, Executive Director

*For membership information please contact
the Type Directors Club office.*

# MEMBERSHIP

George Abrams
**Ad Agencies/Headliners**
Mary Margaret Ahern
Kelvin J. Arden
**Arrow Typographers**
Leo Avila
Leonard F. Bahr
Don Baird
Aubrey Balkind
Arnold Bank[†]
Gladys Barton
Clarence Baylis
Edward Benguiat
Peter Bertolami
Emil Biemann
Godfrey Biscardi
Roger Black
Art Boden
Friedrich Georg Boes
Garrett Boge
David Brier
Ed Brodsky
Kathie Brown
William Brown
Werner Brudi
Bernard Brussel-Smith*
Bill Bundzak
Aaron Burns
Joseph Buscemi
Steve Byers
Daniel Canter
**Cardinal Type Service, Inc.**
Tom Carnase
Alan Christie
Travis Cliett
Mahlon A. Cline*
Tom Cocozza
Robert Adam Cohen
Ed Colker
Freeman Craw*
James Cross
Ray Cruz
Derek Dalton
Ismar David
Whedon Davis
Cosmo De Maglie
Robert Defrin
Claude Dieterich
Ralph Di Meglio
Lou Dorfsman
John Dreyfus[†]
William Duevell
Curtis Dwyer
Joseph Michael Essex
Eugene Ettenberg*
Leon Ettinger
Bob Farber
Sidney Feinberg*
Joseph A. Fielder

Blanche Fiorenza
Holley Flagg
Norbert Florendo
Glenn Foss
Dean Franklin
Elizabeth Frenchman
Adrian Frutiger[†]
David Gatti
Stuart Germain
John Gibson
Lou Glassheim*
Howard Glener
Jeff Gold
Edward Gottschall*
Norman Graber
Austin Grandjean
Kurt Haiman
Allan Haley
Edward A. Hamilton
Mark L. Handler
William Paul Harkins
Sherri Harnick
Horace Hart
Bonnie Hazelton
Diane L. Hirsch
Fritz Hofrichter
Terry Hull
**International Typeface
    Corporation**
Donald Jackson
Mary Jaquier
Allen Johnston
R.W. Jones
R. Randolph Karch
Rachel Katzen
Michael O. Kelly
Scott Kelly
Tom Kerrigan
Lawrence Kessler
Peggy Kiss
Zoltan Kiss
Robert Knecht
Steve Kopec
Linda Kosarin
Gene Krackehl
Bernhard J. Kress
Walter M. Kryshak
Jim Laird
Wilford Bryan Lammers
Günter Gerhard Lange
Jean Larcher
Mo Lebowitz
Alan Leckner
Arthur B. Lee*
Judith Kazdym Leeds
Louis Lepis
Robert Leslie[†]
Professor Olaf Leu
Ben Lieberman

Wally Littman
John Howland Lord*
John Luke
Ed Malecki
Sol Malkoff
Marilyn Marcus
Stanley Markocki
John S. Marmaras
Frank B. Marshall III
James Mason
Jack Matera
John Matt
Frank Mayo
Fernando Medina
**Mergenthaler Linotype
    Corporation**
Douglas Michalek
R. Hunter Middleton[†]
John Milligan
Michael Miranda
Oswaldo Miranda
Deborah Mix
Barbara Montgomery
Richard Moore
Ronald Morganstein
Minoru Morita
Tobias Moss*
Leslie Mullen
Richard Mullen
Keith Murgatroyd
Louis A. Musto
Rafael Navarro
Alexander Nesbitt
Ko Noda
Jack Odette
Thomas D. Ohmer
Motoaki Okuizumi
Brian O'Neill
Gerard J. O'Neill*
John H. Ott
Vincent Pacella
Zlata W. Paces
Luther Parson
Charles Pasewark
**Pastore DePamphilis
    Rampone**
Eugene Pattberg
Ray Pell
Ronald Pellar
**Photo-Lettering Inc.**
Roma Plakyda
Roy Podorson
Louis Portuesi
Stephen Pregman
Janice Prescott
David Quay
Elissa Querze
Erwin Raith
John Rea

Bud Renshaw
Ed Richman
Jack Robinson
Edward Rondthaler*
Robert M. Rose
Herbert Rosenthal
**Royal Composing Room**
Joseph E. Rubino
Gus Saelens
Fred Salamanca
Bob Salpeter
David Saltman
John N. Schaedler
Hermann Schmidt
Klaus Schmidt
Michael G. Scotto
William L. Sekuler*
Julie Silverman
Richard Silverman
Jerry Singleton
Martin Solomon
Jeffrey Spear
Vic Spindler
Rolf Staudt
Walter Stanton
Murray Steiner
William Streever
Doug Stroup
Ken Sweeny
William Taubin
Jack George Tauss
Anthony J. Teano
**Techni-Process Lettering**
Bradbury Thompson
**Tri-Arts Press**
Susan B. Trowbridge
Professor Georg Trump[†]
Lucile Tuttle-Smith
**Typographic Designers**
**Typographic House**
**Typographic Innovations Inc.**
**Typovision Plus**
Edward Vadala
Jan Van Der Ploeg
Eileen Vincent-Smith
Jurek Wajdowicz
Herschel Wartik
Professor Kurt Weidemann
Ken White
Cameron Williams
Stanley Yates
Hal Zamboni*
Professor Hermann Zapf[†]
Roy Zucca

*Charter member
[†]Honorary member
Sustaining members are
indicated in boldface type.

# INDEX